From Acting to Performance

From Acting to Performance collects for the first time major essays by performance theorist and critic Philip Auslander. Written over more than a decade, from the mid-1980s to the present, the essays survey the changes in acting and performance that occurred during the crucial transition from the ecstatic theatre of the Vietnam era to the ironic postmodernism of the 1980s.

This collection begins with analyses of the modern theories of acting that inspired the theatrical experimentalists of the 1960s, including those of Antonin Artaud, Jerzy Grotowski, Jacques Copeau, and Peter Brook. Subsequent essays contrast these conceptions of acting with the emerging postmodernist theatre and performance of the 1980s, represented by the Wooster Group and Willem Dafoe. Discussions of postmodernism in performance examine the indebtedness of ideas about postmodern theatre to art criticism and the politics of postmodernist theatre and dance. The last section is devoted to the status of the body in theatre, performance art, and stand-up comedy, and includes essays on Vito Acconci, Roseanne Barr, Augusto Boal, Kate Bornstein, and Orlan.

Philip Auslander is Associate Professor at the Georgia Institute of Technology. He is currently a contributing Editor for *TDR: The Journal of Performance Studies*. Previous publications include *Presence and Resistance: Postmodernism and Cultural Politics in Contemporary American Performance*.

From Acting to Performance

Essays in Modernism and Postmodernism

Philip Auslander

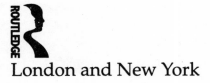

London and New York

First published 1997
by Routledge
11 New Fetter Lane, London EC4P 4EE

Simultaneously published in the USA and Canada
by Routledge
29 West 35th Street, New York, NY 10001

© 1997 Philip Auslander

Typeset in Palatino by Routledge
Printed and bound in Great Britain by Redwood Books,
Trowbridge, Wiltshire

British Library Cataloguing in Publication Data
A catalogue record for this book is available from the British Library

Library of Congress Cataloguing in Publication Data
A catalogue record for this book has been requested

ISBN 0–415–15786–2 (hbk)
ISBN 0–415–15787–0 (pbk)

For Deanna Sirlin, my One and Only

Contents

Acknowledgments

I would particularly like to thank Talia Rodgers for her support of this project, and Herb Blau for useful criticism and good advice. I would also like to thank Tanya Augsburg and Maria Pramaggiore for helping me research Chapter 11 at a time when it was impossible for me to do it myself.

Although they are far too numerous to mention by name, I would like to thank all those who included my papers on panels they organized, and all the editors of journals and books who selected my work for publication. Editorial feedback from such sources has been one of my most valuable sources of criticism. I would also like to thank all of the colleagues who heard and read this material at various stages of its development – I've learned a lot from you.

I would like to thank my family: my mother, Bernice Auslander, and my father, the late Maurice Auslander, who encouraged and indulged my theatre habit from a very early age; and my sister, Leora Auslander, who has always been a friend and a colleague as well as a sibling.

This book is dedicated partly to the memory of Bonzo (The Dog) Sirlin, a lively companion throughout the writing of these essays. She is sorely missed.

All of the essays collected here have existed in many forms: as conference papers, journal articles, and book chapters. What follows is a brief, selective history of each chapter.

" 'Holy theatre' and catharsis" (Chapter 2) appeared originally in *Theatre Research International*, 9, 1 (1984). It has been revised for inclusion here.

" 'Just be your self': *logocentrism* and *différance* in performance theory" (Chapter 3) was my contribution to the New Poetics panel at the annual conference of the American Theatre Association in

San Francisco, 1984. It was subsequently published in *Art and Cinema* (New Series), 1, 1 (1986), and in *Acting (Re)Considered*, edited by Phillip Zarrilli (1995). It has been revised for inclusion here.

"Task and vision: Willem Dafoe in *LSD*" (Chapter 4) was commissioned for a special issue of *TDR* on the subject of performance personae. That issue never came off, but the essay appeared (severely edited) in another special issue on the Wooster Group (*TDR*, 29, 2), reprinted here by permission of MIT Press, © 1985. The unedited version was published in *Acting (Re)Considered*, edited by Phillip Zarrilli (London and New York: Routledge, 1995). That version has been revised for inclusion here.

"*Presence* and *theatricality* in the discourse of performance and the visual arts" (Chapter 5) was my contribution to the State of the Profession panel at the annual conference of the American Society for Theatre Research in Providence, Rhode Island, 1992.

"Toward a concept of the political in postmodern theatre" (Chapter 6) is reprinted from *Theatre Journal*, 39, 1 by permission of the Johns Hopkins University Press, © 1987.

"Embodiment: the politics of postmodern dance" (Chapter 7) is reprinted from *TDR*, 32, 4 by permission of the MIT Press, © 1988.

"Vito Acconci and the politics of the body in postmodern performance" (Chapter 8) is reprinted from *After the Future: Postmodern Times and Places*, edited by Gary Shapiro, by permission of the State University of New York Press, © 1990.

"Boal, Blau, Brecht: the body" (Chapter 9) appeared originally in *Playing Boal: Theatre, Therapy, Activism*, edited by Mady Schutzman and Jan Cohen-Cruz (London and New York: Routledge, 1994). It has been revised for inclusion here.

" 'Brought to you by Fem-Rage': stand-up comedy and the politics of gender" (Chapter 10) is reprinted from *Acting Out: Feminist Performances*, edited by Lynda Hart and Peggy Phelan, by permission of the University of Michigan Press, © 1993.

Part of "The surgical self: body alteration and identity" (Chapter 11) was published as "Orlan's Theatre of Operations," *TheatreForum*, 7 (1995). I presented an earlier draft of the current essay to the Gender/Technology Conference organized by E. Ann Kaplan at the Humanities Institute at the State University of New York at Stony Brook, 1996.

1 Introduction

The title of this collection, for which I have my editor, Talia Rodgers, to thank, is evocative for me on several levels. On a personal level, *From Acting to Performance* suggests the course the development of my own interests has followed, from an original commitment to theatre toward a broader conception of performance and its genres. (I hope it is not presumptuous to suggest that many theatre scholars of my generation share this intellectual history with me.) The same phrase suggests the direction of developments in my original area of interest, experimental theatre, over the last twenty-five years or so. Whereas the modernist and avant-gardist theatres of the late nineteenth through the mid-twentieth centuries conceived of their work in terms of innovations in acting, subsequent postmodernist innovations have resulted from a reconsideration of the very nature of the activity that takes place on the stage, and the development of performance art, in which artists from non-theatrical backgrounds have brought divergent sensibilities to bear on the act of performance. Finally, the title phrase evokes developments and debates within the American academy surrounding the evolution of Peformance Studies as a discipline apart from Theatre Studies. It is with these debates that I shall begin my discussion here. Despite the antagonisms expressed on both sides, the title of this book expresses my perception of the relationship between Theatre Studies and Performance Studies as one of continuity rather than rupture.

Detecting within me a histrionic impulse, my mother sent me off to acting classes beginning around age nine. Thus began my life-long involvement with an art form and an academic field in which I eventually earned two graduate degrees. Throughout high school, I worked intensively in the theatre, primarily as an actor, taking a relatively uncritical view of the enterprise. It was only as an

undergraduate that I began to think about the social, cultural, and political significance of theatre. That I attended college during the immediate post-Viet Nam, post-Watergate period had much to do with this growing emphasis. I left college briefly to study acting at professional schools in New York, but was so disenchanted with the lack of intellectual curiosity among my fellow students that I returned to a conventional undergraduate education at a university without a theatre department. It was during this time that my own investigations of theatrical avant-gardism and reading in performance theory brought home to me that theatre is a much larger category than I had originally conceived it to be, and that it is, in turn, a subset of a still larger category reasonably called performance.

To me, then and now, this insight seems wholly unproblematic. I have never felt that my (admittedly often strained) allegiance to theatre is somehow compromised by the notion that it is part of a larger picture. My academic career has been reflective of the peaceful coexistence of the concepts of theatre and performance: I frequently teach dramatic literature but, as this collection will attest, I almost never write about plays, preferring to focus on performance texts and theories of performance. Early in my scholarly career, this meant examining theories of acting rather than more conventional theatre historical or critical issues. Even as I have moved away from theatre as my primary object of study, I have always felt that my work has remained rooted in the same fundamental concerns.[1]

One of the flashpoints for recent debates over the relationship of Theatre Studies to Performance Studies was Richard Schechner's 1992 editorial "A New Paradigm for Theatre in the Academy." Always interested in stirring up controversy, Schechner declared that "The new paradigm is 'performance,' not theatre. Theatre departments should become 'performance departments'" (1992: 9). Predictably and appropriately, this aggressive gesture provoked a number of responses, some quite virulent.[2]

My own response was to wonder how carefully Schechner had considered his use of Thomas Kuhn's vocabulary of scientific revolution to describe this potential revolution in the study of theatre and performance. Kuhn (1970) stipulates that, in science, a new paradigm not only replaces the existing one, but *invalidates* it (indeed, this is the only way scientific paradigms can be invalidated). Competing scientific paradigms are incommensurable and mutually exclusive: if you accept the new paradigm, you must

reject the previous one. So different are the premises on which competing paradigms are based that scientists who accept different paradigms cannot even speak meaningfully with one another. In Kuhnian terms, Theatre Studies would not be a subset of postrevolutionary Performance Studies – it would be the repudiated paradigm. Theatre would be as phlogiston to performance's oxygen: theatre scholars and performance scholars would be unable to engage in meaningful exchange; those who insisted on the validity of the Theatre Studies paradigm would be regarded as quacks akin to those who would defend the scientific integrity of astrology against that of astronomy.

As the thumbnail biographical sketch I have offered here should imply, my own practical and scholarly experience of theatre and performance suggests that the relationship between Theatre Studies and Performance Studies is not best described as a paradigm shift. The concept of performance enabled me to extend my original inquiry into the nature of theatre to other forms (e.g., performance art and stand-up comedy) and to look at those other forms in much the same way that I had previously considered theatre. The evolution of Performance Studies out of Theatre Studies, Speech Communication, and Anthropology has the character of what Kuhn calls the *articulation* of a paradigm. By articulation, Kuhn means the application and extension of a paradigm to new areas of research. Elin Diamond has identified some of the basic questions emerging from the study of theatre that are also fundamental to the study of performance more broadly construed:

> [P]owerful questions posed by theater representation – questions of subjectivity (who is speaking/acting?), location (in what sites/spaces?), audience (who is watching?), commodification (who is in control?), conventionality (how are meanings produced?), politics (what ideological or social positions are being reinforced or contested?) – are embedded in the bodies and acts of performers.
>
> (Diamond 1996: 4)

That these questions are being directed to an expanded range of texts, performance genres, and theories within American theatre departments (see J. Dolan 1995: 30–1) exemplifies the process of articulation. From this perspective, Performance Studies appears to be an articulation of the Theatre Studies paradigm, not a revolutionary new paradigm. Indeed, it may not even be possible, within Western culture, to think "performance" without thinking

"theatre," so deeply engrained is the idea of theatre in both performance and discourse about performance. "[I]t is *theater* which haunts all performance whether or not it occurs in the theater" (Blau 1987: 164–5). "[T]heater is the repressed of performance" (Diamond 1996: 4) even, perhaps especially, when it is a kind of performance that is overtly antitheatrical. [3]

The selection and organization of the essays here is meant to reflect this perspective on the relationship of theatre and performance as well as the development of my own work. Although the essays are not presented in strict chronological order, they are arranged to give a sense of that development. Although I have edited and revised the essays, in some cases substantially, I have endeavored not to alter them in ways that would efface their original arguments, even where I might think differently today. The essays are very much products of the times in which they were written, and I did not want them to lose that time-bound quality.

The first section, "From Acting to Performance," provides an overview of the developments I have been discussing here. I feel that I am taking something of a risk in reprinting as early a piece as "'Holy theatre' and catharsis," the first essay in that section. In the course of working on this volume, however, I became more and more convinced that it was important to include this piece, in part because I realized how many times I return in later work to the figures and ideas mentioned there as objects of comparison, usually to take issue with them. The figures and conceptions of theatre discussed there become emblematic in my later work of a theatrical modernism against which I see postmodernist performance reacting. The idea that theatre could serve radical spiritual and, therefore, political purposes (although the political dimension is not explored in this essay) was absolutely central to my aesthetics and politics when I first started thinking seriously about theatre, as it undoubtedly was for many others who came of age in the Viet Nam era. My enthusiasm for conceptions of "holy" theatre, especially in its communitarian varieties, came out of my acquaintance with the work of the Living Theatre and, through them, the writings of Antonin Artaud and Jerzy Grotowski. Part of my intellectual project at the time I wrote this essay was to provide a history for this conceptualization of theatre, tracing the communitarian impulse that animates Peter Brook's theatre work back to the too little-discussed Jacques Copeau (in another essay here, I posit Adolphe Appia as the originator of this stream of thought). I offer this essay as a starting point because it represents the terms under

which I entered theoretical discourse on performance: enthusiasm for talking about acting, interest in the avant-garde, commitment to a communitarian view of theatre informed by the ecstatic political theatres of the 1960s. It is important to note that my approach to all these things was defined in terms of a very traditional analytical concept: catharsis, a concept little used in cutting-edge theatre scholarship since the 1970s.[4]

The difference between the first essay and the second, both of which are about modernist theories of acting and address the work of Grotowski, among others, can be summed up in one word: Theory. Between 1979 and 1983, I received degrees from two graduate programs in theatre, both of which were Theory-Free Zones at the time. The Theory and Criticism I studied in these programs was limited to traditional dramatic theory; I emerged from graduate school completely unacquainted with the current trends in literary and cultural theory (e.g., semiotics, deconstruction, reader-response theory, feminist theory, etc.). I suspect that my experience was fairly typical, in that the application of Theory to Theatre Studies in the North American academy only began in the early 1980s. (I date its advent to 1982, with the publication of Herbert Blau's *Take Up the Bodies: Theater at the Vanishing Point* and the two essays in *Modern Drama* that I discuss in Chapter 5. Other important developments, such as Elinor Fuchs's engagement with deconstruction and post-modernism around 1983, and Sue-Ellen Case's *Feminism and Theatre* [1988], followed in the next few years.) The watershed event for American scholars was the presence of two competitive panels on the program of the 1984 conference of the American Theatre Association. Collectively entitled "Toward a New Poetics," these panels were designed to examine the implications for theatre of the new critical methodologies we were beginning to acknowledge. My paper, "'Just be your self': *logocentrism* and *différance* in performance theory" (Chapter 3), analyzed modernist acting theory in light of Derridean deconstruction.

I cannot overemphasize the importance of the New Poetics panels.[5] Those sessions, and the considerations of how new ideas might infuse theatre practice and scholarship arising from them, galvanized the field in a way that few concepts or events have since (I felt a similar energy at the First Annual Performance Studies Conference in 1995, but I'm not sure it will prove to have the same generative power; see Auslander 1995b). The New Poetics was the point of entry into American Theatre Studies for all varieties of structuralist, poststructuralist, and identity-based critical theories,

the success of which can be measured by the scholarly production of the last decade, especially in the area of feminist theatre studies. For myself, deconstruction provided a way of gaining a critical perspective on the acting theories I had examined analytically, but uncritically, up to that point. This perspective enabled me to see both the theories and acting itself in terms of an expanded notion of textuality, and to understand how they might be subject to the same critiques other kinds of texts were undergoing. Because the panel was organized around the idea of a New Poetics, I was particularly interested in what deconstruction might mean for future theatre practice. Since my focus at the time was on the Derridean concept of *différance*, I concluded that one could not base a method of acting or a style of theatre directly on deconstruction. Later, when I started exploring the question of postmodernist political theatre, deconstruction provided the basis for conceptualizing a necessary strategy.

The third essay in this first section, "Task and vision: Willem Dafoe in *LSD*," is an analysis of a particular performer's work. I placed this essay here because it continues the discussion of deconstructive theatre practices begun in Chapter 3, and also because the Wooster Group's performance style is based in recognizable tropes of acting, yet, by deconstructing those very tropes, becomes something other than acting. With the inclusion of this essay, this section maps in small the transitions I want to chart in this book. It suggests the development of my own work from traditionally based analysis of acting toward a more theoretically informed performance criticism, which occurred at a moment of major change in the discipline generally. It also indicates historical transitions in theatre itself: from an aspiration to universal levels of communication toward much more localized discourses; from the modernist avant-garde and the ecstatic theatres of the 1960s toward postmodernism; and a progressive redefinition of theatrical mimesis away from "character" toward "performance persona," with consequent redefinitions of the function of the performer's self in relation to performance.

Although I embraced the skepticism implicit in deconstruction, I was frustrated by its seeming inappropriateness as a framework for discussing political theatre, in which I have a longstanding interest. Theories of postmodernism seemed to me to offer both a convincing description of contemporary culture and a context in which that discussion might take place, and became the theoretical commitment of my work from the mid-1980s on. The three essays

grouped in the second section of the book under the title of "Postmodernism and Performance" address two fundamental issues: the role played by the concept of postmodernism in defining the relationship of performance to theatre, and the question of what postmodernist political performance might look like. The first essay in the section, *"Presence* and *theatricality* in the discourse of performance and the visual arts," was written for an American Society for Theatre Research conference on the relationship of theatre and the visual arts in 1992. It occurred to me that 1992 marked the twenty-fifth anniversary of the publication of Michael Fried's notorious essay "Art and Objecthood" (1968 [1967]), a central text for critical work on postmodernism in both the visual arts and performance, and, therefore, a suitable object of discussion at the conference. I wanted to show that the relation of opposition between theatre and performance that informs many discussions of postmodernist performance was generated out of Fried's opposition of color field abstraction and minimalism in visual art, and explore the irony of the use of Fried's implicitly anti-postmodern polemic by critics championing the postmodern in performance.

The next two chapters assert my thesis that the models we still have for political art and theatre, which descend from the modernist avant-garde and the 1960s, are no longer viable and that the project of political art must be reconceptualized in postmodernist terms. Both essays deal directly, though in different contexts, with the question of what that means for theatre and performance. Even though the material in my essay "Toward a concept of the political in postmodern theatre" appears scattered through my book *Presence and Resistance: Postmodernism and Cultural Politics in Contemporary American Performance* (1992a), I have included it here (as Chapter 6) for two reasons. The first is simply that it has never been reprinted in its original form. The second, more substantial, reason is that, together with Chapters 7 and 8, which also have never been reprinted, it forms a sequence of essays, all written around the same time, that touch on theories and practices in theatre, dance, and performance art in the context of a particular view of political art under postmodernism. That view, which repudiates the transgressive stance of the modernist avant-garde in favor of a concept of resistant political art, is adumbrated and justified in Chapter 6, where I also discuss its implications for theatre. The same concept then serves as the basis for my critique of Susan Foster's *Reading Dancing* (1986) in Chapter 7 and, indeed, as the

ground of the analyses of performance practices that make up the final section of the book.

The theoretical questions that surround the performing body have long intrigued and perplexed me. As some notes and passing references in several chapters here suggest, I have wondered particularly whether the body in performance can be accounted for semiotically, for the body seems in some ways to defeat signification. On the other hand, to posit the body as an absolute, originary presence beyond signification is neither accurate nor theoretically defensible. The problematic of the performing body lies in the tension between the body's inevitably serving as a signifier while simultaneously exceeding, without transcending, that function: "when the intention is to present the body itself as flesh . . . it remains a sign nonetheless When the intention is to present the performer's body as primarily a sign . . . , corporeality always intervenes . . . " (Erickson 1995: 66–7). The essays in the third section, entitled "Postmodern body politics," continue the discussion of the signifying body begun in Chapter 8 and atttempt in various ways to arrive at a non-essentialist view of the body that nevertheless acknowledges its corporeality.[6]

The first essay in this section, "Vito Acconci and the politics of the body in postmodern performance," opens with a restatement of the question concerning postmodern political art explored in the previous two chapters, and a cultural critique of the status of the body in modernist theories of acting that complements the deconstructive critique in Chapter 3. Thereafter, I analyze Vito Acconci's "body art" of the early 1970s as a postmodern political art practice focusing on the body and its cultural significations. The next chapter, "Boal, Blau, Brecht: the body," situates Augusto Boal's work in relation to modernist performance theory and argues that Boal's formulation of the "spect-actor," an entity which combines the functions of theatrical spectator and actor in a single body, provides a way of reconceptualizing postmodern subjectivity without denying its fracturing, so as to recover a space for critical distance and, hence, politics in postmodern performance.

The third essay in this section, "'Brought to you by Fem-Rage': stand-up comedy and the politics of gender," may seem anomalous in that it is the only essay in this collection to look at a popular cultural performance genre. I have argued elsewhere (Auslander 1992b) that the stand-up comedy produced during the comedy boom of the 1980s must be understood as a specifically postmodern phenomenon, qualitatively different from the cultural positioning

of earlier stand-up comedy. Although I do not wish to rehearse yet again the oft-stated claim that postmodernism is characterized by a breakdown of the distinction between high art and mass culture, I would suggest that such a breakdown has indeed occurred in the distinction between avant-gardistic and popular performance (see Auslander 1989). One consequence of this breakdown is that one can no longer assume that positive political work can be done only by vanguard art; as my analysis of *The Roseanne Barr Show* demonstrates, popular cultural texts, too, can be understood as resistant political art. In addition to that analysis, this chapter presents the work of women stand-up comedians as a discourse in which the body is the locus of a critical analysis of gender in culture. Women comics also engage in a discourse of bodily transformation that relates both to Acconci's manipulations of, and attempts to alter, his own body and to the work of Orlan and Kate Bornstein, the two performance artists discussed in the final chapter. Whereas the women comics discussed in Chapter 10 subject the body to purely verbal, discursive transformations, Acconci goes beyond the verbal in his actions on his own body. These actions produce only partial and temporary transformations; in the high-stakes body performances undertaken by Orlan and Bornstein, the transformations are surgical and permanent. My discussion of their work in "The surgical self: body transformation and identity" (Chapter 11) continues my analysis of bodily gender performance and resistant political art, while simultaneously carrying that analysis into the realm of techno-medical interventions on the body that foreshadow the issues to be addressed in the cyborg culture of the very near future.

The body, then, is a central problematic of theatre and performance, and of the essays in this book, from the first discussion of Grotowski's view of the actor's physicality in Chapter 2 through the analyses of postmodern performance practices that make up the third section. Other specific problematics that recur throughout the essays gathered here, cutting across the categories of theatre and performance, include: character, self, representation, presence, communality, political art, avant-gardism, and resistance. I hope the reader will enjoy tracing the development of these themes as they weave through the essays collected in this volume.

Part I

From acting to performance

2 "Holy theatre" and catharsis

Peter Brook coined the term "holy theatre" to describe performance that aspires to the communication of intangible, universal levels of experience: "the currents that rule our lives," "a reality deeper than the fullest form of everyday life" (1969: 40). This desire to penetrate the surface of experience characterizes not only Brook's work but that of his predecessors Jacques Copeau and Antonin Artaud, and his contemporary Jerzy Grotowski.[1] The writings of these men, all directors as well as theorists, define two concepts of theatre that share the lofty goal of renovating the human spirit through the revelation of universal truths. One conception, which descends from Copeau and finds echoes in Brook's writings, is of a communal theatre that brings its spectators into emotional harmony with one another by celebrating their common identity as human beings. The other "holy" theatre, defined by Artaud and Grotowski, is a therapeutic theatre designed to accomplish spiritual renewal by unmasking repressed psychic materials. "Holy" theatre in its various forms may be the modern equivalent of classical tragedy because it is overtly concerned with altering the audience's affective state, with achieving catharsis (Innes 1981: 253–4). For my present purpose, that of distinguishing communal from therapeutic theatre, I will employ two notions of catharsis, one derived from Aristotle, the other from psychotherapy.

Although Aristotle's reference to catharsis in the *Poetics* (VI: 2) is vague and undeveloped, his discussion of it in the *Politics* (VIII: 7) is more revealing. In this text, Aristotle describes catharsis as the effect of a piece of music on its listener. Music excites emotion in the listener, but does so in a way that enables a safe discharge of emotional reactions:

For every feeling that affects some souls violently affects all souls more or less; the difference is only one of degree. Take pity and fear, for example, or again enthusiasm. Some people are liable to become possessed by the latter emotion, but we see that, when they have made use of the melodies which fill the soul with orgiastic feeling, they are brought back by these sacred melodies to a normal condition as if they had been medically treated and undergone a catharsis. Those who are subject to the emotions of pity and fear and the feelings generally will necessarily be affected in the same way; and so will other men in exact proportion to their susceptibility to such emotions.[2]

Humphry House has interpreted the Aristotelian notion of catharsis as an educative function: through catharsis, we are trained in the use of our emotions and brought closer to the balanced inner state of the ideal Aristotelian good and wise man (1958: 108–10).[3] It is important to note that Aristotle here states that catharsis can be induced by an abstract symbolic art, music, as well as by identification with characters in a mimetic presentation. He also suggests that catharsis can follow on emotions other than pity and fear; because these are the only emotions mentioned in the *Poetics*, it is often assumed that they are the only ones associated with catharsis. Teddy Brunius has disproved another common assumption by pointing out that because the classical mind did not make the same distinctions between author, text, performance, and audience characteristic of modern analytics, catharsis is not exclusively the effect of performance on an audience: author, performers, and audience alike experience catharsis as a result of their contributions to the work of art (1966: 58–9).

A psychoanalytical definition of catharsis is offered by T. J. Scheff: a cathartic experience enables a patient "to relive, and therefore resolve, earlier painful experiences which were unfinished" under conditions that allow patients sufficient distance from their own experiences to relive them safely (1979: 13). Therapeutic catharsis is typically characterized by spontaneous physical trauma (shaking, crying, convulsions, fits of anger, etc.) accompanied by images of past experiences replayed as though in a film. Scheff's idea is based on "re-evaluation theory," which suggests that experiencing unresolved events anew enables one to assimilate them by perceiving that they are no different in kind from other, normally assimilated, events, and thus to resolve them on a conscious level (Scheff 1979: 53). The fundamental difference between the

Aristotelian and the psychoanalytical view is that whereas the former sees catharsis as a type of learning, the latter sees it as a form of healing. The emphasis in Aristotle is on the ability to perceive oneself in terms of something greater; the theory Scheff discusses focuses on the need to resolve individual conflicts through introversion.

These two definitions of catharsis also contain implicit theories of communication. At issue here is the distinction between symbol and cause: a symbol of an affective state is an image that prompts one to form a concept of that state; an image that produces an affective state in its perceivers is the cause of the state. Whereas by definition a symbol must produce the same concept in the minds of all those for whom it is a symbol, an image may cause different affective responses in different people (see Osborne 1973: 108). In Aristotle's concept of catharsis, the performance is both symbol and cause: it arouses in the audience the same emotions it evokes symbolically through musical modes or mimesis. In therapeutic catharsis, the stimulus for catharsis is primarily a cause rather than a symbol. The discursive meaning of the image or memory that brings on a cathartic effect is far less important than its catalytic function in the curative process.

An important corollary to theories of holy theatre is that the verbal and physical languages of the stage should be systems of signs understandable to all human beings, independent of their cultural affiliations. From a psychological point of view, it is reasonable to say that the idea of a universal theatre language presupposes a psychic structure such as the collective unconscious postulated by C. G. Jung. According to Jung, the collective unconscious is a level of the psyche

> made up of contents which, regardless of historic era or social or ethnic group, are the deposits of mankind's typical reactions since primordial times to universal human situations, such as fear, danger, the struggle against superior power, relations between the sexes, between children and parents, hate and love, birth and death, the power of the bright or the dark principle, etc.
>
> (Jacobi 1973: 10)

In my discussion, I will consider the role of the collective unconscious, in conjunction with catharsis, in the theories under consideration.

COMMUNAL THEATRE: COPEAU AND BROOK

In an address given at Geneva in 1923, Jacques Copeau summa-
rized his view of the human needs theatre can fulfill:

> An audience is not just a group of people assembled by chance
> who go here or there in search of more or less heady amuse-
> ments. There are nights when the house is full, yet there is no
> audience before us. What I describe as an audience is a gathering
> in the same place of those brought together by the same need,
> the same desire, the same aspirations to satisfy a taste for living
> together, for experiencing together human emotions – the ravish-
> ment of laughter and that of poetry – by means of a spectacle
> more fully realized than that of life itself. They gather, wait
> together in a common urgency, and their tears or laughter incor-
> porate them almost physically into the drama or comedy that we
> perform to give you a stronger sense, and a more genuine love,
> of your own humanity.[4]
>
> (Copeau 1955: 38–9)

He went on to describe the theatre's "religious mission, which is to
unite people of every rank, every class – I was going to say, and
should say here, every nation. This is what we have attempted at
the Vieux-Colombier for the past ten years" (1955: 40).

Copeau saw the theatre as a potentially universal communica-
tion uniting its participants in a communal experience and
instilling in them a new sense of human worth. He hoped to
develop such a universal expression by stripping from the theatre
whatever he perceived to be superfluous to it, and thus rediscover
its essence. As Copeau indicated in an essay of 1926, he viewed
the theatre as an art of abstraction analogous to music: "The
essence of drama, deriving from its origins, is to be simultane-
ously speech and song, poetry and action, color and dance. To say
it all in one word as did the ancient Greeks: music" (quoted in
Anders 1959: 68). Copeau was inspired by the ideas of Émile
Jacques-Dalcroze. He was impressed with an exercise he saw at
Dalcroze's school in which

> the student began by waiting in silence followed with a move-
> ment and a kind of cry or exclamation. This primitive evolution
> of expression from silence and immobility to movement, sound,
> and then the word seemed to Copeau to be the most natural
> progression for dramatic studies.
>
> (Leigh 1979: 13)

This progression became the basis of the acting curriculum at the École du Vieux-Colombier.

Copeau believed that in order for an actor's words to have meaning, the actor must first be in physical touch with the universal concept that lies behind the words. In practice, this process had two stages. The first was the neutralization of the student's personality; as Sears Eldredge and Hollis Huston have pointed out (1995 [1978]: 121), Copeau wanted his actors' inner state to be a neutral ground equivalent to the Vieux-Colombier's *tréteau nu*, "a more universal state of mind – where all men are alike – before the distinguishing, individualizing characteristics appear" (Eldredge 1979–80: 220). The second stage encompassed exercises intended to bring the actor into spiritual empathy with all forms of life, animate and inanimate. Communication was to take place at a primary, physical level until the work naturally gave rise to speech. Waldo Frank, who observed Copeau's students, describes this progression in their improvisations:

> The pupils of Copeau are taught to articulate what might be called the Platonic essence of a tree, an animal, an ocean . . . their voices must learn to do without words, in the establishing of pictures or of passions, or even of complex human situations. The props of story, set, verisimilitude of facial gesture and of spoken word are taken from them: so that in their graduation to the high plane of literary drama they may be energetically freed to establish in the word the distinctions and elaborations which are the essence of true poetics.
>
> (Frank 1925: 589)

Peter Brook shares Copeau's vision of the theatre as communion, a coming together. Brook's description of the interaction between audience and performer is couched in terms very similar to those of Copeau's Geneva address:

> Occasionally, on what he calls a "good night," [the actor] encounters an audience that by chance brings an active interest and life to its watching role – this audience assists Then the word representation no longer separates actor and audience, show and public: it envelops them: what is present for one is present for the other. The audience too has undergone a change. It has come from a life outside the theatre that is essentially

repetitive to a special arena in which each moment is lived more clearly and more tensely.

(Brook 1969: 127)

Like Copeau, Brook sees art as the attempt to express the roots of experience: "a most powerful explanation of the various arts is that they talk of patterns which we can only begin to recognize when they manifest themselves as rhythms or shapes ... " (1969: 38). Brook has duplicated Copeau's process of moving from essences to words in his own work with actors. In *The Empty Space*, Brook describes experiments undertaken during his so-called "Theatre of Cruelty Season" (1964)[5] in which he and his performers tried to communicate with one another without language and with word-less sound languages and silences, experiments that culminated in productions based on both texts and improvisation (1969: 44–7). Brook writes:

> A word does not start as a word – it is an end product which begins as an impulse, stimulated by attitude and behavior which dictates the need for expression ... for the actor the word is a small visible portion of a gigantic unseen formation.
>
> (Brook 1969: 12)

In developing *Orghast* (1971), Brook had his actors improvise around mythic themes, notably the stories of Prometheus and Oedipus. With the assistance of British poet Ted Hughes, they created sound words which were supposed to be congruent to the ideas they were expressing. Brook and Hughes were impressed when an invented word bore a strong resemblance to a real word in a language unknown to the person who created it. Hughes's word for "light," HOAN, turned out to be the Farsi term for "ray of light" (Smith 1972: 43–4). Brook and Hughes took such occurrences as justifications for the belief in a universal level of consciousness. For Brook himself, "the basic theme of the work is the examining of forms of communication to see whether there are elements in the theatrical vocabulary that pass directly, without going through the stage once removed of cultural or other references" (Smith 1972: 248).

Copeau and Brook, then, see theatre as a cross-cultural phenomenon that somehow awakens in its audiences an under-standing of basic human needs, although neither writer explains the mechanism which makes this possible. Jung's and Aristotle's ideas help in the interpretation of their theories. Copeau's and

Brook's theatres are both symbol and cause: the archetypal materials on which they are based (Platonic ideograms, universal language and mythography) produce images corresponding to the same archetypes in the minds of the audience. In Aristotle's view, catharsis is an emotional response to art that typifies the emotional nature of the spectator, the emotions by which the spectator is "liable to become possessed." The response to a universal theatrical representation arises from the collective unconscious; it typifies the emotional nature of human beings in general rather than the inclinations of individual spectators. It is this feeling of shared response that produces the sense of unity Copeau and Brook describe. The impression that author and actor experience the same catharsis as the audience further enables the spectator to enter into the performance emotionally, to be at one with it. That the theatre is clearly a special place also contributes to catharsis: Copeau and Brook stress the differences between theatre and life, the notion that theatre is an intensified version of experience. Divorced from reality yet reflecting it, communal theatre carries artists and audience together to a level of universal emotional response then returns them to quotidian reality with a keener sense of the psychic structures shared by all people. Whereas in Aristotle's view the new balance achieved through catharsis is a step toward the emotional equilibrium of the good and wise man, Copeau and Brook imply that the balance achieved is a fresh understanding of the individual's relationship to the collective. Like Aristotle, they believe that the spectator leaves the theatre in a condition close to an ideal affective state. The spectacle accomplishes this in much the way music does – through abstract theatrical elements (rhythm, sound, archetypal imagery) rather than through mimesis.

The assumption underlying the idea of communal theatre is that the theatrical experience is necessarily benign. Implicit as an article of faith in both Copeau's and Brook's writings is the supposition that a simple recognition of shared psychic states is sufficient to bring people together. This belief reflects an optimistic world view – a pessimist might argue that the universals uncovered by a holy theatre would very likely be the ugly, divisive aspects of the psyche that we repress precisely because we cannot acknowledge them as parts of ourselves. This opposite belief concerning "the currents that rule our lives" is implied by Artaud's formulation of a *Théâtre de la cruauté*.

THERAPEUTIC THEATRE: ARTAUD AND GROTOWSKI

Artaud's ideas in *Le Théâtre et son double* have more in common with Copeau's than one might expect.[6] Artaud's belief that theatre could express what he calls "la métaphysique" corresponds to Copeau's efforts to reach a level of universal truth. Artaud wrote that the theatre would be worthless "unless the true theatre were able to give us a glimpse of a reality of which we now perceive only one aspect, but whose fulfillment occurs on other levels" (1964: 109). His description of the sorts of material he would have liked to present on his stage relates to Jungian archetypes:

> certain unusual ideas which can never be delimited or even formally depicted. These ideas, which touch on Creation, Becoming, and Chaos, are all of a cosmic order, and provide a preliminary notion of a realm from which the theatre has completely absented itself.
>
> (Artaud 1964: 107)

The desire to "touch on Creation, Becoming, and Chaos" is also evident in Copeau's list of themes for mask exercises, which includes: the waking of creatures after winter, worship, Ceres, witches, the worship of demons (quoted in Eldredge 1979–80: 210).

There are also parallels between the technical means advocated by Artaud and Copeau. Although Artaud's descriptions would seem to indicate an interest in "total theatre," Timothy Wiles has argued that because Artaud is primarily concerned with the essence of the theatrical event, his theory is actually reductive (1980: 127). Artaud's desire to have actors embody "de véritables hiéroglyphs" (1964: 48), ideograms for archetypal concepts, is similar to Copeau's desire that his students create what Waldo Frank called Platonic essences. A major difference between Artaud's conception of theatre and Copeau's is Artaud's definition of theatre and alchemy as "so to say virtual arts that contain neither their ends nor their reality in themselves" (1964: 58). The implication of this dictum is that the staging of a performance is not the objective of the theatre Artaud proposes. Artaud saw the theatre as a means to an end: the complete psychic upheaval he called *la cruauté*. *Le Théâtre de la cruauté* is therefore more causal than symbolic; although Artaud's performances were to have been concretions of mythological symbols, their point would have lain not in the communication of meaning through symbols but in the achievement of an effect. The ultimate goal of *le Théâtre de la*

cruauté is the same as that of communal theatre: to re-establish life on healthier spiritual terms.

> One must believe that life can be renewed by the theatre Also, when we speak the word "life," it must be understood that it's not a question of external facts, but of that fragile and palpitating center forms never touch.
>
> (Artaud 1964: 18)

But in Artaud's theatre this profound amelioration is achieved through purgation, not communion:

> The essential theatre is like the plague, not because it is contagious but because, like the plague, it is the revelation, the foregrounding, the exteriorization of a latent depth of cruelty that enables all of the perverse possibilities of the spirit to manifest themselves in an individual or a people.
>
> (Artaud 1964: 37)

Artaud adopts the posture of a psychoanalyst in suggesting that if we can recognize and confront our dark impulses we can be free, or at least in control, of them. The process is horrifying and difficult; le Théâtre de la cruauté "unknots conflicts, releases forces, opens possibilities; and if these possibilites and forces are dark, it is not the fault of the plague nor of the theatre, but of life itself" (1964: 38). Like an alchemist searching for the Philosopher's Stone, Artaud sought theatrical images that would release a flood of repressed psychic materials within the minds of his audiences. Although he believed these images to be archetypal, he recognized that catharsis can be an individual as much as a communal experience: each of us has private as well as common demons to exorcise. If Copeau's and Brook's use of archetypes can demonstrate to an audience its common store of human experience, Artaud's might well throw each spectator into a maelstrom of individual psychic repressions.

It is difficult to discuss Artaud's theory in practical terms; as Grotowski has noted, he "left no concrete technique behind him, indicated no method" (1968: 111). In Artaud's vision of theatre, the actor experiences catharsis before the audience, not simultaneously with it as in Copeau's and Brook's theories. Artaud likens the actor to "a victim of plague who runs in screaming pursuit of his images" (1964: 30) and goes on to say that the actor's frenzy spreads, like an epidemic, to take hold of the spectators (1964: 31–3). He believed the actor to be the central figure in a process that unites the spectator and the intangible; he writes of "a seventh state . . . joining the tangible

with the intangible" and claims that "the actor carries within himself the key to this state" (1964: 159–60). By being aware of the use of the body, the actor can manipulate the spectator's affective condition: "To know which points on the body to touch is to be able to throw the spectator into magic trances" (1964: 163). These ideas again underline Artaud's focus on the causal aspect of theatre. It is more important for the actor to produce an effect with symbolic gestures than to communicate a discursive meaning with them. In his own words, Artaud wanted his theatrical language "not to express thoughts, but to *cause thinking* . . . " (1964: 83, original emphasis).

In discussing Jerzy Grotowski, one must distinguish between his earlier ideas and those underlying his subsequent para-theatrical experiments. Like Copeau, Brook, and Artaud, the Grotowski of *Towards a Poor Theater* (1968) believed in the existence of a universal theatre language. He described his type of spectacle as "an elementary language of signs and sounds – comprehensible beyond the semantic value of the word even to a person who does not understand the language in which the play is performed" (1968: 52). This language is made up of ideograms "which evoke associations in the psyche of the audience" (1968: 39) derived from universal levels of experience. "New ideograms must constantly be sought and their composition appear immediate and spontaneous. The starting point of such gesticulatory forms is the stimulation of one's own imagination and discovery in oneself of primitive human reactions" (1968: 142).

Grotowski's earlier theory resembles Copeau's thought in certain respects. Copeau's impulse to discover the essential core of theatre is the predecessor of Grotowski's call for a "poor" theatre. The Grotowskian "via negativa," the actor's "passive readiness to realize an active role" (1968: 17), is similar to Copeau's actor's divestment of personality and has a similar spiritual purpose: the denial of worldliness. Grotowski called his performers "holy actors" and thought of them as exemplary figures for whom performance was an act of self-sacrifice. His basic precept was identical to one of Copeau's: "It is all a question of giving oneself" (1968: 38).[7] Self-abnegation serves different purposes in their respective theories, however. Copeau felt that the actor should divest herself of her own personality in order to assume a role; the actor's self-sacrifice lies in this willingness to deny herself for the sake of achieving unity with the audience through a representation. The Grotowskian actor's process is the reverse – the role functions as a means by which the actor may achieve self-exposure and revelation.

He must learn to use his role as if it were a surgeon's scalpel, to dissect himself. It is not a question of portraying himself under given circumstances or of "living a part." The important thing is to use the role as a trampolin, an instrument with which to study what is hidden behind our everyday mask – the innermost core of our personality – in order to sacrifice it, expose it.

(Grotowski 1968: 37)

Dramatic character had a complex function in this process of performative self-exploration. In addition to serving the actor as an instrument of self-dissection, character operated as a protective "screen" between actor and audience, so that the actor's raw psyche was not exposed directly to the spectators. The presence of characters in the performance was also intended to liberate the spectators' deeper psychic functions by distracting their intellectual faculties: "the screen of the 'character' kept the mind of the spectator occupied in such a way that the spectator might perceive, with a part of himself more adapted to this task, the hidden process of the actor" (Richards 1995: 98). Character thus served as a means by which the actors' process of psychic dissection could be made available to the audience without exposing it directly to the audience's conscious scrutiny. Grotowski's approach to character is thus the diametric opposite of Copeau's: whereas Copeau wants the actor to purge her own personality in order to assume that of a character, Grotowski advocates the use of character as a tool for exploring the self.

Grotowski's actor training program was intended to eliminate the actor's physical resistance to the uncensored expression of psychic impulses; the actor was taught to use the body to express psychic impulses directly in physical metaphors (Grotowski 1968: 16). The psychic skinning undergone by Grotowski's actors was meant to stimulate the same sort of activity in the spectator, the stripping away of socially imposed behavior, with self-knowledge as the object:

The spectator understands, consciously or unconsciously, that such an act is an invitation to him to do the same thing, and this arouses opposition or indignation, because our daily efforts are intended to hide the truth about ourselves not only from the world, but also from ourselves.

(Grotowski 1968: 37)

The therapeutic nature of Grotowski's Poor Theatre is emphasized in his stipulations concerning audiences: "We are concerned with the spectator who really wishes, through confrontation with the performance, to analyze himself" (1968: 140). Although he felt that self-analysis must take place in a supportive atmosphere, Grotowski's Poor Theatre was not a communal theatre; Wiles has observed that Grotowski's use of relatively obscure dramatic texts, his distortion of those texts, and his actors' rapid and frequently unintelligible speech all served to distance audiences from his performances (1980: 152–4). Believing that people have become too differentiated by socialization to be united by universal myths or images, Grotowski proposed to focus on the individual in a therapeutic theatre that contrasts culturally generated myth with personal reality:

> the theatre must attack what might be called the collective complexes of society, the core of the collective subconscious ... the myths which are not an invention of the mind but are, so to speak, inherited through one's blood, religion, culture and climate.
>
> (Grotowski 1968: 42)

The purpose of this confrontation with collective mythology was to make the spectator more aware of both her individuality and her relationship as an individual to collective configurations.

> While retaining our private experiences, we can attempt to incarnate myth, putting on its ill-fitting skin to perceive the relativity of our problems, their connection to the "roots," and the relativity of the "roots" in light of today's experience.
>
> (Grotowski 1968: 23)

Grotowski's use of myth was intended to allow the actor and spectator to arrive at the private truth of self-knowledge rather than the general human truth Copeau and Brook sought to reveal. Grotowski's view of myth is different from those of Copeau, Brook, and Artaud because he sees it as cultural rather than archetypal in origin, and, therefore, as less authentic than impulses originating in the psyche. Unlike the three other figures under discussion here, Grotowski sought to promote a critical attitude toward mythic archetypes by encouraging his audiences to re-evaluate them in light their own individual and collective experiences.

As a form of therapy, Grotowski's Poor Theatre was more cause than symbol. Although his actors presented ideogrammatic images,

the purpose of their work was to provoke similar activity in the spectator – their physical expression was metaphoric for the process of self-discovery they were undergoing. The object of their performance was not to communicate an image of an affective state but to produce a state of self-contemplation in the spectator by example. Grotowski's theory is crucially different from Artaud's in this respect. Whereas Artaud believed that psychic activity could be triggered directly by exposure to certain kinds of universal images, Grotowski felt that these images must be presented in a context which implies a critical method of approaching them. If Artaud wanted to produce an automatic response in his audience, Grotowski asked his audience to work toward catharsis.

Artaud and Grotowski propose two different views of thera-peutic catharsis in the theatre. Artaud's version adheres closely to the model described by Scheff. Artaud's comparison of theatre to the plague even suggests, metaphorically, the spontaneous physical eruptions characteristic of therapeutic catharsis. Whereas Scheff holds that catharsis is achieved by the resolution of unfinished personal experiences, Artaud wanted his audience to relive archetypal experiences, materials from the collective unconscious unfinished in that they have never been manifest to consciousness, as well as personal ones. Grotowski's idea is more complex: specta-tors and actors re-experience archetypal events in a critical context – they attempt to "put on the ill-fitting skin" of myth. By seeing how mythic experiences do and do not correspond to their own, participants in Grotowski's theatre came to know themselves better. Conversely, the act of comparison also enabled them to understand the contents of the collective unconscious. Artaud's and Grotowski's theatres are primarily introspective – the purpose of purgation and self-knowledge is to function as a healthier indi-vidual and to understand the basis of one's own psychic functioning. In Copeau's and Brook's respective communal theatres, the object was to reveal and celebrate the common bases of all human activity; health was to be achieved by communion with others rather than by exploration of one's own repressed psychic materials. Similarly, the relationship of actor to audience is different in the communal theatres than in Artaud's and Grotowski's. Actors and audience are united by the performance in Copeau's and Brook's formulations: they share catharsis. Artaud's theory stresses the effect of theatre on its audience. The actors' catharsis precedes and causes the audience's; the end of Artaud's theatre is the purga-tive release of repressed materials in the minds of the spectators.

Grotowski's actors also experience catharsis, but they neither share catharsis nor cause the audience to experience it automatically. Rather, they present the possibility and means of catharsis to the spectator, who must perceive and choose to enter into their self-exploratory state in order to achieve it.

In 1970, Grotowski turned his back on performance and focused his attention on paratheatrical, experiential events.[8] The theoretical aspect of this work represents a synthesis of communal and therapeutic concepts of catharsis. The essential purpose of Grotowski's paratheatrical events was the same as that of his theatre: to encourage people to "disarm," to strip away the false veneer imposed on them by socialization and reveal themselves as they truly are. The invitation to the audience which was formerly implicit in Grotowski's theatre became explicit in the paratheatrical events. It was no longer enough for actors to serve as examples by demonstrating a process of self-analysis: the actors became guides who created situations in which participants undertook to analyze themselves directly. Grotowski rejected his earlier interest in ideogrammatic action – he divested his work of symbolic significance. His paratheatrical events were purely causal: they did not represent something to an audience, but engaged groups of initiates directly in psychophysical activity.

Grotowski's paratheatrical events were therapeutic in that his main concern was with enabling people to overcome their fear of their true selves and to heal the mind–body schism created by Western civilization. In keeping with its therapeutic nature, Grotowski's project was individualistic in emphasis: like his Poor Theatre, it appealed to a certain kind of person and enabled each participant "to go to the end of his own quest" (Grotowski, quoted in Mennen 1975: 58). Nevertheless, Grotowski spoke of these events as communion and described his work space as "a place where a communion becomes possible" (Grotowski 1973: 133–4). In reconciling the individualism of therapy with an interest in commonality, he took an important theoretical step beyond Copeau, Brook, and Artaud by suggesting that the individual participant's catharsis makes communal catharsis possible. Whereas Copeau and Brook hold that the theatre speaks to the audience as a collective whole and Artaud felt that the theatre as plague affects each individual at the level of the individual psyche, Grotowski found that the revelation of self within a communal context produces communal catharsis by offering a glimpse of that aspect of the collective unconscious which he considered to be of psychic, rather than cultural, origin:

If someone wishes to be sincere with regard to his own life, giving it a pledge with his own flesh and blood, one might assume that what he reveals will be exclusively personal, individual. It is not the whole truth, however; there is a certain paradox about it. If one carries one's sincerity to the limit, crossing the barriers of the possible, or admissible, and if that sincerity does not confine itself to words, but reveals human being totally, it – paradoxically – becomes the embodiment of the total man, with all his past and future history. It is then superfluous to go to the trouble of analyzing, whether – and how – there exists a collective area of myth, an archetype. That area exists naturally, when our revelation, our act reaches far enough, and if it is concrete.

(Grotowski 1973: 122)

Grotowski's paratheatrical approach reversed his previous one. Instead of actors representing a way of dealing with the collective unconscious as a *fait accompli* described in a language of physical ideograms, each individual is encouraged to make the journey herself and discover her own imagery. Individual self-exposure undertaken in an arena of similarly exposed individuals produces a "cleansing of our life" (Grotowski 1973: 119) by eliminating the fear we feel before the unknown other. It is no longer a matter of the Christ-like self-sacrifice Grotowski saw in his "holy" actors but of self-analysis leading to communal catharsis.

Like all the theories outlined here, Grotowski's paratheatrical work was based on disputable psychological and semiological assumptions. The appeal of the concept of "holy theatre" in its various manifestations is neither logical nor scientific, but derives from its emphasis on catharsis, its belief that art (or something which approaches art, in the case of Grotowski's paratheatrical projects) can have a direct effect on its audience at the psychic level, and that this effect, however it is defined, is ultimately of a health-giving nature.

3 "Just be your self"

Logocentrism and *différance* in performance theory

I am afraid of falling into philosophy
Tortsov, in Stanislavski's *An Actor Prepares*

Among the terms Jacques Derrida employs in his deconstructive critique of Western philosophy, of what he calls the "metaphysics of presence," are *logocentrism* and *différance* (1978: 279–80). Logocentrism is "the orientation of philosophy toward an order of meaning – thought, truth, reason, logic, the Word – conceived as existing in itself, as foundation" (Culler 1982: 92; see Derrida 1976: 30 ff). Derrida, who denies the existence of such a foundation, points out that every mental or phenomenal event is a product of difference, is defined by its relation to what it is not rather than by its essence. If nothing can legitimately claim to possess a stable, autonomous identity, then there is nothing which can be invested with the authority of *logos*. In his discussions of language and linguistics, Derrida refers frequently to Saussure's double hypothesis that because the relationship between signifier and signified is arbitrary, the production of meaning derives from the interaction of linguistic units, not from additive arrangements of nuggets of meaning contained in words (see, e.g., Derrida 1976: 30 ff; 1981a: 17–36; 1982: 9 ff). "The difference which establishes phonemes and lets them be heard remains in and of itself inaudible" (Derrida 1982: 5); meaning is produced by the action of something which is not present, which exists only as an absence. Derrida demonstrates that meaning is generated by a productive non-presence he calls *différance*, defined as "the playing movement that 'produces,' but does not precede, differences" (1982: 11). The act of signification produces its own significance; there is no transcendent *logos*, no order of meaning which grounds the activity of signification, no presence behind the sign lending it authority.

Derrida's critique has broad applications to performance theory. In discussion, we often treat acting as philosophers treat language – as a transparent medium which provides access to truth, *logos* or a grounding concept which functions as *logos* within a particular production. In his own discussion of the theatre, Derrida identifies the playwright's intended meaning as its *logos*:

> The stage is theological for as long as its structure, following the entirety of tradition, comports with the following elements: an author-creator who, absent and from afar, is armed with a text and keeps watch over, assembles, regulates the time or the meaning of the representation, letting this latter *represent* him as concerns what is called the content of his thoughts, his intentions, his ideas.
>
> (Derrida 1978: 235, original emphasis)

This author-creator "enslaves" actors, directors, etc.; the implication is that, if the theatre could do away with the playwright, it would cease to be theological. As I will try to show here, the theatre remains theological as long as it is logocentric, and the *logos* of the performance need not take the form of a playwright's or creator's text. Other grounding concepts include the director's concept[1] and, more interesting, the actor's self. We often praise acting by calling it "honest" or "self-revelatory," "truthful"; when we feel we have glimpsed some aspect of the actor's psyche through her performance, we applaud the actor for "taking risks," "exposing herself." One example must stand for many: Joseph Papp was once quoted as saying: "With Brando in *Streetcar* or Olivier in *The Entertainer*, the actor exposed himself in such a way that it was a kind of revelation of soul" (quoted in Kakutani 1984: 1).

With what authority can such a statement be made? As semioticians who have studied acting have discovered, the performing actor is an opaque medium, an intertext, not a simple text to be read for "content." We arrive at our perception of a performance by implicitly comparing it with other interpretations of the some role (or with the way we feel the role should be played), or with our recollection of the same actor in other roles, or with our knowledge of the stylistic school to which the actor belongs, the actor's private life, etc. (see, e.g., Elam 1980; Passow 1981). If our perception of the actor's work derives from this play of differences, how can we claim to be able to read the presence of the actor's self back through that performance?

The problematic of self is, of course, central to performance

theory. Theorists as diverse as Stanislavski, Brecht, and Grotowski all implicitly designate the actor's self as the *logos* of performance; all assume that the actor's self precedes and grounds her performance and that it is the presence of this self in performance that provides the audience with access to human truths. Their theories are aptly summarized by a sentence of Joseph Chaikin: "Acting is a demonstration of self with or without a disguise" (1972: 2). For Stanislavski, the disguise must be based on the actor's own emotional experience; Brecht wants the disguise to be separable from the actor's own persona and reflective of social experience. As I discussed in the previous chapter, Grotowski believes that the actor must use the disguise of her role to cut away the disguise imposed on her by socialization, and expose the most basic levels of self and psyche. Although Stanislavski, Brecht, and Grotowski all theorize the actor's self differently, all posit the self as an autonomous foundation for acting. An examination of these theories of acting through the lens of deconstructive philosophy reveals that, in all three theorizations, the actorly self is, in fact, produced by the performance it supposedly grounds.

Stanislavski's discourse on acting is inscribed firmly within logocentrism: he insists on the need for logic, coherence, and unity – the "unbroken line" – in acting and invokes the authority of such theological concepts as soul and spirit in his writings (1936: 237). There is no question but that the presence of the actor's self as the basis of performance is for him the source of truth in acting: he defines good acting as acting based on the performer's own experience and emotions. He privileges the actor's self over his or her role by stating, on the one hand, that actor and character should fuse completely in performance (1936: 196) and, on the other, that an actor can never play anyone but herself, since she "can't expel [her] soul from [her] body and hire another to replace it" (1936: 188). The merging of actor and character thus results exclusively in a fresh presentation (or representation) of self.

This privileging of self is also manifest in another aspect of Stanislavski's theory. He treats actor and character as autonomous entities, each with its own soul. Because it is impossible for the actor either to divest herself of her own soul or to penetrate fully into another's, she can only hope to find emotions of her own that are analogous (Stanislavski's word) to the character's (1936: 166). The most important terms of that analogy, the choices that make one actor's interpretation of a role different from another's (an essential aspect of the appearance of self-revelation in acting), are

determined by the difference between the actor's emotional reper-
toire and the character's. The uniqueness of the interpretation is,
therefore, a function of this difference, not of the actor's self-
presence emanating from her performance.

The actor's self, the basis for an unbroken line of characteriza-
tion, is itself fragmented. Stanislavski divides the self into
consciousness and the subconscious, identifying the latter as the
source of truth, the seat of "emotions that are dearer to [the actor]
than his everyday feelings" (1936: 166). As Wiles notes, Stanislavski
"uncritically equates 'meaning' with psychological 'inner truth,' the
imprecise term he uses throughout his work" (1980: 20).[2]
Paradoxically, although Stanislavskian performance is grounded in
subconscious materials which cannot be perceived or known
consciously (1936: 13), the (perceived) presence of those materials
behind a performance is the only valid criterion for truth in acting.
This paradox necessitates the adumbration of a psychotechnique
designed to help the actor's conscious self "fool [her] own nature"
(Stanislavski 1936: 85), the subconscious, into providing inspiration.
Stanislavski posits the presence of self in performance as the
highest good, but his psychology is based on the idea that true self-
presence is impossible.

In his reading of Freud, Derrida asserts that the making
conscious of unconscious materials is a process of creation, not
retrieval: "There is then no unconscious truth to be rediscovered by
virtue of having been written elsewhere" (1978: 211). The process of
recording unconscious materials itself creates those materials,
which exist only as traces in the unconscious, not as fully formed
data. Thus, "Everything begins with reproduction" (1978: 211) and
"we are written only as we write" (1978: 226). The unconscious is
not a source of originary truth – like language, it is subject to the
vagaries of mediation.

For the most part, Stanislavski treats the subconscious as what
Derrida shows it is not: a repository of retrievable data, as in his
famous metaphor of the house through which the actor searches
for the tiny bead of a particular emotional memory (Stanislavksy
1936: 164). He acknowledges, however, that memory distorts, that
the information we retrieve is not the same as the data we store,
adding that distorted memories are of greater use to the actor than
accurate ones because they are purified, universalized, and, there-
fore, aesthetic in nature (1936: 163). Furthermore, he suggests that
it is advisable at times for an actor consciously to alter her experi-
ences prior to recording them in memory so as to make them

"more interesting and suited to the theatre than the actual truth" (1936: 88). Despite his commitment to the ideal of self-presence, Stanislavski seems to realize that the self does not exist independently of the processes by which it is revealed to itself and others, that the self which is supposedly exposed through the medium of acting is in fact produced by the mediation of psychotechnique between the conscious and the unconscious levels of the actor's psyche. Earlier in this chapter, I pointed out that the individuality of an actor's interpretation of a role derives from the difference between the actor's emotional repertoire and the character's. It now seems that the actor's emotional repertoire derives in turn from the process of acting itself, which necessitates the distortion of emotion memory. The play of difference which produces a particular characterization is produced by the play of difference that defines the acting process. It is not surprising, then, that when Tortsov, Stanistavsky's alter ego in *An Actor Prepares*, is asked by a student whether the actor's subconscious "inspiration is of a secondary rather than a primary origin," he is unable to answer (1936: 165).

Brecht overturns Stanislavski's central priority: he privileges the conscious mind over the subconscious because even that level of the psyche has been poisoned by social indoctrination: "it is almost impossible to extract the truth from the uncensored intuitions of any member of our class society even when a man is a genius" (Brecht 1964: 94). Brecht wants the actor to "Demonstrate [her] knowledge ... of human relations, of human behavior, of human capacities" (1964: 26) by not allowing herself to be "raped" (1964: 93) by the character but by keeping the character at some distance from herself and showing it to the audience. Brecht engaged his actors in a tripartite rehearsal process. After an initial period of acquainting herself with her character and its motivations, the actor goes on to a "Stanislavskian" phase of empathetic character work from the "inside." Finally, the actor takes a step back from the character and "examines it once again 'from outside, from the point of view of society'" (Rouse 1995 [1984]: 240) and incorporates this point of view into the "gest of showing" which underlies Brechtian performance (Brecht 1964: 136, 203). Brecht privileges the actor over the character, but for a different reason than Stanislavski: in order that the actor's commentary on the character be meaningful to the audience, the actor must be present as herself as well as in character, and her own persona must carry greater authority than the role.

But what is this actorly persona? Roland Barthes suggests that "the [Brechtian] actor must present the very knowledge of the [play's] meaning ... The actor must prove ... that [she] guides meaning toward its ideality" (1977: 74–5). Wiles enlarges on this description by indicating that the Brechtian actor "feigns to inhabit a position of knowledge that is superior to the audience" (1980: 82); the actor "speaks from the position of a Marxist utopia in which the problems of the play that Brecht suggests can be solved have been solved" (1980: 80). To guide the play's meaning properly, the actor must pretend to possess knowledge which, historically, she cannot possess. The persona that the Brechtian actor presents alongside of the character that she portrays is a fictional creation.

What is the basis for this fictional persona? Barthes and Wiles both indicate that this persona is in service to the play's meaning, an observation which leads us by a circuitous route back to a basic form of logocentrism. Wiles suggests convincingly that the actor's pretended persona is an ironic stance adopted partly as a gesture of hostility toward the audience (1980: 82). In the "Short Organum", Brecht himself proposes another view:

> Without opinions and objectives one can represent nothing at all. Without knowledge one can show nothing; how could one know what would be worth knowing? Unless the actor is satisfied to be a parrot or a monkey he must master our period's knowledge of human social life by himself joining in the war of the classes.
>
> (Brecht 1964: 196)

Brecht implies that in order for the actor to possess the authority to comment on her character and the play from the proper sociological perspective, she must be able to ground her performative commentary in personal social experience, the kind of experience that is as important for Brecht as private, emotional experience is for Stanislavski. Brecht's exhortation that the actor must lead a politically active life is different in emphasis, but not all that different in spirit, from Tortsov's declaration to his students that "a real artist must lead a full, interesting, beautiful, varied, exacting and inspiring life" (Stanislavski 1936: 181).

The dilemma of Brechtian performance is that, for all of Brecht's emphasis on rationality and the undermining of theatrical illusion, the actor must convincingly portray something that she is not, the persona Barthes calls the "master of meaning" (1977: 75). Brecht's solution to this dilemma is to ground the actor's persona as actor in

the actor's life experience as a social being. Unlike Stanislavski, Brecht does not detail the technique by which the actor translates experience into performance (Rouse 1995 [1984] points out that Brechtian acting has more to do with an overall approach than with a specific methodology), but it is clear that the presence of the social self in performance is important to Brecht, who has as little use for the parrot-actor and the monkey-actor as Stanislavski has for the representational actor. Although the ideological gap between Brecht and Stanislavski is wide, the ethos behind their respective theories of acting is the same: performance can be truthful only if it invokes the presence of the actor's self. Brecht is more overtly aware than Stanislavski of the nature of the theatre as discourse; he defines a number of concepts which expose the mechanics of theatrical signification, but he does not escape the seemingly inevitable grounding even of this exposure in presence.

Grotowski's privileging of self is more radical than either Stanislavski's or Brecht's. He is concerned with the relation of the "mask of lies" we wear in everyday life to the "secret motor" behind the mask (1968: 46, 52). By confronting the everyday self with "its deep roots and hidden motives" (1968: 52), Grotowski hopes to produce revelation, "an excess of truth" (1968: 52–3). As discussed in the previous chapter, the Grotowskian actor's self-exposure and sacrifice is an invitation to the spectator to do the same thing on a less extreme level, to discover and confront the truth about herself. Grotowski privileges the self over the role in that the role is primarily a means of self-examination and a "screen" behind which that process can occur safely. The Poor Theatre is not only of the self but for the self – its purpose is to serve as therapy for both actor and spectator (1968: 46).

What is the language of self-revelation? Derrida writes that the self "is inscribed in language, is a 'function' of language, becomes a speaking subject only by making its speech conform to the system of the rules of language as a system of differences" (1982: 15). The self is inseparable from the language by which it expresses itself – it is a function of, and does not precede, that language. Grotowski proposes to eschew dependence on verbal language in the theatre, preferring "an elementary language of signs and sound – comprehensible beyond the semantic value of the word even to a person who does not understand the language in which the play is performed" (1968: 24). This language is made up of ideograms, physical expressions of basic psychic movements:

we attempt to eliminate the [actor's] organism's resistance to this psychic process. The result is freedom from the time-lapse between inner impulse and outer reaction in such a way that the impulse is already an outer reaction. Impulse and action are concurrent: the body vanishes, burns and the spectator sees only a series of visible impulses.

(Grotowski 1968: 16)

Grotowski suggests that a physical language could surmount the mediation of difference by becoming transparent and making psychic impulses directly visible to an audience. He grounds self-presence in physical presence, a seemingly irrefutably originary presence.

But even if the time-lapse which Grotowski describes is eliminated, it is not clear that the body transcends the play of difference that constitutes language. Derrida, through his reading of Artaud, points out that the body, too, is constituted by difference:

Organization is articulation, the interlocking of functions or of members . . . , the labor and play of their differentiation The division of the body into organs, the difference interior to the flesh, opens the lock through which the body becomes absent from itself, passing itself off as, and taking itself for, the mind The organ welcomes the difference of the stranger into my body: it is always the organ of my ruin, and this truth is so original that neither the heart, the central organ of life, nor the sex, the first organ of life, can escape it.

(Derrida 1978: 186)

Because it is organized, the body is not an organic, undifferentiated presence. The internal division of the body means that we are "several" to begin with, to paraphrase another passage from Derrida (1978: 226), and permits confusion between self and other, mind and body. The body is no more purely present to itself than is the mind and is therefore no more autonomous a foundation for communication than is verbal language. Grotowski would like to see the body vanish and burn in the communication of psychic impulses, but such a neat division between psyche and body is not possible if the body "passes itself off as, and takes itself for, the mind." Pure physical expression of and by the body is impossible for a body which is differentiated within itself and not present to itself. The mind cannot communicate the body without being defined by "the rules of language as a system of differences," and

the body cannot express the mind without being defined by its own system of differences. Pure self-exposure is no more possible on a physical level than on a verbal level because of the mediation of difference.

It has not been my purpose to discredit the theories under discussion here, for they remain valuable and provocative conceptions of acting and its functions. I only want to indicate their dependence on logocentrism and certain concepts of self and presence. Stanislavski states that the actor's self is the basis of performance, but his own working out of this idea leads him to posit that the self is produced by the very process of acting it is said to ground. Brecht would have the actor partly withhold her presence from the character she plays in order to comment on it. To do so, however, the actor must endow another fictional persona with the authority of full presence, a theoretical movement which makes Brecht's performance theory subject to the same deconstructive critique of presence as Stanislavski's. Grotowski proposes the actor's body as an absolute presence which banishes difference, but does not take into account the action of difference within the body itself. It is not a question of discarding these theories or of ironing out inconsistencies within them, but one of recognizing that they are subject to the limits of the metaphysical assumptions on which they are based. If we are to use them, we must realize that, like metaphysics, they demand that we accept these assumptions on faith. A deconstructive critique of these theories suggests that when we speak of acting in terms of presence, defined implicitly as the actor's revelation of self through performance, we must realize that we are speaking at most metaphorically, and that what we refer to as the actor's self is not a grounding presence that precedes the performance, but an effect of the play of *différance* that constitutes theatrical discourse.

In a well-known essay on Claude Lévi-Strauss, Derrida writes that there are two responses to the realization that all is *différance*, to "the lost or impossible presence of the absent origin." One is the "saddened, negative, nostalgic, guilty" response which "dreams of deciphering a truth or an origin which escapes play and the order of the sign" (1978: 292). The other response is what Derrida describes as the response

> which is no longer turned toward the origin, affirms play and tries to pass beyond man and humanism, the name of man being the name of the being who ... throughout his entire history, has

dreamed of full presence, the reassuring foundation, the origin
and the end of the play.

(Derrida 1978: 292)

"Play is the disruption of presence" (1978: 292); an affirmation of
the play which makes meaning at once possible and impossible is
the alternative to the yearning for presence.

It is clear that the theories of "holy" theatre discussed in the
previous chapter constitute versions of the first response Derrida
mentions, the nostalgic yearning for truth and origin sought, in
these instances, through ideograms and archetypes. Consideration
of two other examples may serve as a starting point both for
conceptualizing acting that corresponds to the second response
Derrida identifies, the affirmation of play, and seeing some of the
problems inherent in such a conceptualization. In the practice of
"transformational acting" pioneered by the Open Theatre, "the
theatrical or sociological style of a scene is transformed (restoration
comedy to soap opera to Brechtian *lehrstücke* to Hollywood melo-
drama) in the course of an improvisation" (Pasolli 1972: 21). To
some extent, transformational performance in which the actor leaps
from style to style or from role to role self-consciously dramatizes
the construction of the actor's self from the language of theatre.
Inasmuch as the transformations are ends in themselves and not in
service to the meaning of the material being performed, they begin
to suggest an ungrounded play of theatrical signification. In prac-
tice, however, transformational acting produces polysemy, multiple
meanings which imply the presence of an "horizon" of meaning,
not the open, limitless production and deferral of meanings to
which Derrida refers (1981b: 350). The practice also invites the spec-
tator to search out the element that remains consistent throughout
the transformations: the actor's presence. Both outcomes prevent
transformational acting from escaping logocentrism. Another
example, which comes closer to doing so, is to be found in
Diderot's *Paradoxe sur le comédien* (c. 1773). Diderot describes a
party stunt for which David Garrick would place his head between
folding doors and run through a gamut of facial expressions associ-
ated with particular emotions. As Diderot realized, Garrick's
dissociation of signifier and signified raised vital questions on the
relation of the actor's self and her expressive means (1970: 168).
Unlike later transformational experiments, Garrick's stunt was
purely gratuitous play, not in service to the realization of any text
or the production of any meaning. Arguably, however, it, too,

referred to a horizon of meaning, whether one sees that horizon as the demonstration of Garrick's own virtuosity, which reinstates a logocentric author function, or as the social conventions that made Garrick's expressions recognizable as representing particular emotions, or as the inevitable reference of theatrical signifiers to their normal usages, even when divorced from that context.[3]

Although it is intriguing to speculate on what a deconstructive poetics[4] of acting might look like, such speculation runs counter to the spirit of deconstruction itself. Derrida's philosophy is descriptive and analytical, not prescriptive or programmatic: deconstruction cannot exist independently of the thing it deconstructs. Fundamentally, deconstruction is the analysis of the play of *différance* within existing discourses and the implications of that analysis for the meanings imputed to those discourses. We cannot build a philosophy on *différance*, for to treat *différance* as originary is a contradiction in terms: "To say that *différance* is originary is simultaneously to erase the myth of a present origin" (Derrida 1978: 203). Derrida acknowledges that *différance* is itself a manifest term for something which properly has no name and does not exist (1982: 26–7). He therefore resorts to such measures as coining some words and crossing out others (writing "under erasure") to indicate, in the first case, the need to refer to conceptual non-entities and, in the second, the inescapable use of the metaphysical terms and concepts that are the very objects of his critique in order to articulate that critique.

Rather than embarking on the impossible task of imagining the performance of *différance*, it makes more sense to conceptualize deconstructive acting and theatre as performance equivalents for Derrida's practice of writing "under erasure," using language bound up in the metaphysics of presence and crossing it out. Deconstructive theatre, therefore, might simultaneously use the vocabularies of conventional acting methods and styles and undermine them. Brecht obviously moved in this direction, but his theory of acting demands that the actor's political persona be endowed with unquestioned presence. Although his theory allows for the creation of many, even contradictory, meanings in a performance, the implication is that a resolution of these conflicts is both possible and desirable, since that would imply the resolution of social conflicts. His theatre thus remains teleological and theological.[5] A fuller examination of performance that might be understood as deconstructive in the terms I have suggested here will be the concern of my discussions of the Wooster Group in Chapters 4 and 6.

4 Task and vision
Willem Dafoe in *LSD*

I'm this particular guy who has to go through these particular paces. It's not so much that I'm putting forward my personality, but because of the various actions I have to do, I'm presenting my personality in how I field those actions. That is the acting in it. I'm a guy given a character, a performing persona, and I'm going through these little structures, and how I field them is how I live in this piece.

<div align="right">Willem Dafoe</div>

Task and vision, vision in the form of a task.

<div align="right">John Ashbery, "Years of Indiscretion"</div>

A discussion of Willem Dafoe is inevitably a discussion of the Wooster Group, the performance collective of which he is a member and which has been the most important formative influence on his approach to acting/performing. Dafoe draws a distinction between these activities; his hesitation to make it categorical reflects the Wooster Group's multi-tracked, polysemic production style. The essential structural principle of its work is juxtaposition, often of extremely dissimilar elements (e.g., a reading of *Our Town* with a comedy routine in blackface in *Route 1 & 9*). The performers refer to and practice a variety of performance modes and styles in each piece, ranging from realistic acting to task-based collage (*Point Judith*), from work on familiar texts to recreations of the Wooster Group's own processes and experiences. The Wooster Group's *LSD* (. . . *Just the High Points* . . .), performed during 1984 and 1985, was, amongst other things, a performance compendium that included all of the interests just mentioned and restated images and concerns explored in previous pieces. (For a fuller discussion of *LSD*, see Chapter 6.)

The baseline of the Wooster Group's work is a set of performance personae adopted by its members, roughly comparable to the "lines" in a Renaissance theatre troupe. These personae, while not

fixed, recur from piece to piece and reflect to some extent the personalities and interactions of the collective's members.

> These [pieces] are made specifically for us. In this configuration of people, we do tend to make characters, life characters and characters in the productions. If you want to get real blocky about it, Ron [Vawter] is tense, kind of officious; he's the guy who's the link to the structure, he stage-manages the thing, he pushes it along, he's got a hard edge. I serve the function of sometimes being the emotional thing. The man, a man.[1]

Or, as Dafoe also puts it, Everyman.

The interaction of these personae has provided the Wooster Group with a theme which, with variations, has been explored in a number of productions. In the first section of *Point Judith*, which consisted of an autonomous one-act play, Vawter's character mocked Dafoe's younger man, calling him "Dingus," questioning his sexual prowess. In *Hula*, Vawter portrayed the leader of a seedy hula dance team trying to keep his second banana (Dafoe) in step and in line. Dafoe, in turn, seemed to be competing with him for the attention of the third dancer, acted(?)/danced(?) by Kate Valk. The second section of *LSD*, a reading of Arthur Miller's *The Crucible*, finds Vawter's Reverend Parris incoherently accusing Dafoe's John Proctor of witchcraft. Variations on the theme of older man/younger man, boss/subordinate, oppressive conformity/good-natured anarchy were interlaced with undertones of sexual competition whenever the two performers worked together.[2]

The choice of Dafoe to represent the emotional man is itself a (successfully) eccentric one. In his early films, he played a series of punks, villains, down-and-outers. "[Film people] tend to see me as pretty tough, but they do on the street as well. The way people treat me in life is they treat me like I'm gonna slug 'em if, you know" Dafoe's stereotypically "tough" physiognomy plays against his emotional performance persona to create a blur: the actor who's perceived as tough on the street or in the context of film and its system of signs and icons is a leading man in Wooster Group performances because that is the function he fulfills in that context, relative to those other performers.[3]

The Wooster Group's personae occupy an ambiguous territory, neither "non-matrixed performing" (Kirby 1995 [1972])) nor characterization. This ambiguity was exemplified in *Hula* by the audience's uncertainty as to whether it was watching a group of New York avant-garde performers doing hula dances for reasons of

their own or whether there was, in fact, a kind of scenario being played out. Dafoe smiled frequently and seemed genuinely to enjoy his dancing (by contrast with Vawter, whose main focus was on keeping the others in step). But who was smiling: Dafoe, enjoying the dance, or a dancer played by Dafoe, or both? There were characters, but so slightly delineated as to function almost as subtext, but subtext for what? Dafoe observes that the characters were not formalized in any way; perhaps, as he suggests, what appeared in the performance to be a minimal, but nevertheless present, level of characterization (a sort of "characterization degree zero") was simply "the baggage that comes along with having these particular people on stage" dancing together. The "characters" arose from the activity: the task and the specific performers engaged in it.

> When we make a theatre piece, we kind of accommodate what [the performers] are good at or how they read. They have functions, so it's not like we treat each other as actors and there has to be this transformation. We just put what Ron brings to a text and formalize it: it definitely comes from Ron as we know him, as he presents himself to the world and then, of course, when you formalize it and it becomes public in a performance, that ups the stakes a little bit. That's not to say Ron is just being himself, but you're taking those qualities that he has and you're kind of pumping them up and putting them in this structure.

The Wooster Group's process is self-referential and hermetic, even solipsistic. Performances are structured around the performers and their personae, personae which originate as the performers' self-presentation, and are then refined through confrontations with texts, and the act of performing. Dafoe: "I'm serving a structure I helped make and it helped make me in this public event." In this respect, the Wooster Group's approach to performance exemplifies Elinor Fuchs's description of postmodern theatre as "a stage turned curiously in upon itself, blurring the old distinctions between self and world, being and thing; and doing so not through a representation of the outside world but through the development of a performance art 'about' performance itself" (1983: 2). Wooster Group performances, indeed, are less representations of an exterior reality than of the relationship of the performers to the circumstances of performance. Their style of performing, which at once evokes and critiques conventional acting, could be described as performance "about" acting.

The absence of transformation in Wooster Group performance,

compared with more traditional modes of acting, is important to Dafoe – he insists that the Wooster Group does not place the premium on believability demanded by realistic acting, with its implication that the actors are really experiencing the emotions they portray. Referring to a section of *LSD* in which he places glycerin in his eyes to s(t)imulate tears (a motif of many Wooster Group pieces), Dafoe states,

> Once you show the audience you're putting it in, it takes the curse off of it. Then it takes away, "Oh, what a fabulous, virtuoso performer he is, oh, he's crying!" That's something I could do. But [using the drops] makes things vibrate a little more, because you get your cake and eat it, too. You see the picture of the crying man, you hear the text, you see the whole thing before you.

The Wooster Group would trade illusionism for a more profound ambiguity. The technical processes of acting are demystified, as by the glycerin, but the central issue of mediation, of what intervenes between performer and audience, is raised and left intentionally unanswered. The performers' simultaneous creation and demystification of effects associated with conventional acting make their performance deconstructive of acting in the sense discussed at the end of the previous chapter: they place "acting" under erasure. (I will expand upon the implications of this deconstruction in Chapter 6.)

For Dafoe, performance is essentially a task, an activity: the persona he creates is the product of his own relation to the "paces" he puts himself through in the course of an evening. While unconscious of the audience, he is hyper-conscious of creating a public image. The multiple, divided consciousness produced by doing something with the knowledge that it is being observed, while simultaneously observing oneself doing it, yields a complex confrontation with self.

> The more I perform, the more my relationship to the audience becomes totally abstract. Different performers, actors need different things. For example, Spalding [Gray] loves an audience. He really feels them out there. I don't. It's a totally internal thing. Even when [I] have a character, I'm always curious to see how I read, what people think I am, who I am, and then you lay the action on top of that so you're confronting yourself in these circumstances. It's open-ended. I'm not presenting anything; I'm

feeling my way through. If you were acting something, if you were very conscious of acting a character, somewhere you would close it down, you'd present it. You'd finish it. In this stuff, you never know.

"Feeling his way through" the actions he has been assigned, the effects he knows he must produce, is the subject of Dafoe's performing. *LSD* is a layered production. In Part 1, the performers read from books; in Part 2, they "play" characters from *The Crucible*. Part 3 consists of a minutely accurate re-creation of the Wooster Group's behavior while trying to rehearse Part 2 on acid. Even when playing a character, Dafoe perceives his internal process while performing only in terms of his consciousness of, and relation to, the performance context. He makes no distinction between being himself in the first part, playing John Proctor in the second, and playing himself (stoned) rehearsing John Proctor in the third. All are manifestations of a single performing persona.

I never think about John Proctor. I do think about what the effect of a certain speech should be, or a certain section should be. I do respond to "here, you should relax a little bit more because you should have a lighter touch, he should be a nice guy here. Here, he can be pissed. Here, he's had it." And "he" is me because "John Proctor" means nothing to me. There's no real pretending, there's no transformation, John Proctor's no different than the guy reading the Bryan book [in Part 1], he's no different than the guy in the third section who's saying, "Hey, come on, where the hell are we?" Just different action is required of him.

The complexity of his physical and vocal scores is liberating to Dafoe. Because his performance is not a matter of interpreting a role but one of re-enacting decisions based on the evolution of the Wooster Group's personae made in the construction of the piece, "it's just about being it and doing it." This leaves the mind free – instead of trying to fill the moment with emotions analogous to the character's (Stanislavski), the performer is left to explore his own relationship to the task he is carrying out.

There are kind of meditative moments in even the most active parts, of even *The Crucible*. There's a speech where I say, "Whore!"; I accuse Abigail. Sometimes my mind kind of wanders in that. There's a double thing happening. I'm saying the text, but I'm always wondering what my relationship to the text is. Me, personally, not the character – 'cause I don't know

about the character. If someone asked me about John Proctor the character, I wouldn't be able to tell him a thing.

The possibility of meditativeness leads to a kind of catharsis, defined entirely in terms of the performance structure:

> The way I get off in the performances is when I hit those moments of real pleasure and real clarity and an understanding about myself in relationship to the structure; it is work, it is an exercise of me for two hours, behaving a certain way, and it can become meditative.

The creation of persona from self results in a measure of self-understanding. The kind of catharsis Dafoe describes is different in crucial respects from those discussed in Chapter 2. Although this catharsis takes self-understanding as its object, and is therefore therapeutic rather than communal, that understanding is limited to a clarity of perception about the relation of the self to the performance. No larger structure of knowledge, whether of the individual psyche or the collective unconscious, is invoked. If, in postmodern performance, the self is understood to be a *persona*, a textual entity generated by the performance context, catharsis, too, must be defined in textual terms.[4]

Film acting is the unavoidable point of reference for a definition of performance as the development of a persona.[5] (By the mid-1980s, Dafoe had appeared in half a dozen commercial films as well as experimental ones.) He sees his film persona (the tough guy) as basically similar to his Wooster Group persona (the vulnerable man), "the only difference being that I usually play something dark. In these films that I've done there's a real dark streak, there's a mean streak that I don't so much have [in Wooster Group pieces]." Dafoe draws parallels between the process of making a film and that of making a theatre piece. Typecasting, "the fact that they've cast me in this role, is not unlike a certain kind of tailoring that we do at the [Performing] Garage." The technical requirements of film acting correspond to the score of a Wooster Group performance and provide Dafoe a similar opportunity for reflection on his relationship as a performer to an inclusive process.

> When you're doing a scene, you've gotta hit that little mark and if you don't hit the mark it spoils the shot. And, somewhere, I respond to that. Most people find that distracting, but that allows the frame for something to happen; it cuts down on my

options and I'm a little more sure about what I want to do at any given point.

As in Wooster Group pieces, the imposition of a specific task creates a degree of freedom within the structure.

You get no sense of having to produce anything. What you're thinking about in a funny way is your relationship, almost literally, to this whole big thing, the 20 guys around, the black box, you're dressed up in a suit or you're dressed up in leather. You get some taste of what they want you to come across with, but what energizes you is the whole situation.

It is this consciousness of the whole situation that Dafoe finds valuable in both his theatre and film work and which becomes the material of his performance. The issues he raises – persona, distance, audience perception of the performer, the performer's perception of himself – are always part of performance, but are usually sublimated, at least in conventional work, to emphases on character and psychology. Film has frequently played consciously with the ambiguities of persona, but often in a purely manipulative way, as when movies are tailored to the gossip surrounding their stars to create a low-grade illusion/reality *frisson* for their audience. The intent of Dafoe's work with the Wooster Group is to make these issues part of the performance's subject by acknowledging that the performers' personae are produced by the process as much as the process is produced by the performers. "Task and vision, vision in the form of a task"; the work's vision is the task as performed by a certain group of people, and the task is a vision of what the performance should be and what these people can do. Within this closed and circular system, Dafoe's performance persona is at once his presentation of self to the audience and his image of himself performing. There is a certain frankness to the approach; the performed image is generated by the activity of the moment, by what the audience sees him doing under the immediate circumstances. Task/vision, vision/ task; "The perfection of a persona is a noble way to go."

Part II

Postmodernism and performance

5 *Presence* and *theatricality* in the discourse of performance and the visual arts

Nineteen ninety-seven marks the thirtieth anniversary of one of the most vexed points of intersection of critical discourses on the visual arts and performance. I am referring to Michael Fried's notorious essay "Art and Objecthood," first published in *Artforum* in 1967. In this polemic against minimalist (or, as he calls it, literalist) art, Fried condemns minimalism for what he describes as its inherent theatricality and dependence on presence. Fried's strident and intemperate tone, as well as his apparently virulent, underexplained antitheatricalism, have made his essay an easy target, especially for critics championing post-abstract art and postmodernist performance. My objectives here are to offer a hopefully somewhat more nuanced reading of Fried's essay than it usually receives from champions of postmodernism, and to indicate its importance in establishing the terms of much critical discussion of postmodernism in the visual arts and performance, especially in the late 1970s and early 1980s.

Fried's argument against minimalist art is embedded in a theory of modernism that Fried inherited, with modifications, from Clement Greenberg. In a lengthy footnote to the essay, Fried takes issue with Greenberg's contention that modernism in painting takes the form of a continuous process of "testing" visual conventions and discarding the "dispensable, unessential" ones. Through this process of distillation, modernist painting, in Greenberg's view, expresses the essential qualities of painting as a medium: "flatness and the delimitation of flatness" (Greenberg, "Art After Abstract Expressionism" [1962: 30] quoted in Fried 1968 [1967]: 123, n. 4). Fried adopts Greenberg's approach, but wants to make the determination of essence more historical, more contingent. "[T]he crucial question," he writes,

is not what these minimal and, so to speak, timeless [essences of painting] are, but rather what, at a given moment, is capable of compelling conviction, of succeeding as painting. This is not to say that painting has no essence; it is to claim that that essence – i.e., that which compels conviction – is largely determined by, and therefore changes continually in response to, the vital work of the recent past.

(Fried 1968 [1967]: 123–4, n. 4)

Fried's perception was that, in the mid-1960s, painting could only "compel conviction" as painting by staving off the challenges to its aesthetic autonomy mounted by, for example, American Pop Art and French New Realism (my examples, not Fried's). Both styles suggested that anything can be the subject matter of art or even art itself, and, conversely, that the art object therefore has no special status. Under this assault, Fried declares, "modernist painting has come to find it imperative that it defeat or suspend its own object-hood" lest paintings be "experienced as nothing more than objects" (1968 [1967]: 120).

As Fried develops this historical imperative in his essay, he sets up a relationship between his notion of "objecthood" and concepts of "theatre" and "theatricality." The problem with minimalist art, in Fried's initial formulation, is that "It aspires not to defeat or suspend its own objecthood, but on the contrary to discover and project objecthood as such" (1968 [1967]: 120). A few pages later, he indicates that "the literalist espousal of objecthood amounts to nothing other than a plea for a new genre of theatre; and theatre is now the negation of art" (1968 [1967]: 125), implying that the asser-tion of what Fried calls "objecthood" is equivalent to what he now calls "theatre." Still later in the essay, Fried makes this relationship between objecthood and theatricality even more explicit when he states that "the imperative that modernist painting defeat or suspend its objecthood is at bottom the imperative *that it defeat or suspend theatre*" (1968 [1967]: 135, original emphasis). "Theatricality" thus comes to replace "objecthood" in Fried's rhetoric as the term denoting the enemy of modernist painting.

By "theatricality," Fried means first of all that minimalist sculp-ture asserts its own presence, and that it depends for its completion and fulfillment as an aesthetic object on the presence of a spectator – it is not self-sufficient and self-referential in the way Fried believes modernist art to be. "[T]heatre has an audience – it exists for one – in a way the other arts do not; in fact, this more than

anything else is what modernist sensibility finds intolerable in theatre generally" (1968 [1967]: 140). Another aspect of Fried's theatricality is its "preoccupation with time – more precisely, with the *duration of the experience*"; Fried identifies such a preoccupation with temporality as "paradigmatically theatrical" (1968 [1967]: 145, original emphasis). Modernist art achieves what for Fried is a higher state than mere presence, which he describes as a "present-ness" that transcends temporality, "the condition, that is, of existing in, indeed of secreting or constituting, a continuous or perpetual *present* . . . " (1968 [1967]: 146). The viewer's experience of such art is one of complete and instantaneous apperception: "It is as though one's experience [of such work] *has no* duration . . . because *at every moment the work itself is wholly manifest*" (1968 [1967]: 145, original emphasis). (It is noteworthy that whereas Fried wants to make Greenberg's account of modernism more historical by building into it the idea that the essence of painting is historically determined and contingent, he is repulsed by art that he perceives as providing the viewer with an experience of such temporal contingency.)

Even without some of his most inflammatory remarks about theatricality and its corrupting influence, which I have omitted intentionally, Fried's essay is obviously easy for a student of the theatre to hate. I have summarized portions of the essay in some detail, however, because I think it is important to understand the actual nature of Fried's argument. It is certainly true that Fried's vilifying use of the terms "presence," "theatricality," and "theatre" smack of an antitheatrical prejudice. Such prejudice was widespread in the art world of the 1960s, manifest not only in Fried's formalist criticism, but also in the antitheatrical bias of early art performance, including Happenings and conceptual perfor-mance, and in the dislike of theatre expressed by the artists who made those performances (Copeland 1989).

I want to argue, however, that reading Fried's essay primarily as an example of the art world's antitheatrical prejudice is reductive. Fried's prejudice is not against theatre *per se*. In Fried's usage, the term "theatricality" does not denote the essence, or even a quality, of the theatre as an art form. Indeed, Fried describes modernist theatre as being engaged in the same battle against theatricality as the other modernist arts, citing Artaud and Brecht as examples (1968 [1967]: 140). In other words, Fried is prejudiced against "theatricality," but not against the theatre as such, and even his prejudice against theatricality, because it is based on an analysis of what modernism must do to maintain its integrity at a particular

historical moment, is contingent, not absolute. Rosalind Krauss has pointed out that "theatre," in Fried's essay, "is an empty term whose role it is to set up a system founded upon the opposition between itself and another term" (1987: 62–3). Krauss identifies this other term only as "the nontheatrical" (1987: 62); in Fried's historical account, "the nontheatrical" clearly is modernism.

Fried describes the theatrical as a *sensibility* overtaking the art world in the 1960s: "what has compelled modernist painting to defeat or suspend its own objecthood is not just developments internal to itself, but the same general, enveloping, infectious theatricality that corrupted literalist sensibility in the first place . . . " (1968 [1967]: 137). In thirty-year retrospect, it has become clear that Fried's "theatricality" is what we now call "postmodernism." Fried's account of the "war" (his metaphor) between modernism and theatricality is, in fact, the agon of modernism and postmodernism, with Fried as the correspondent reporting from the front. Indeed, the list of artists that Fried links with the minimalists as partaking in the theatricalist sensibility could stand as a partial genealogy of the postmodern, particularly in the visual arts: the Surrealists, John Cage, "Kaprow, Cornell, Rauschenberg, Oldenburg, Flavin, Smithson, Kienholz, Segal, Samaras, Christo . . . " (1968 [1967]: 130, n. 8). Fried himself notes this correspondence, observing that "In the years since 'Art and Objecthood' was written, the theatrical has assumed a host of new guises and has acquired a new name: post-modernism" (1983: 233–4, n. 17). To do Fried's historical account justice, I must note that he characterizes the literalist sensibility as "a response to the same developments that have largely compelled modernist painting to undo its objecthood – more precisely the same developments seen differently, that is, in theatrical terms, by a sensibility already theatrical . . . " (1968 [1967]: 136). In other words, whereas color field abstraction is the *modernist* response to a certain problematic in the history of painting, minimalism is the *post*modernist response to that same problematic. Implicit in Fried's essay is an account of postmodernism which suggests that postmodernism arose within the problematic of late modernism, not somehow "after" modernism or as the result of a rupture with modernism.

From the vantage point of the 1990s, it is clear who won Fried's war; suffice it to say that Fried was not rooting for the victors. His continued championing of the work of such artists as Larry Poons and Anthony Caro as "a body of work that seemed to me then, and continues to do so today, the most important and distinguished

painting and sculpture of our time" (1987: 55) can only seem quixotic. As Douglas Crimp points out in an essay on the art of the 1970s, Fried's nightmare came true: "what he feared would replace [presentness in art] as a result of the sensibility he saw at work in minimalism – what has replaced it – is presence, the *sine qua non* of theatre" (1984 [1979]: 177).

Many commentators (including Copeland 1989; Crimp 1984 [1979]; and Sayre 1989) imply or assume that the backlash against Greenbergian formalism in the art and criticism of the 1970s and 1980s discredited Fried's argument against theatricality. Because that argument takes Fried's binary opposition of modernism and theatricality as its premise, however, it operates in a discursive field defined by Fried even as it claims to be refuting his position. Rather than question (or deconstruct) the opposition that generates Fried's argument, these commentators merely reverse his evaluation: whereas Fried privileges modernism over theatricality, his adversaries simply privilege theatricality over modernism without questioning the validity of defining the issue in this way. Although Fried's advocacy of color field painting and modernist sculpture well into the 1980s makes him seem a champion of lost causes, "Art and Objecthood" clearly set the terms for much of the critical discussion of art after minimalism, and much of the theoretical discussion of postmodernism, even for those who vehemently reject its conclusions.

Crimp's essay "Pictures" (1984 [1979]), in which he argues that the visual art of the 1970s took performance as its informing episte-mology, is an example (Sayre (1989) adopts a similar stance). Crimp agrees with Fried that theatricality represented a threat to the integrity of modernism, but argues against Fried's negative judg-ment of the postmodern by claiming that art informed by a theatrical sensibility has proven itself historically: "judging from [such art's] current vitality we need no longer regret or wish to reclaim, as Fried did then, the shattered integrity of modernist painting and sculpture" (1984 [1979]: 116). Crimp's rejoinder is salutary in that he argues in favor of a large body of work that Fried continues to dismiss as merely trivial. Crimp's response, however, validates Fried even as it challenges him, for it accepts his account of the nature of modernism, and defines postmodernism as a counter-reaction to that version of modernism. By reifying Fried's position, along with Greenberg's, as the late modernism against which postmodernism defines itself, Crimp unintentionally recu-perates postmodernist art for the very critical discourse it is said to

have surpassed. By foreclosing the definition of modernism in this way, this discourse of postmodernism repeats the modernist gesture of defining itself "against a past perceived as inert" (H. Foster 1984 [1982]: 200). Fried's own account of the relation of modernism and postmodernism, in which postmodernism emerges within modernism as a different response to current problematics, is more complex, dynamic – and, possibly, more accurate – than an account which sees postmodernism as supplanting and superceding a static and outmoded modernism.[1]

Considering Fried's antitheatricalism, it is perhaps more surprising that "Art and Objecthood" had the same agenda-setting influence over critical discourse on performance emerging in the late 1970s and early 1980s as it had over the account of post-modernism developed in the visual arts criticism of that period. While Sayre's characterization of Fried's essay as "perhaps the earliest to examine the aesthetic assumptions of performance art" (1989: 6) is misleading (since Fried's essay is not about perfor-mance), some important theoretical speculation on performance is situated in the discursive field constituted by Fried's account of presence and theatricality. My examples here will be two essays that appeared in *Modern Drama* in 1982, one by Josette Féral and another by Chantal Pontbriand, both of whom use Fried as a point of departure for efforts to distinguish performance from theatre. Although I do not wish to imply that these essays are in any sense identical or interchangeable, my emphasis here will be on the ground they share with each other and with Fried.[2]

Drawing their examples chiefly from the 1970s work of such conceptual performance artists as Vito Acconci and Elizabeth Chitty, and such theatre directors as Richard Foreman and Robert Wilson, Pontbriand and Féral propose that what they call "perfor-mance" can be seen as deconstructing "theatre." They suggest that performance exists in an antagonistic relationship with theatre, emphasizing that performance specifically deconstructs theatre's essential features: "Performance rejects all illusion" (Féral 1982: 171); it "presents; it does not represent" (Pontbriand 1982: 155). Both claim that performance is characterized by fragmentation and discontinuity (rather than theatrical coherence) in narrative, in the use of the body and performance space, and in the performance/audience relationship. Thus understood, performance deconstructs and demystifies theatre: "Performance explores the under-side of theatre, giving the audience a glimpse of its inside, its reverse side, its hidden face" (Féral 1982: 176).

In the context of this discussion, Féral quotes Fried to the effect that "Art degenerates as it approaches the condition of theatre" (1968 [1967]: 141) and goes on to assert that "If we agree with Derrida that theatre cannot escape from representation . . . and if we also agree that theatre cannot escape narrativity . . . then it would seem obvious that theatre and art are incompatible" (Féral 1982: 175). Féral thus transplants Fried's argument from one critical era and context to another. Whereas Fried argued that theatricality was the enemy of art understood from the point of view of Greenbergian modernism, Féral argues, on very similar grounds, that theatricality is the enemy of art understood from the point of view of Derridean poststructuralism. Féral goes on to argue that the kind of presence characteristic of performance (again, in opposition to theatre) is what Fried called "presentness," "the condition, that is, of existing in, indeed of secreting or constituting, a continuous or perpetual present" (1968 [1967]: 146). Féral's claim for performance is that "since it tells of nothing and imitates no one, performance escapes all illusion and representation. With neither past nor future, performance takes place" (1982: 177). It is performance's defeat of theatrical representation that enables it, in Féral's view, to "secrete a continuous present."[3]

Pontbriand makes much the same point, evoking Fried even more explicitly. She uses the phrase "post-modern presence" to distinguish the presence of performance from that of theatre, and describes the former by saying "the characteristic presence of performance could be called presentness – that is to say, performance unfolds essentially in the present time" (1982: 155). Like Féral, Pontbriand makes the link between the presentness of performance and its refusal of representation: "what is involved [in performance] is indeed an obvious presence, not a presence sought after or represented; this desire to discover, then, a here/now which has no other referent except itself" (1982: 157).

This last claim sounds strikingly like those Fried makes for the self-sufficient modernist painting. Indeed, the degree to which these accounts of postmodern performance restate Fried's account of modernist art is almost startling. Like Greenberg and Fried, Féral and Pontbriand are concerned to locate the essential characteristics of a medium (in their case, performance) and to argue that its assertion of those characteristics in their pure form distinguishes it from, and places it in opposition to, other media (theatre, in particular). In both cases, this drama is played out against a backdrop of historical necessity: compare Fried's claim that the defeat of objecthood is

the imperative facing painting in the 1960s with Féral's claim that, in the wake of Derrida and poststructuralism, performance must defeat representation.

What is anomalous in this comparison, of course, is that both accounts focus on the same aesthetic criterion. Whereas Fried posits presentness as a defining characteristic of modernist art, Féral and Pontbriand posit it as a defining characteristic of postmodern performance. At first glance, it may seem that Féral and Pontbriand have effected a kind of deconstructive reversal of Fried by recuperating the very thing that he prizes about the experience of modernist art for what they declare to be a postmodern form. I would be more inclined to argue, however, that Féral's and Pontbriand's respective uses of the concept of presentness do not constitute a reversal of Fried at all, but, rather, demonstrate the degree to which Féral's and Pontbriand's ideas are steeped in the Greenberg–Fried account of modernism. What seems to be operating here is the very Greenbergian–Friedian notion that the concepts "modernism" and "postmodernism" are medium-specific and historically contingent. To Fried in the Pop Art mid-1960s, painting needed to defeat objecthood and assert presentness in order to retain its specificity as a medium, and to assert the integrity of modernism against an emerging postmodernism. To Féral and Pontbriand in the deconstructionist early 1980s, performance needed to defeat representation and assert presentness in order to establish its specificity as a medium (that is, to distinguish itself from theatre) and to differentiate an emerging postmodernism from an existing modernism. The critical stakes are different, of course; while Fried speaks in the name of preserving the modernist status quo, Féral and Pontbriand champion the new postmodernism. Nevertheless, both discourses are firmly inscribed within the Greenbergian mythic narrative of a medium's struggle to discover and assert that which is specific to itself. Féral's and Pontbriand's essays do not so much deconstruct Fried as dress up Greenbergian aesthetics in poststructuralist clothing.

That the term "theatre" can function as a figure for an emerging postmodernism for Fried *and* as a figure for a dessicated modernism for Féral and Pontbriand is symptomatic of the medium-specificity of both arguments. In the context of the visual arts, Fried's theatricality is a postmodernism threatening to an established modernism; in the context of performance, theatricality is the modernism against which an emergent postmodernism defines itself. We would do well to remind ourselves here of

Krauss's observation that, in Friedian discourse, "theatre" functions primarily as an empty term used as the negative figure in a binary opposition. Although Féral and Pontbriand are talking about theatre in a more literal sense than Fried, they use the term "theatre" in much the same way – one more indicator of how firmly ensconced in the Friedian discursive field their commentary is.

At its thirtieth anniversary, the importance of Fried's "Art and Objecthood" is clear. Although the essay is about visual art, not theatre, Fried's use of a theatrical vocabulary has proven to have had a decisive effect for critical discourses on both the visual arts and performance. Although Fried's side lost the battle of sensibilities, it certainly did not lose the war of words. As I have tried to show, critical discourses on postmodernism in both the visual arts and performance staked out positions on the discursive field of Greenbergian modernism defined by Fried, and found themselves unintentionally perpetuating Greenberg's legacy of formalist criticism even while speaking for artistic practices that have no place in the Greenbergian scheme. But even this victory may have proven Pyrrhic for Fried. The final irony of this chapter in the history of criticism may be that, in trying to stave off the encroachment of postmodernism and theatricality in the visual arts, Fried established a discourse that made it possible to theorize postmodern performance, a phenomenon that is virtually the antithesis of the hermetic modernist abstraction Fried sought to protect.

6 Toward a concept of the political in postmodern theatre

A number of critics and theorists have expressed alarm over the supposed apoliticality of American experimental theatre of the 1980s, alarm which often seems to imply nostalgia for the impassioned engagement characteristic of the experimental theatre community of the previous decade. Some decry what they label the "formalist" bent of recent experimental theatre as ideologically regressive;[1] some suggest that the deconstructive modality of much current experimental theatre is inherently antithetical to meaningful political *praxis*.[2] Deconstruction and apoliticality are often linked in these writings with the concept of postmodernism: deconstruction is seen as a characteristically postmodern aesthetic strategy, apoliticality as either a cause or a symptom of the prevalence of the deconstructive aesthetic.[3]

I would like to suggest here that "the postmodern condition" (Lyotard 1984) has not rendered political theatre impossible – though it has made it necessary to rethink the whole project of political art – and to propose a rough schema describing a postmodern political theatre, its concerns and strategies. I will begin with an account of the cultural situation confronted by the postmodern political artist which has necessitated a transition from transgressive to resistant political art. I will then examine the concept of presence, which is the specific problematic theatre theorists and practitioners must confront in re-examining our assumptions about political theatre and its function, before offering an analysis of what I consider an example of postmodern political theatre, the Wooster Group's *LSD (. . . Just the High Points . . .)*.

POLITICAL ART UNDER POSTMODERNISM

If there is a crisis in the theory and practice of political art under postmodernism – and there clearly is – it is a historical crisis brought about by uncertainty as to just how to describe our cultural condition under multinational capitalism, by the obvious inappropriateness of the political art strategies left over from the historical avant-garde of the early twentieth century and from the 1960s, and by a widespread critical inability to conceive of aesthetic/political *praxis* in terms other than these inherited ones. As the profusion of terms describing our times (postmodern, postindustrial, superindustrial, late capitalist, neocapitalist, multinational capitalist, etc.) suggests, a clear picture of the present is not easy to come by, though all of these formulations imply that the classical conceptions of capitalism and modernism are not adequate to its description.[4] Whether this is the result of a historical or epistemological rupture and exactly when such a rupture may have occurred are important issues but lie beyond the scope of this essay. My assumption here is that the transition from modernism to postmodernism in American experimental theatre, especially in the role of politics in that theatre, occurred in the early 1970s, though it was anticipated in the late 1960s by, for example, Richard Foreman's early plays and some performance art.[5]

A fundamental aspect of postmodern culture may be the collapse of the distinction between the economic and cultural realms, the "breakdown in the old structural opposition of the cultural and economic in the simultaneous 'commodification' of the former and 'symbolization' of the latter" (H. Foster 1985: 145). As Fredric Jameson suggests, this breakdown is "to be imagined in terms of an explosion: a prodigious expansion of culture throughout the social realm" rather than a disintegration of the cultural (1984b: 87). This conflation of the cultural and the economic renders "critical distance" impossible – the cultural can no longer presume to stand back from the economic/political and comment on it from without. From one point of view, this situation presents an insurmountable problem, for without critical distance, critique seems to become impossible. We must be able, therefore, to conceive of postmodern culture not as a "closed and terrifying machine" against which "the impulses of negation and revolt, not to speak of those of social transformation, are increasingly perceived as vain and trivial" (Jameson 1984b: 57), but as "a conjuncture of practices, many adversarial, where the cultural is an arena in which active contestation is possible" (H. Foster 1985: 149).

Jameson and Foster part company to an extent over the exact historical status of this conception. Jameson feels that post-modernism (which he describes as "the cultural logic of late capitalism") has created such social – and even perceptual – confusion that the primary function of the postmodern political artist is a pedagogical one: to provide "cognitive maps" which will help us "to grasp our positioning as individual and collective subjects and regain a capacity to act and struggle" (1984b: 91). Foster, who does not use the term "postmodernism" extensively and who sees the present social formation as "a new conjuncture [of contesting forces] – not . . . a clear epistemic break" (1985: 152), does not stress the need for "cognitive mapping" prior to the identification of the adversarial practices which make up our culture. Foster suggests that the "transgressive" politics of avant-gardism presuppose cultural limits which are no longer relevant to the seemingly limit-less horizon of multinational capitalism, and calls for an understanding of political art as "resistant" rather than transgres-sive: "the political artist today might be urged not to represent given representations and generic forms but to investigate the processes and apparatuses which control them" (1985: 153). This investigation must take place within the terms of the postmodern cultural formation: "we are within the culture of postmodernism to the point where its facile repudiation is as impossible as any equally facile celebration of it is complacent and corrupt" (Jameson 1984a: 63). As Foster emphasizes, the transition from transgression to resistance is not merely a theoretical proposition – one can see it clearly in the visual arts in the development from the programmatic avant-gardes of the 1920s to the "cool" demeanor of Pop Art to the deconstructive experiments of today. A similar transition can be traced in theatre from the workers' and agit-prop theatres of the 1920s and 1930s to the communitarian radical theatre troupes of the 1960s to the postmodernism exemplified by Robert Wilson, Richard Foreman, the Wooster Group, and so on. This is not to suggest that all postmodern art or theatre is culturally resistant; as Foster notes, "a postmodern of resistance . . . arises as a counter-practice not only to the official culture of modernism but also to the 'false norma-tivity' of a reactionary postmodernism" (1983: xii).

Foster also suggests that a resistant political/aesthetic practice might work to reveal the counterhegemonic tendencies within the dominant discourse (i.e., the underdogs amongst adversarial cultural practices) and even to propose a vision of "the utopian or, better, the desired" along with a deconstruction of the processes of

cultural control (1985: 179). Foster's suggested strategies do not exclude Jameson's notion of cognitive mapping; taken together, their theorizing suggests a comprehensive view of the role of the political artist in postmodern culture, a role which incorporates the functions of positioning the subject within dominant discourses and of offering strategies of counterhegemonic resistance by exposing processes of cultural control and emphasizing the traces of nonhegemonic discourses within the dominant without claiming to transcend its terms. This formulation resembles Derrida's call for "A new writing [to] weave and interlace . . . two motifs of deconstruction"; his definitions of those motifs and of caveats associated with them are instructive in this context. The deconstructive options are:

a. To attempt an exit and a deconstruction without changing terrain, by repeating what is implicit in the founding concepts and the original problematic, by using against the edifice the instruments or stones available in the house Here, one risks ceaselessly confirming, consolidating . . . at an always more certain depth, that which one allegedly deconstructs.
b. To decide to change terrain, in a discontinuous and irruptive fashion, by brutally placing oneself outside, and by affirming an absolute break and difference . . . such a displacement can be caught [in "forms of *trompe l'oeil* perspective"], thereby inhabiting more naïvely and more strictly than ever the inside one declares one has deserted.

(Derrida 1982: 135)

Derrida's second problem is theoretically less exigent for Jameson's and Foster's respective theorizations of the postmodern than for deconstruction *per se*, for neither claims that postmodernist political art can place itself outside dominant cultural formations. The danger which Derrida underlines, that of simply restating the original formation rather than mounting a genuine critique of it, is, however, endemic to the kinds of practices Jameson and Foster describe, as we shall see in my discussion of the Wooster Group's *LSD*. But before offering an analysis of that production, I would like to examine the problematic which theatre theorists and practitioners must confront in reconceiving political theatre after the 1960s as resistant rather than transgressive.

THE PROBLEMATICS OF PRESENCE

Joseph Chaikin's *The Presence of the Actor* (1972), along with much theoretical and quasi-theoretical writing on theatre of that period, suggests that the actor's presence before the audience is the essence of theatre and that the use any particular theatre makes of that presence defines its ideology.[6] In theatrical parlance, *presence* usually refers either to the relationship between actor and audience – the actor as manifestation before an audience – or more specifically to the actor's psychophysical attractiveness to the audience, a concept related to that of *charisma*. As I discussed in Chapter 3, concepts of presence are grounded in notions of actorly representation – presence is often thought to derive from the actor's embodiment of, or even possession by,[7] the character defined in a play text, from the (re)presentation of self through the mediation of character, or, in the Artaudian/Grotowskian/Beckian line of thought (the "holy" theatre discussed in Chapter 2), from the archetypal psychic impulses accessible through the actor's physicality. The assumption behind much of the experimental theatre and performance of the 1960s (really the period from about 1964 to about 1974) was that because the presence of the actor as one living human being before others is spiritually and psychologically liberating, pure presentation of performer to audience is the best means available to the theatre to make a radical spiritual/political statement. This assumption no longer seems tenable in light of the suspicion that has been cast upon the whole notion of presence, a suspicion which derives from the apparent collusion between political structures of authority and the persuasive power of presence.

The 1960s was a difficult decade for the American theatre. "Establishment," professional theatre could say little about what was going on around it, and even radical theatre movements had trouble competing with the theatre of the streets. Additionally, as the Living Theatre was forced to admit at Avignon in 1968, radical theatre supported, willy-nilly, authoritarian social systems by generally participating in the structure of theatre as an institution. Even more disturbing was the growing tendency to see political reality as theatre: "spectacle managers" from all points on the ideological spectrum staged rallies and demonstrations; "guerrilla theatre" events were designed in many cases to be indistinguishable from spontaneous behavior. To an important extent, the ideological battle became a battle for control of the means of persuasion. As in Genet's *Balcony*, the revolution succeeded in

changing the imagistic content of life-as-theatre for a while, but retained its essential dramaturgy.[8] Those radicals who believed that the point of the upheaval was to substitute "peace scenarios" for repressive ones (Baxandall 1969: 62) failed to see that to adopt the concept "scenario" is to construct the new ideology on the corner-stone of the old.

The manipulation of opinion through performance and the blur-ring of distinctions between theatre and reality during the Viet Nam and Watergate periods contributed to the discrediting of theatre as a potentially radical art form. That Abbie Hoffman and Richard Nixon seemed to have fundamentally the same ideas about the manipulation of presence led to a growing suspicion that to invoke the power of presence is to link oneself inextricably with the workings of a repressive status quo. In a thoughtful essay, Canadian artist Vera Frenkel cites a psychoanalytical definition of charisma as "projection . . . by which we attribute to others, espe-cially a leader, entertainer or artist the secret images within ourselves" (1981: 37). She goes on to state that postmodern perfor-mance seeks to escape presence by working against mutual projection between audience and performer and toward "a non-charismatic understanding which permits us not to believe so readily in the other as the keeper of our treasure and our disease" (1981: 38). By undermining her own presence, the performer seeks to escape identification as the Other and the power relations implied by that identification. Frenkel's central examples – Joseph Beuys's performance art and Hans Jürgen Syberberg's film *Hitler, A Film From Germany* (1979) – are both rooted in the experimental arts of the 1960s. Both also respond, however, to Hitler's manipulation of presence and projection for authoritarian ends.

The suspicion of presence and of simple presentation of performer to audience that suffuses postmodern experimental theatre derives, then, from the anxiety created by historical demonstrations of collusion between presence as charisma or salesmanship and repressive power structures. In theatre, presence is the matrix of power; the postmodern theatre of resistance must therefore both expose the collusion of presence with authority and resist such collusion by refusing to establish itself as the charis-matic Other. Bertolt Brecht's theory and practice are exemplary in this regard but, as I showed in Chapter 3, Brecht's formulation of the need to maintain a distance between actor and character in performance depend on a traditional notion of presence to the extent that the actor's persona as commentator on the character

must be invested with the authority of presence in order for that commentary to carry more weight than the character itself. There is much a postmodern political theatre can learn from Brecht, but such a theatre must also move beyond Brecht, for whom the transgression of the conventions of bourgeois theatre remains to the point. (I will return to the question of post-Brechtian, postmodernist political theatre in my discussion of Augusto Boal in Chapter 9.)

LSD FROM *THE CRUCIBLE*

A full description and performance history of the Wooster Group's production *LSD* (. . . *Just the High Points* . . .) are available elsewhere (Aronson 1985); my purpose here is to examine the production in terms of the theoretical framework I have outlined by looking at the Wooster Group's investigation of the suppression of difference within cultural and political representations, the deconstruction of presence which enables that investigation to avoid merely restating the images and structure it evokes, and, finally, the Wooster Group's appropriation of Arthur Miller's *The Crucible* in its own performance text.

The Wooster Group's manipulation of iconography in *LSD* reasserted the workings of difference suppressed by dominant cultural codes primarily through an examination of racial and sexual representation in *The Crucible*. As Arnold Aronson indicates, the representation of blacks by whites is the issue raised by the Wooster Group's use of blackface to present the character of Tituba. He argues, however, that when the actress who plays Tituba goes on, still in blackface, to play Mary Warren, "the sign becomes separated from its object" (1985: 76), leaving the audience to impose its own interpretive schema on the displacement. I would argue that it is precisely at this moment of the emptying of the sign that the gesture becomes political, for it is when the arbitrary character of the sign is asserted that the significance of its imposition on one group by another stands out most clearly. In their earlier production of *Route 1 & 9* (1981–2), the Wooster Group had performed Pigmeat Markham comedy routines and danced to "soul" music in blackface, allegedly causing the New York State Council on the Arts to revoke their grant for a year (Aronson 1985: 67). However one reads the Wooster Group's gesture, as satirical, deconstructive, or racist, it clearly raised the question of what constitutes a potentially counterhegemonic appropriation of an image, and what merely restates that image.

Just as *LSD* articulated questions about the representation of racial difference, so it explored the representation of sexual difference. *LSD* points out some of the perhaps not so subtle sexism in Miller's play. Miller characterizes Abigail as essentially cynical (threatened with exposure, she absconds with money and vanishes, only to reappear, Miller tells us in the published text, as a Boston prostitute [1959: 140]). Given this portrait, the play is unable to represent the persecution of "witches" as the effort of a patriarchal society to suppress independent women.[9] By juxtaposing sections of *The Crucible* with materials related to Timothy Leary and his place in the history of the 1960s, the Wooster Group somewhat recuperated this interpretive possibility through an implicit comparison of the persecution of Abigail and her followers with that of Leary and his (i.e., Abigail appears as visionary rather than as cynic). The use of male and female iconography in *LSD* addresses similar questions of gender representation. Director Elizabeth LeCompte chose to have the men in the production wear contemporary dress while the women dressed in period costumes appropriate to the Salem locale of *The Crucible*. The men often spoke through microphones, while the women did not. (LeCompte: "The women got the costumes, the men got the mics" [quoted in Aronson 1985: 72].) This assignment of the trappings of (the [literal] voice of) authority to the men and those of a historical domesticity to the women occupies another uncomfortable space, neither clearly sexist nor clearly deconstructive. This distribution of means can be discussed in terms of the Wooster Group's analysis of theatrical signification: in a sort of dispersal of theatrical sign functions, the men received the sign of oral, textual signification, the women that of visual, pictorial signification. But there is still much to unpack in the association of the male with the text, the traditional locus of authority in theatre, and the female with the image, the "secondary" elaboration of text in production. The final image of *The Crucible* section of *LSD*, an image of women "dancing" produced by having the men sit and dangle their legs behind the women, who were standing on a higher level, though visually exciting and very funny, was similarly disturbing. The image of the dancing doll-woman powered by male legs and the assignment of the "work" of dancing to the men while the women stood and posed again may or may not have succeeded as deconstruction. Clearly, the Wooster Group's manipulations of loaded iconography ran the risk of "confirming . . . at an always more certain depth, that which one allegedly deconstructs" described by Derrida. This risk

is mitigated, however, by the Wooster Group's deconstruction of presence, which enables the performers to eschew charismatic projection, and thus discourages the spectator from endowing either representation or representor with authority, and encourages the spectator to focus instead on the process of representation itself and its collusion with authority.

In modern, Western theatre, the question of presence cannot be separated from that of the authority of the text – the actor's presence is conventionally defined in relationship to character, which in turn is delineated by the dramatic text. The ideological effectiveness of presence, however, requires that the authority of the text be conferred on the actor; the authorizing text itself must disappear behind the performance. The Wooster Group employed various types of reading in *LSD*, thus asserting its grounding in text (Fuchs 1984: 51–3; see also Fuchs 1985). In the first segment, actors read random selections from texts relevant to Timothy Leary; in the second part, they read scenes from *The Crucible* while seated at the same long, narrow table used in the first section. In the first scene, the actors appeared to be reading "as themselves" while, in the second, they invoked a degree of characterization through vocal inflection, gesture, and so on. Character thus became a problematic, not a given: is there a distinction between reading someone else's words when those words purport to record the author's own experience, and reading someone else's words when those words purport to create the illusion of a fictional character's present experience? (As I noted in Chapter 4, the same problematic was broached in the Wooster Group's *Hula*, albeit in a different way.) Reading's reading; a text's a text. The text, which is supposed to disappear, remained stubbornly, physically present, its pages cluttering the set. By asserting their dependence on text yet radically problematizing their relationship to it, the Wooster Group dissected the major structure of authority in traditional theatre. It was a question not of declaring, with Artaud (1964), "No more masterpieces"; but of simultaneously occupying and resisting the given structure of textual authority.

The Wooster Group's resistance of presence was also manifested in its acting strategies. Of the two kinds of reading mentioned, the second, reading from the script, seems closer to "acting" than the other, reading from non-theatrical texts. But when performance's origins in textuality are not effaced, it becomes difficult to make such a distinction. The actors made no clearly greater investment of self in one procedure than the other; in both cases, they were liter-

ally "on book": the text had not been internalized. Additionally, signs of emotional commitment in acting were distanced and demystified. I already discussed Willem Dafoe's use of glycerin to depict John Proctor's break-down in Chapter 4. Another example would be Ron Vawter's reading/playing of Reverend Parris. Vawter spoke his lines at breakneck speed, substituted gibberish for many of them, yet "played" the emotions behind them through gesture, facial expression, vocal inflection, and so on. While Dafoe adhered to the text, he created its externalizations artificially; Vawter, who seemed to produce emotion from within himself, garbled the text. Vawter's performance as the ideologue who speaks gibberish persuasively became a set piece, a pointed, if unsubtle, mini-satire of presence and its collusion with authority. (It should be clear that the concept of noncharismatic performance I am advancing here does not stipulate that performance must be uninteresting or unengaging. On the contrary; what is at stake is a critique of presence in which the charismatic performance is accompanied by its own deconstruction.)

These performance strategies were recapitulated at a greater level of complexity in the third section of *LSD*, a minutely accurate re-creation of the Wooster Group members' behavior while trying to rehearse its reading of *The Crucible* after having taken LSD. Ironically, this most conventionally mimetic section of the piece may have done the most to decenter the audience's relationship to the production. The actors played themselves reading characters from *The Crucible*, already a dispersion of the conventional concept of self in Western acting. The use of the hallucinogen widened the gap between the actors playing themselves and the selves they were playing. Because they had used the drug, the actors were unable to retrieve their own experience for use in the scene – their behavior while using LSD was videotaped and the scene was a re-creation of the experience, unavailable to the actors themselves, as mediated by the taping. The actors' mimetic presentation of what had been their own reality was in fact grounded in a second-hand, textual record of an experience whose very nature made re-creation at first hand impossible. The audience was thus deprived of the ability to assume it could read the imprint of the actor's self back through her performance; this blurring of identity nullified the possibility of charismatic projection.

The actor's disinvestment of self in this kind of performing, especially in the context of post-war American theatre and its affection for confessional, "method" acting, raises the specter of

formalism; recall that Dafoe makes little distinction between his working method in Wooster Group productions and his approach to film acting, both of which he describes as being more about the actor's relationship to the process than to character. Indeed, the seeming ease with which the post-1960s generation of American theatre experimentalists has adapted itself to the demands of commercial film and television may seem disturbing; certainly, the ability to move back and forth fluidly between commercial and political/aesthetic performance was not considered a worthy objective by the sixties generation. This is not to suggest that theatrical experimentalists of that decade did not participate in commercial projects, but only that the current generation clearly no longer feels the need to justify such work on the grounds that it makes other, politically subversive, work possible. (*LSD* in fact includes a film of Ron Vawter in Miami which can be construed as a memento of his participation in an episode of the *Miami Vice* television program.) From a postmodernist point of view, this adaptability is arguably symptomatic of a healthy lack of distinction between high and popular art in postmodern culture; from the perspective of a more traditional analysis of political art, it could be seen as implying an alarming lack of integrity on the part of young experimental artists. Certainly, the phenomenon raises the question of whether or not the avant-garde or political artist need claim to take up a position outside of the dominant discourse; my argument here suggests that such a claim has no clear utility under postmodernism. In order to address a conception of culture as a conjuncture of adversarial cultural practices, the artist must position herself among those practices.

The thematic terrain of *LSD* is broad and far-reaching. The performance juxtaposed a number of kinds of historical documentation. The testimonial writings of the first section (first- and third-person accounts of and by the Beat generation and Leary's circle) preceded *The Crucible* section. *The Crucible*, of course, is partly about the nature of false testimony, and so immediately problematized the material preceding it. Miller's play is itself a metaphorical historical document of the McCarthy era (see Miller 1978); the Wooster Group played dangerously with Miller's metaphor by staging parts of his play as if it were a Senate hearing, with the actors seated at the table, speaking into microphones, pushing papers, consulting one another before answering. This staging made explicit Miller's implicit metaphoric strategy and held it up for examination. The Wooster Group also conducted its

own research, tape-recording interviews with Ann Rower, once employed by Leary as a babysitter. During the performance, actress Nancy Reilly listened to the tape on headphones and repeated lines from it. The articulation of these many documentary forms through the varieties of acting/reading/performing already discussed raised questions about the nature of both the materials themselves and their (re)presentation. Is the babysitter's informal spoken testimony more dependable than the "official" (for-the-public) writings presented in the first section? Are there meaningful differences between the performers' *reading* in the first section, *reading/acting* in the second (*Crucible*) section, *acting/reading* in the third (*Crucible* on LSD) section, and Reilly's act of *repeating*? What the production ultimately demonstrated was the eradication of difference amongst these many types of messages and articulations – written and spoken, "factual" and "fictional," "literal," and "metaphoric," public and private – through the mediation of performance.

This effect was compounded and projected onto a specifically social plane by the inclusion in the final section of quotations from the public debates between Leary and G. Gordon Liddy. History contracts, vertiginously: Liddy, one-time Watergate "plumber" in the service of President Richard Nixon who, as a Congressman, was a central figure in the House Un-American Activities Committee hearings referred to metaphorically in *The Crucible* (see Goldman 1960: 132, 135), ends up teamed with Leary in a traveling road show debate. Needless to say, Leary, Liddy, and Nixon all wrote or have written books and made the rounds of televised "talk" and "magazine" shows, while Liddy is the host of a talk radio show. The telescoping of historical discourses and performance mediations in *LSD* becomes a figure for what Jean Baudrillard calls the "mediatization" of politics in contemporary society, which has broken down the distinctions between political and purely social activities: "if, thanks to the media, the political re-emerges under the category of *faits divers*, thanks to the same media the category of *faits divers* has totally invaded politics" (Baudrillard 1981: 175). This eradication of difference, by effectively neutralizing the political ("the media . . . are in deliberate pursuit of the political act, in order to depoliticize it" [1981: 175]), abets the dominant ideology, which, Baudrillard argues, is "homogeneous with the general form of the mass media" (1981: 174). Thus, ideological distinctions, if any, amongst Leary, Liddy, and the shadow figure of Nixon disappear under mediatization, as do distinctions amongst their various crimes against state and citizenry and their respective punishments

(or lack thereof). Baudrillard's vision is the dark underside of Jameson's notion of "a prodigious expansion of culture throughout the social realm." For Baudrillard, the incursion of the cultural into the social has destroyed the possibility of a cultural critique of the social; for Jameson and Foster, the same condition has revitalized the possibility of such a critique. In Baudrillard's terms, the glut of "information" produced by our seeming willingness to accept anything as grist for the mediatizing mill "devours its own contents": "Instead of causing communication, *it exhausts itself in the act* of staging the communication; instead of producing meaning, it exhausts itself in the staging of meaning" (1983: 97–8, original emphasis). We are left with the stagings: Liddy and Leary's hollow spectacle of a debate, presented on college campuses and documented on film; Liddy playing a parody of the persona described in his book *Will* (1981) on television's *Miami Vice*. (That members of New York's experimental performance community, rock stars, and political figures have all taken "guest villain" roles on *Miami Vice* suggests a cultural leveling of dizzying dimensions!)

That the Wooster Group does not stand apart from mediatization and the resulting commodification of political action and rhetoric is clear from Dafoe's and Vawter's participation in mass-cultural forms. *LSD* demonstrates the workings of mediatization, but is also caught up in them. The production makes no attempt to assess the truth value of any one documentation over any other, any mode of presentation over any other: the production is as much a symptom of information's self-consumption as an analysis of it. The Wooster Group's deconstruction of presence, however, makes its presentation self-conscious enough to resist the numbing effect of mediatization as described by Baudrillard and to work somewhat as Jameson's postmodern political art by making clear that if we are to position ourselves politically, we must be prepared to contend with the commodification of politics which levels discourse and masks difference, and the mediatization by which the dominant ideology nullifies the counterhegemonic.

I have tried to suggest that the Wooster Group's *LSD (. . . Just the High Points . . .)* represents at least a preliminary step toward a postmodern political theatre. Such a theatre of resistance "investigates the processes which control [given representations]" (H. Foster 1985) through its examination of iconography and the effects of mediation on political imagings, and operates within the terms of postmodern culture conceived as a conjuncture of adversarial practices and discourses. *LSD*, with its many layers and types of

discourse, can be seen as an image of culture conceived "as an arena of contestation" (H. Foster 1985); arguably, it may be said to serve the pedagogical function described by Jameson by encouraging a mode of perception that will enable the spectator to make sense of the dislocating postmodern sensorium. If this theatre is less programmatic than more traditional models of political theatre, if it seems to ask as many questions as it answers, it may be well to bear in mind that "clearly this is not a 'confrontational' moment in the classical political sense" (H. Foster 1985: 153) and, paraphrasing Hal Foster, to describe the Wooster Group as "a theatre with a politic" rather than a "political theatre" (1985: 155).[10]

The Wooster Group came closest to the confrontational, transgressive stance of the historical avant-garde in its appropriation of Miller's play, which led to a quasi-legal skirmish between author and theatre. The details of Miller's maneuverings with the Wooster Group are available in an article by David Savran (1985); suffice it here to say that Miller found the Wooster Group's use of his text objectionable and obtained a "cease and desist" order against them, closing the production in January of 1985. In constructing their performance texts, the Wooster Group seems to assume a poststructuralist idea of textuality like that advanced by Barthes, for whom a text is "a multi-dimensional space in which a variety of writings, none of them original, blend and clash. The text is a tissue of quotations drawn from the innumerable centres of culture" (1977: 146). This formulation creates obvious problems for the legal concept of text as property upon which Miller based his claim. If the text is made up of quotations to begin with, if it arises in some sense from the culture itself and not from the idiosyncratic mind of the writer (who must therefore be described as "scriptor" rather than as "author" [Barthes 1977: 147]), what right of ownership may that writer assert over it? To posit a distinction between the issue of textual interpretation and that of legal entitlement as does Savran (1985: 101) [11] is to miss the point, not only because the law is itself always a matter of interpretation (Dworkin 1983), but also because the theatre is precisely a locus at which critical/aesthetic and social practices intersect. What distinguishes the Wooster Group's appropriation from a confrontational, avant-gardistic gesture is its unintentional character. LeCompte correctly describes the conflict with Miller as "an inevitable outcome of our working process" and as a part of the Wooster Group's "necessary relationship to authority" (quoted in Savran 1985: 39);[12] confrontation with authority is a *result*, but not the *object*, of the Wooster Group's

process. The Wooster Group seems blithely, perhaps utopianly, to proceed as if the poststructuralist critical/theoretical concept of text as "a tissue of quotations" belonging more to a culture than an individual were already in place as part of the social hegemony. The effect of the Wooster Group's action is not so much to question Miller's rights over his text as to show what would be possible in the realm of cultural production if those rights were not in force, thus emphasizing the importance of the connection between the cultural and the social/political. *LSD* can therefore be seen as an example of the dual writing described by Derrida, which both uses "against the edifice the . . . stones available in the house" and opens a window in the wall of the house to provide a glimpse of what lies beyond it.

7 Embodiment

The politics of postmodern dance

[T]he new political art – if it is indeed possible at all – will have to hold to the truth of postmodernism, that is to say, to its fundamental object – the world space of multinational capital – at the same time at which it achieves a breakthrough to some as yet unimaginable new mode of representing this last, in which we may again begin to grasp our positioning as individual and collective subjects and regain a capacity to act and struggle which is at present neutralized by our spatial as well as our social confusion.

Fredric Jameson, "Postmodernism or the Cultural Logic of Late Capitalism"

In her book, *Reading Dancing: Bodies and Subjects in Contemporary American Dance*, Susan Leigh Foster writes against the grain of a theoretical tradition which, like some of the theories of acting discussed in the first two chapters, sees the performing body as an originary presence, foundation for an autonomous physical language. Foster describes the theory of twentieth-century American concert dance as deriving from the belief that dance is

the most appropriate medium of expression for primal, emotional, and libidinal dimensions of human experience. Dance is seen as an outlet for intuitive or unconscious feelings inaccessible to verbal (intellectual) expression. Based on this model, dancers often cultivate a sanctimonious mutism, denying what is verbal, logical and discursive in order to champion the physical and the sensate.

(S. Foster 1986: xiv–xv)

Because it can ostensibly restore us to a "natural" physical condition, dance is imagined in this theoretical tradition "as a medium that can return us to vital energy and an unalienated sense of wholeness" (S. Foster 1986: xvi). The result of this theorization is to mystify the processes of making and performing

dance, to render dance "unspeakable" (1986: xvi), inaccessible to discursive analysis.

Foster's project is to reconceive contemporary American concert dance as a socially encoded discursive practice by treating the danced image as sign (in the [post]structuralist sense) and by "'de-naturalizing' our notion of the self and our assumptions about the body" (1986: 237, n. 3).[1] Although *Reading Dancing* is neither explic-itly about postmodernism nor explicitly about political art practices, it grapples implicitly with the thorny question of what sorts of political art practice are viable within postmodern culture. In "The Signifying Body: Reaction and Resistance in Postmodern Dance," an article published before the full-length study, Foster deals directly with the issue of which postmodern dance practices explore and expose "the politics of representation" (1985: 47), and which are complicit with hegemonic representations. Read in conjunction with the earlier text, *Reading Dancing* can be seen as an exposition of the theoretico-historical narrative grounding and justifying Foster's view of the politics of postmodern dance.[2]

Although Foster does not present a theory of postmodern culture *per se*, the structure of her historical account of contemporary American concert dance clearly postulates that postmodern dance emanates from a choreographic *episteme* radically different from those governing the other forms of dance she discusses. In order to theorize dancing as text, Foster clusters the four "master" tropes of rhetoric with modes of representation and examples of contempo-rary American and earlier choreographies (see Table 7.1). In Foster's argument, these clusters become paradigms for different kinds of danced representation, paradigms which are transhistor-ical in the sense that any of the four types of representation may appear in the dance of any Western culture at any moment in history since the Renaissance.[3]

In her discussion of postmodern dance, Foster posits the exis-tence of a fifth paradigm, "reflexive choreography," which deconstructs the "objectivist" approach to movement associated with Merce Cunningham "to show the body's capacity to both speak and be spoken through in many different languages" (1986: 188). To suggest that the postmodern needs to be accounted for in terms of an *episteme* different from the four master tropes which efficaciously account for danced representation since the Renaissance is to suggest an epistemological rupture of historical significance at the origin of the postmodern. This fifth paradigm comes to occupy a privileged position in Foster's narrative as the

Table 7.1

Literary trope	Choreographic mode of representation	Contemporary choreographic example	Historical examples
Metaphor	Resemblance	Hay	Late Renaissance European court spectacles (1530–1650)
Metonymy	Imitation	Balanchine	Neoclassical proscenium theatre ballets (1680–1760)
Synecdoche	Replication	Graham	American expressionist modern dance (1890–1950)
Irony	Reflection	Cunningham	Contemporary, postexpressionist experimental dance (1950–present)

Source: Foster (1986: 236)

Beyond of the history of dance, unrepresentable by any of its paradigmatic tropes. Postmodern dance is at once outside that history and superior to it, governed by a choreographic *episteme* which is the condition of possibility for dance practices that can, simply, do more (or permit more to be done) than the others.

Whereas the chapters devoted to the exposition of Foster's four paradigms are entitled "Reading Dance," "Reading Choreography," and "Readings in Dance's History," the chapter devoted to the postmodern bears the title "Writing Dancing." The verbs in these titles refer to the activity of the spectator with respect to the dance: as spectator, I can only read the history and practice of dance written under the four paradigmatic tropes of representation; I cannot intervene in them. Under the fifth paradigm, I participate in the writing of the dance. Using Barthes's distinction between "readerly" and "writerly" texts, Foster argues that the postmodern choreographic *episteme* includes the spectator as an equal partner in the composition of the dance; I become "a relatively immobile ... performer" (1985: 61; 1986: 224) actively

engaged in writing dancing rather than a passive spectator reading someone else's "dance."[4]

It is with the introduction of this fifth paradigm that politics, indeed a social vision, enters Foster's discourse, for questions of who or what is speaking through the body and in what language, of what discourses are inscribed on/in the body, are clearly questions of power relations of the sort excavated by Michel Foucault. One of the political values of reflexivity in postmodern dance is precisely that it raises such questions by engendering a dance practice which "undertak[es] a sustained and systematic examination of its own production [and . . .] offers an ongoing inquiry into the implications of any choice of form" (1985: 47). Hierarchies of representation are thus denatured: reflexive dancing "divests the [performing] subject of any sovereign claims over the body" (1986: 220); the spectator, as much as the dancer or choreographer, speaks and is spoken through the performing body. "This methodology privileges working together, patience, alertness, the willingness to negotiate and the ability to play around with things" (1985: 62; 1986: 223) and "promote[s] a more democratic distribution of power amongst all subjects and bodies" (1985: 48).

Not all reflexive dance fulfills this democratic program, however; Susan Foster agrees with Hal Foster that there are two postmodernisms, one politically resistant, the other reactionary.[5] Whereas resistant postmodernist art is concerned, in Yvonne Rainer's phrase, with "the simultaneous representation of fictions and the fiction of representation" (quoted in S. Foster 1985: 46), reactionary postmodernism merely "mines the forms of the past for their nostalgic and novel impact" (1985: 47), producing, as Hal Foster suggests, a new metafiction, a return to, not a critique of, origins (1983: xii). For Susan Foster, the work of the Grand Union and of Meredith Monk are exemplary of resistant postmodern dancing, while Twyla Tharp's choreography exemplifies reactionary postmodern dance. The particular artistic strategies she describes as resistant include: the assertion and disruption of a linear narrative; the aforementioned refusal of mastery over the body; the engagement of the audience in the process of composition through the dancers' gaze; the "situat[ing] of dance as one discourse among many" and its consequent deprivileging through intermedial approaches (1985: 61); and metacommentary on the dancing itself which provides the spectators with a method for seeing "how, ultimately, all interpretations, including their own, would be woven together in one collective fabric" (1985: 62; 1986: 223). This description is of the

Grand Union; particularly attractive to Foster in Monk's work is the use of ritual structures which also create a "collectivizing impulse" by referring to "a larger context of which the performers and viewers form but a small part" (1985: 62–3; 1986: 223). These strategies enable the Grand Union and Monk to "fulfill the radical promise of postmodernist art" (1985: 47).

Tharp's work is marked as reactionary because it maintains a distance from the spectator (the dancers' gaze is used to draw attention to their own technical mastery, not to commune with the audience (1985: 61)), and because its version of narrative disruption "allows viewers one last reverie" (1985: 52; 1986: 219), but ultimately reifies the cultural images it manipulates (e.g., the traditional male and female roles imaged in ballroom dance). Tharp uses disruptive strategies as ornament: "the eclectic vocabulary, ingenious parody and disaffected style – poke fun at dance traditions without actually commenting on the dances in which they occur" (1985: 52; 1986: 219). Because Tharp's metacommentary never turns in on itself, her "dances deny the viewer access to their own workings. They present the choreographic process for consumption rather than for collaboration" (1985: 52; 1986: 220).

An understanding of Foster's communitarian view of resistant postmodern dance practice provides a vantage point from which awkward moments in her theory and her readings of dance's history in *Reading Dancing* can be seen as strategically necessary to her argument. Her theory of representation is uncertain at points where it must account for the relationship between dance as representation and the objects that dance represents. Such phrases as "worldly events" and "worldly experience" (1986: 65) attempt to describe the latter, accompanied by a note explaining that "any given artistic event ... refers to itself as an artistic event and to the cultural and social circumstances of which it is a part" (1986: 245, n. 4). This grounding of representation in experience is not very satisfying; one can easily argue that an art event inevitably *refers* to cultural and social circumstances whether it *represents* them or not.

Another problematic moment in the theory is foregrounded in Foster's argument that a running dancer in one of Deborah Hay's pieces represents the act of running by reflecting it (1986: 70). Foster's definition of reflection includes the condition that "reflective representation makes exclusive reference to the performance of movement and only tangentially alludes to other events in the world" (1986: 66). The sum of these two propositions seems to be

that a dancer running in a Hay piece represents (through reflection) a dancer running in a Hay piece, a somewhat unwieldy formulation. Why not simply say that the dancer *is* a dancer running in a Hay piece rather than a sign for one?[6] I read these moments as strategic in Foster's effort to open a space for her politics within the discourse of dance. Rather than referring only to an aesthetic realm or representing inchoate, primal levels of human experience, dance takes its place as a representation of worldly (i.e., social) experience. Even dance actions which seem to have no referent beyond themselves are nevertheless representations, and therefore participate in the political economy of representation that is the object of resistant postmodern dancings' deconstructions. As text, such actions can also take up positions in narratives and can (potentially) be used as disruptive elements in them.

Foster's theory cannot allow for the possibility that there may be moments in dance at which representation does not occur, for such an allowance would admit the further possibility that dance can provide access to an originary, uncoded body and its "unspeakable" referents after all.[7] She quotes Raymond Williams's *Sociology of Culture* to the effect that "formal [artistic] innovation is a true and integral element of [social] changes themselves: an articulation, by technical discovery, of changes in consciousness which are themselves forms of consciousness of change" (S. Foster 1986: 244, n. 1). Dance which represents "worldly events" can change the shape of those events through innovation (e.g., reflexivity) in its own representational modes, innovation which both results from and contributes to changes in consciousness.

In a note on her own use of literary tropes, Foster defines metaphoric, metonymic, synecdochic, and ironic dance forms (1986: 235, n. 1). As described by Foster, these tropes fall into two categories, which I shall call "pure representation" and "ideological representation." In metaphoric dance, "the choreographer's task is to translate worldly events into movement, while the viewer's role is to find in the movement its allegorical significance." This type of representation is "pure" in the sense that it is imagined as sheer encoding which, in principle, is perfectly decipherable. In ironic dance, "the dance becomes another of the many activities that make up the world The choreographer, by focusing on the physical articulations of the body, may still express dramatic content, but this message will be one of several the viewer can choose." Ironic representation is less "pure" than metaphoric representation, but is still directly engaged with the world as it is. By contrast,

metonymic and synecdochic dance forms are ideological in that they seek to transform the world through representation. Metonymic dance "improves upon, as it replaces, the world to which it refers"; the choreographer of synecdochic dance "transform[s] personal experience into universal condition," perhaps the ideological gesture *par excellence*.

The tropes giving rise to pure representation are associated in Foster's account with choreographers who are historically on the edge of postmodernism, if not postmodernist (Hay and Cunningham),[8] and whose work employs strategies similar to those Foster valorizes as resistant in her discussion of the Grand Union and Meredith Monk: engagement of the spectator, polyvalence, deprivileging of dance as discourse and of the dancer as specialist. The tropes giving rise to ideological representation are associated with choreographers whose work does not share in the democratizing impulse valorized by Foster but emphasizes the hierarchical traits of technical mastery, rigid discipline, individual genius, and exhibition before a passive audience (Balanchine and Graham). These choreographers "'make the world over' into the image of the dance" (1986: 235, n. 1) and impose that image on the spectator through performances which maintain traditional distance and distinctions of function between dancer and spectator. Foster's taxonomy clearly sets the stage for postmodern choreographers who go "beyond" Hay and Cunningham to be identified as politically resistant, and for Tharp's work to be condemned as ideologically reactionary. In fact, Foster eventually inserts Tharp's work into a homological relationship with neoclassical ballet, and, thus, with the "ideological" trope of metonymy (1986: 222).

Foster's clustering of tropic and representational modes with examples of dance practice (in Table 7.1 above) discloses some improbable homologies, particularly that between the allegorical court dances of the late Renaissance and Deborah Hay's work as instances of metaphoric representation by resemblance. At first glance, nothing could seem less alike than Hay's democratic spirituality and her semimystical notion of "cellular consciousness," and the highly formalized, rigorously patterned, and literarily allegorical dances of the Renaissance court. Foster admits that

> the social and historical forces surrounding the two sets of performances could not be more dissimilar. Hay's avant-garde dances are located at the margins of power, whereas the court

dances were consummate achievements of the most powerful elite of Renaissance society.

(S. Foster 1986: 101)

Nevertheless, she argues that the choreographers of Renaissance court dances approached their work in much the same spirit as Hay approaches hers, and made similar demands of their dancers. Blurred distinctions between art and life, and between social dance and aesthetic performance, characterize both forms.

Foster states that the purpose of her historical inquiry is to "identify the historical specificity of meaning in dance" (1986: 100) by comparing dance forms which use the same representational mode at different historical moments. In practice, however, her method has a different result. In comparing Hay's work with Renaissance court dances, Foster remarks that "if one is to comprehend what it might have been like to choreograph, perform, and watch Renaissance dances, then it may be helpful or even necessary to enter into them, using a contemporary example like Hay as a guide" (1986: 102). This position denies historical specificity by suggesting that we can understand a past event through our greater understanding of a recent event despite the fact that the two events occur under radically different historical and social conditions.[9] In the following passage, in which she argues that Hay's "performances nevertheless come closest [of any contemporary dance forms] to approximating the grace of the Renaissance concerts," Foster removes the dances from their historical contexts and compares them on the basis of essentialistic, nonhistorically specific features:

Hay, through her idea of cellular consciousness, shows a concern like that of the Renaissance choreographers, with their theories of concinnity in and among bodies, to establish a genial rapport among all parts of the body and between the body and its surroundings. As a result, she might be said, like the Renaissance choreographers, to produce movement – fluid and sustained, deft and full – that avoids any excess or restraint. Performing such movement skillfully depends less on conforming the body to a particular shape at a given time than on accommodating one's own supple movement to that of others and to the features of the space itself. In this sense, dancers in Hay's concerts, like those who danced in the Renaissance performances, distinguish themselves not by displaying virtuoso skills but, instead, by exercising their sense of proportion and timeliness.

(S. Foster 1986: 118)

Foster privileges performance as a physical act embodying certain universal characteristics (grace, proportion, timeliness) over the historically specific significances of physical embodiments as representations. The action of the body becomes an absolute index to similarity: whatever "grace," "proportion," and "timeliness" meant in the Renaissance and whatever they mean today, to use one's body in accord with those principles then is analogous to doing so now.

Most interesting in the present context is the epistemological similarity Foster sees between Renaissance cosmology and Hay's idiosyncratic Taoism. Whereas the concept of human action as part of a divinely choreographed dance was built into the Renaissance *episteme*, "Hay must create her own mystical sense of a universal dance" (1986: 105). This epistemology underlies both the Renaissance choreographers' and Hay's use of "the mode of resemblance for representing the world in their dances . . . to articulate a graceful rapport between dancer and society and between human movements and the movement of the universe" (1986: 101). This vision of a "universal dance" is similar to the scene of commonality, of dancers and spectators (distinctions amongst whom are not rigidly defined) gaining an awareness of "a larger context of which [they] form but a small part" that Foster sees in the work of Meredith Monk. Foster also sees both Hay's and Monk's work as evoking the "sacred" (1986: 13; 1985: 60). In a sense, Foster's tropical pairing of Renaissance court choreographers with Deborah Hay can be read as recuperating Renaissance dance practice as a historical antecedent for resistant postmodern dancings by preserving the communitarian aspects of Renaissance dance while filtering out its hierarchical implications by associating it with Hay. Foster's reading of this episode in dance's history thus contributes to the adumbration of a narrative which culminates in the valorization of resistant postmodern dancings.

Foster claims that her formalist approach is "compatible with a feminist, sociological, or political analysis of dance" (1986: 244, n. 1). I have endeavored to show here that her work is already informed by a politics, that the argumentative structure of *Reading Dancing* is designed to make her positions on the politics of contemporary American concert dance – postmodern dance in particular – seem theoretically and historically inevitable. Her valorization of resistant postmodernist dance as a democratic undertaking which places the spectator on equal footing with the choreographer and dancer is sustained by a theoretico-historical narrative which suggests that postmodern dance springs from a choreographic

episteme which includes a place for the spectator that earlier chore-ographies did not, an *episteme* that is both the culmination and the Beyond of dance's history. Foster's communitarian vision of resis-tant postmodern dancing derives considerable argumentative force from her assertion that precisely the artistic strategies that make such work recognizably "postmodern" also make it collectivistic and democratic. I'm not sure that feminists, Marxists, and others concerned with the politics of particular social groups would find her democratic vision of postmodern dance appealing, for it implies that difference is subsumed by unity as the dance creates a community with its spectators. In any case, this vision is finally not viable as an idea of postmodern political art practice.

The crux of Foster's concept of political art can be glimpsed in her evaluation of Tharp's brand of reflexivity: "The dance pokes fun at its own conservative content, *but offers no alternative*, leaving the viewer caught in its double message" (1985: 63, my emphasis). Presumably, the alternative to such an alienating form of cultural production offered by resistant postmodern dancing is its "priv-ileg[ing] of working together, patience, alertness, the willingness to negotiate, and the ability to play around with things" that in turn generates a "collectivizing impulse." But *can* resistant postmodern art offer an "alternative" and remain resistant? Here, we must return to Hal Foster's terminology. Elaborating on the distinction he coined between "resistant" and "reactionary" postmodernism, Hal Foster introduces a third term, "transgressive" political art, which he associates with the modernist avant-garde: "avant garde connotes revolutionary transgression of social and cultural lines; resistance suggests immanent struggle within or behind them" (1985: 149). The project of the modernist avant-garde was to "posit a limit to cultural experience . . . beyond which lie 'the scandalous, the ugly, the impossible' (in a sense, the sacred)" (H. Foster 1985: 150). As argued in the previous chapter, the transgressive model of political art is inadequate to our current cultural formation; the limitless horizon of multinational capitalism seems to demand another strategy.

In calling for the expression of an aesthetico-political alternative in postmodern dance, Susan Foster inscribes her vision within the senescent modernist project. Her evocation of the ritualizing aspect of Monk's work, of performer and audience unified within a larger whole, her references in her article on postmodern dance to the Grand Union's "sacred play with images from popular culture" and Monk's "chart[ing of] the territory of sacred concerns" (1985:

60) all suggest that hers is indeed a vision of the transgression of cultural limits to a sacred Beyond. (In this respect, Foster's vision of postmodernist dance strongly recalls theories of "holy" theatre, which clearly belong to the modernist *episteme*.) This transgression, Foster implies, can heal traditional rifts in the name of a greater unity, rifts that are only widened by reactionary postmodern dance.

Hierarchical boundaries between the senses and between artistic disciplines are denaturalized by the Grand Union's work and Meredith Monk's; the same boundaries are tacitly reaffirmed in Tharp's choreography (1985: 61; 1986: 220–2). Whereas the Grand Union and Monk articulate a "nonhierarchical, nonorganic interaction between body and subject" (1985: 61; 1986: 221), Tharp resurrects that shibboleth of Western metaphysics, the mind/body problem, by separating the movements of the dancers' heads from those of their bodies (1985: 61). And whereas the historical choreographic homologs of postmodern dance practices employ "pure" representational modes which allow them to engage the world as it is, Tharp's choreography and its homologs enforce their remaking of the world through ideological representations. While Foster is by no means retreating to the traditional idea that dance somehow can "return us to an unalienated sense of wholeness," she is valorizing a practice which produces a sense of participation in a nonhierarchical, self-deconstructing whole which posits itself as an alternative to the alienating cultural hegemony. This formulation begins to sound like Hal Foster's reactionary postmodernism, "postmodernism conceived in therapeutic, not to say cosmetic, terms" (1983: xii).

The reason resistant (as opposed to transgressive) political art practices cannot propose, or function as, alternatives in Susan Foster's sense is that they must above all remain suspicious of all representation. As Jameson writes,

[T]he essential difference between post- and classical modernism [is that] the latter still lays claim to the place and function vacated by religion, still draws its resonance from a conviction that through the work of art some authentic vision of the world is immanently expressed. Syberberg's films are modernist in this classical, and what may now seem archaic, sense. Godard's are, however, resolutely postmodern in that they conceive of themselves as sheer text, as a process of production of representations that have no truth content, are in this sense, sheer surface or superficiality. It is this conviction which accounts for the

reflexivity of the Godard film, its resolution to use representation against itself to destroy the binding or absolute status of any representation.

(Jameson 1981: 112)

Resistant political art like Godard's is reflexive, but if it is "to destroy the binding or absolute status of any representation," it cannot hold out reflexivity as an access to truth. Susan Foster argues that the dancings of the Grand Union and Meredith Monk deconstruct social and cultural representations (e.g., popular culture, gender roles, subject/body relationships), but she does not call into question the truth-value of these dancings' claims to ritual and communal status, even though these claims are effects produced by the workings of signification within the performances. In Foster's account, the unexamined metafiction of communality ends up superseding the deconstructive aspect of the resistant work she analyzes. In a "pessimistic note" at the end of her 1985 text, Foster herself begins to see the problem inherent in her call for alternatives as she observes that the "resistive conventions" she describes have been coopted by merely "slick and fashionable" dance practices (1985: 64). As Dana Polan (1986) argues, even radical acts of disruption can be recouped by the hegemonic as spectacle.

A further critique of Foster's valorization of ritualizing representations as politically resistant also derives from Jameson, this time from his account of reflexivity in art:

It [complacency] is characteristic of the auto-referentiality which informs modern art, a pathology which results from the instability, the effacement often, of an institutional role for the artist in modern, or more specifically, capitalist society. Artists working in a social system which makes an institutional place for cultural production (the role of the bard or tribal storyteller, the icon-painter or producer of ecclesiastical images, even the roles foreseen by aristocratic or court patronage) were thereby freed from the necessity of justifying their works through excessive reflection on the artistic process itself. As the position of the artist becomes jeopardized, reflexivity increases, becomes an indispensable precondition for artistic production, particularly in vanguard or high-cultural works.

(Jameson 1981: 103)

Because I share Susan Foster's position that reflexivity seems to hold out the promise of being a valid strategy for postmodern political art, a strategy that may enable the artist to carry on the "immanent struggle within or behind" cultural lines described by Hal Foster, I would argue that the postmodern artist may be able to turn this pathology against the society that caused it. Jameson might agree. The passage just cited implies, however, that a genuinely ritualizing and communitarian art does not need to be self-reflexive; reflexivity is in fact a symptom of the very impossibility of ritual or communal art within a society which provides no institutional place for the artist. "The modernist aesthetic demands an organic community which it cannot, however, bring into being by itself but can only express" (Jameson 1981: 114). In the absence of such a community, the "collectivizing impulse" created by Monk's work, for example, can only be seen as a cosmetic disguising the artist's lack of authentic vocation in a late capitalist society. Prompted by Jameson's examples of societies which did provide the artist with such a vocation, we can think back to Susan Foster's recuperation of Renaissance court dance, a practice that runs contrary to her democratic vision in its hierarchical aspect, yet is entirely in accord with that vision in its aspect as communal ritual. In this light, Foster's reading of dance's history becomes nostalgic.

A genuinely resistant postmodern dance practice would undoubtedly be reflexive, but would find a way of remaining at the level of "sheer surface or superficiality" in order to "destroy the binding or absolute status of any representation" of bodies and subjects without slipping into the reification of those surfaces, as do Tharp's and other "slick and fashionable" practices. But reification may be inevitable; it is entirely possible that self-deconstruction becomes self-reification at some point (see Jameson 1981: 115). Until the new mode of representing "the world space of multinational capitalism" that Jameson evokes in the epigraph to this essay becomes possible, Hal Foster's notion of resistance is the best model we've got for a political art that can be effective within the terms of postmodern culture. The danger that this practice can turn into its opposite by reifying the representations it supposedly deconstructs is a danger that must be courted. At stake is the very possibility of political art under postmodernism.

Part III

Postmodern body politics

Part II

Postmodern body politics

8 Vito Acconci and the politics of the body in postmodern performance

As the last two chapters suggest, the question of whether there can be viable political art practices under postmodernism is a vexing one. To a great extent, the image of culture offered by the theory of postmodernism echoes that developed in poststructuralist theory. The term "postmodernism" designates "a culture that is utterly coded" in which artists may manipulate "old signs in a new logic" (H. Foster 1984 [1982]: 194) without hoping "to create new discourses out of our mere desire" (Russell 1980: 191), a culture that encodes both artistic discourses and their audiences, and is seemingly capable of absorbing any disruptive action into its economy of signs. As I indicated in Chapter 6, the postmodern political artist has no choice but to operate within the culture whose representations he or she must both recycle and critique. The awkward relationship between the desire for political activism and the acknowledgment that we cannot transcend the terms of our cultural context manifest in discussions of postmodern political art can also be seen in poststructuralist discourse on politics in general, a discourse that apparently can support political action only at highly localized, micropolitical levels (see, e.g., Arac 1986; Bové 1986; Lyotard and Thébaud 1985; Robbins 1986). Much of the most incisive political art, and the most articulate theory, of the 1980s emerged from such specific areas of investigation, especially from various feminist inquiries. All postmodern political art, however, whether micropolitical or global in aspiration, confronts the same issue: the problematic of representation. A postmodern political art cannot rely simply on the (re)presentation of a program, a critique, a desired utopia or perceived dystopia – it must interrogate the means of representation themselves as structures of authority "to question the assumption of truth in the protest poster, of realism in the documentary photograph, of collectivity in the street mural"

(H. Foster 1985: 143), and, by so doing, to expose the ideological discourses that both define and mediate between images and their receptors. The political artist can no longer demand "Paradise Now" without simultaneously examining the intersecting discourses that produced any particular image of paradise, and through which it is reproduced.

In performance, physical presence, the body itself, is the locus at which the workings of ideological codes are perhaps the most insidious and also the most difficult to analyze, for the performing body is always both a vehicle for representation and, simply, itself. Even in the most conventionally mimetic forms of modern Western theatre, the actor's body never fully becomes the character's body. As Herbert Blau puts it:

> In a very strict sense, it is the actor's mortality which is the actual subject [of any performance], for he is right there dying in front of your eyes Whatever he represents in the play, in the order of time he is representing nobody but himself. How could he? that's his body, doing time.
>
> (Blau 1982a: 134)

We can reiterate Blau's emphasis on the body's materiality without necessarily accepting his position that its mortality is the inevitable subject or content of all performance. The performing body is always doubly encoded – it is defined by the codes of a particular performance, but has always already been inscribed, in its material aspect, by social discourses (e.g., science, medicine, hygiene, law, etc.). Typically, modern performance theory has evaded this double encoding by focusing either on one set of codes or the other, either on the body as representation, as "the somatic support for a discursive logos," or on the body as an irreducibly originary presence, the instinctually charged "prime referent in an autonomous theatricality" thought to transcend the discursive (Krysinski 1981: 141, 143).

Each of these theorizations has a long history in the annals of modern performance theory: as discussed in Chapter 3, Constantin Stanislavski may have been the first to systematize the body's long-standing submission to *logos*, to "the unbroken line" of action derived from a dramatic text (1936: 238–9). Adolphe Appia, writing around the turn of the twentieth century, may be the progenitor of the other position. Whereas Stanislavski prompts the actor to explore her own emotions introspectively, Appia, like Copeau after him, exhorts the performer to achieve a neutral state, to "deperson-

alize," in order to allow the body to speak in its own language (1960: 54, 130; 1962: 41). Stanislavski's assumptions concerning the relationship between actor and text underlie most conventional Western theatre; theoretically, this current may culminate in the semiotics that sees the actor's body primarily as an iconic sign for the character's body.[1] The current initiated by Appia is that of the avant-garde, particularly of the "holy" theatre discussed in Chapter 2. As Wladimir Krysinski points out, the "autonomous theatricality" of Artaud and Grotowski is not "the simple rejection of psychological theater. On the contrary, autonomous theater should be examined as an evolution of psychological theater" (1981: 143). Indeed, one can already see a trace of the notion that the body is a site of autonomous expression in Stanislavski's assertion that the rational faculty must convince "our physical natures of the truth of what you are doing on the stage" (1936: 127) – for Stanislavski, as much as for Appia and his progeny, the body is the arbiter of truth.

These theorizations are also allied in a more important way – both want to derealize the performer's body, to make it disappear. The goal of psychological theatre is to make the actor's body disappear into the character's; the goal of autonomous theatre is, in Grotowski's words, to make the body vanish and burn in a flash of pure psychic apprehension (1968: 16; see also Chapters 2 and 3). If, as Michel Foucault and others have argued, a part of the object of social discourse is to discipline the body, to make it manageable, modern performance theory as a social discourse has managed the body by robbing it of its materiality, subjecting it to the discipline of text, whether the dramatic text or the text of archetypal psychic impulse. Although avant-gardist performance theory frequently claims to liberate the body and thus to challenge the social or political hegemony, it fails adequately to conceptualize this liberation by failing to see the body as ideologically produced. As Blau has written,

> There is nothing more coded than the body The ideological matter amounts to this: we are as much spoken as speaking, inhabited by our language as we speak, even when – as in the theatre of the 60s – we sometimes refused to speak, letting the bodies do it.
>
> (Blau 1983: 458)

The problem is not that modernist performance theorists, especially Grotowski, fail to acknowledge that the body is encoded by social discourses, but rather that they suggest that these codes are only an

overlay on the body, that there is an essential body that can short-circuit social discourses. This essential body is a metaphysical, even a mystical, concept: it is asocial, undifferentiated, raceless, genderless and, therefore, neutralized and quietist. The effect of these theorizations is to return the body to the disciplines of the social discourses they claim to circumvent.

In order to recover the possibility of seeing the performing body as an instrument of counterhegemonic artistic production, the history of the body in performance must be conceived as a part of the history of the body itself, a history understood as a study of how the body

> has been perceived, interpreted, and represented differently in different epochs, [of how] it has been lived differently, brought into being within widely dissimilar cultures, subjected to various technologies and means of control, and incorporated into different rhythms of production and consumption, pleasure and pain.
>
> (Gallagher and Laqueur 1987: vii)

A history, in short, of the body's materiality and of difference. The development of modern ideas of acting and performance was simultaneous with the transformation of the "representations and routines of the body ... during the late eighteenth and early nineteenth centuries ... transformations [which] were linked to the emergence of modern social organizations" (Gallagher and Laqueur 1987: vii). And just as "twentieth century thinkers have not really taken up a position outside the nineteenth century's discourses of the body and sexuality" (Gallagher and Laqueur 1987: xv), so contemporary performance theory has not escaped the terms of the modern discourse initiated by, say, Diderot's *Paradoxe sur le comédien* of c. 1773.[2]

If the modern body can be shown to have been produced by the ideological discourses of the late eighteenth and early nineteenth centuries, discourses only recently made visible by contemporary scholarship, the "postmodern body" is the body actively and currently conceived of as produced by ideological encodings, which it cannot simply transcend. In the remainder of this essay, I would like to suggest that the body in some postmodern performance can be understood as a body that exposes the ideological discourses producing it, through performance that insists on the body's status as a historical and cultural construct and that asserts the body's materiality. I will use selections from Vito Acconci's "body art" of the early 1970s as my examples. In choosing Acconci,

whose work was contemporaneous with work such as Grotowski's, which I have already described as modernist, I am suggesting, like Fried, that the distinction between a modernist and a postmodernist artist is an epistemological, not a historical, difference. Grotowski's and Acconci's ideas about the performing body can be seen as different responses to a common problematic. Whereas the modernist artist believes that ideological and cultural codes may be transcended, or even annulled, through transgression, the postmodernist artist recognizes that she must work within the codes that define the cultural landscape.

Some of Acconci's simpler pieces, which might be called "activities" rather than "performances," demonstrate the body's materiality very directly and straightforwardly.[3] In *Rubbing Piece* (1976), Acconci rubbed a spot on his arm until he produced a sore there. In *Waterways* (1971), a video tape, he allows his mouth to fill with saliva until he can no longer contain it, then spills it out into cupped hands (Acconci 1972: 9, 12). Both pieces are, in Blau's terms, examples of the body "doing time": both direct attention to the body's existence in time – the time it takes to raise a sore or to produce a mouthful of saliva. As Acconci himself notes, the body becomes a measuring device. *Rubbing Piece* took place in a restaurant; Acconci's "private activity measures the public activity at the restaurant – 'sore time' rather than 'clock time'" (1972: 9). In *Hand and Mouth* (1970), a short film, Acconci pushes his hand into his mouth until he chokes (1972: 18). In *Runoff* (1970), Acconci ran in place for two hours, then pressed his sweaty body against a painted wall – the sweat stained the wall; some of the paint adhered to his body (1972: 36–7).

All these events involve uses and aspects of the body that are, in and of themselves, seemingly independent of social discourses, ideology, and the like. The body's bruisability, its reflexes, its production of saliva and perspiration, go on regardless of these other issues. But it is precisely because it does these things that the body is absorbed into a cultural economy of representation that emphasizes cleanliness and order – the body's productions must be masked, suppressed, and eliminated by a culture that fears to associate "itself with the excretive functions of city life, functions which produce millions of tons of garbage" (Celant 1980: 76). The body as source of uncleanliness is made to disappear in such a culture; Acconci's insistence on presenting "the body as a system, sweating and spermatic, fecal and salivating" (Celant 1980: 78) exposes the existence of social structures designed to make us forget all those

things, as well as their own failure really to maintain cleanliness, for, as Germano Celant indicates, filth is getting the better of our urban environments (1980: 78).

The major way of suppressing the body's materiality is through representation. As Brian DePalma has shown definitively, bodies can be reconstructed through representation to be exactly what we want them to be – clean, smooth, perfect, erotic. Acconci problematizes representation by leaving no doubt as to which body is carrying out the activity and will bear the mark of it afterward: there is no question of the body as iconic sign here. In his work, the body produces its own crude representations: sweat stains on the wall; the bite marks pressed into ink and printed in *Trademarks* (1970; 1972: 10–11). Acconci printed one bite mark onto a woman's body, the real bite on one real body giving rise to a represented bite on another real body, the whole representation perhaps standing for the male's repressed violence toward the female. For *Trappings* (1970), Acconci withdrew into a closet, where he played with himself, dressing up his penis, talking to it, making it into a "character" (1972: 57). Acconci acted out the popular mythology of the penis, the idea that the penis has a psychology and morality all its own,[4] the sense that men have of being in thrall to a part of the body. In *Conversions*, a film of 1971, Acconci engages the question of gender representation more complexly. He tries in three ways to convert his body into a female body: by burning the hair away from his breasts and attempting to enlarge them; by trying out various physical activities and postures in front of the camera with his penis tucked between his thighs; and by having a woman kneel behind him and take his penis into her mouth, thus producing a penisless image for the camera (1972: 26–9). The experiment is, of course, a failure: Acconci ends up looking nothing like a woman, and this failure is part of the point. Acconci fails because he accepts the facts of his body as they are and tries to work around them. He wants his becoming a "woman" to have some inner reality – he wants to feel what it is like to have a woman's body. What limited success he does have in converting his body is the result of mediation: by facing an unmoving camera, he can create a very roughly female-looking image of his body. "I'm forced to play to the camera – my performance depends on an attempt to handle, control personal information" (1972: 28). The same control is necessary in the third part of the performance, though it is effected by other means: "a girl [*sic*] kneels behind me: I acquire a female form by inserting, losing, my penis in her mouth" (1972: 28). Because we can

see the woman crouched behind him in the film, the representation
– once again – is a failure; the means used to create it are too
visible.[5]

Although I cannot defend Acconci's use (and that is what it is) of
the woman in this film, I do not think this piece ought simply be
reviled as misogynistic or as a particularly noxious reification of a
culturally reinforced image of woman as submissive to even the
most degrading of male desires. The premise Acconci is playing
with here may be the most antifeminist one possible: he, a man,
proposes to co-opt the female body itself through representation, to
demonstrate nothing so modest as the claim advanced by some
literary critics that men can "do" feminist criticism better than
women, but that men can actually *be* women, can occupy and thus
nullify that position of difference. Acconci's ludicrous failure to
become a woman, or even a representation of a woman, stands as
testimony to the "ineluctability of difference," to use Paul Bové's
phrase (1986). While Acconci's piece is obviously strongly mascu-
line in point of view, and certainly cannot be said to place the
woman in anything resembling a "subject position," it nevertheless
postulates a limit to male dominance over women and the shaping
of representations of women. As Stephen Melville remarks of
Acconci in a related context, "What he wants is to touch the other
as what he cannot control and to make his inability to control that
other a proof of the other's existence" (1981: 83 – 4).

Acconci's attempt to lose his maleness, to "become" a woman,
becomes, in its failure, a document of difference. Even if Acconci
did lose his penis, would that make him a woman, or even a repre-
sentation of one? What is the relationship between "female form"
and female gender? To what extent does Acconci's ability to experi-
ence his own body as a woman's body depend on his creation of a
successful representation for the camera? And what of this repre-
sentation? Do we, as spectators, accept an image of a penisless man
as an image of a woman? The spectator's complicity in Acconci's
work is always one of its major issues (Melville 1981: 80). The ques-
tions do not stop at the level of Acconci's obsessive performance,
but ripple out to include broader issues of gender representations,
the ideological currents that underlie them, and, as spectators, our
reception of such representations.

Acconci's deconstruction of representation is not unproblematic
by any means. Anthony Kubiak has said, in reference to the acts of
violence perpetrated against the body in Acconci's and other "body
art," that "marking the body in performance alienates it from itself

and forces it to become a sign (or rather, a sign of a sign) of its phys-
ical presence" (1987: 87). Kubiak is concerned with the relationship
between the scarred body as representation and terrorism as repre-
sentation. This is an important concern; Kubiak is describing the
inevitable risk involved in work that does not profess to transgress
the limits of cultural representation. One must also wonder about
the relationship of Acconci's work to pornography. I would argue
that Acconci's work is not pornographic, if one's definition of
pornography includes the idea that pornography's appeal to (male)
desire enables it to reify its representations of women. While
Acconci's films and performance documentations often share the
grainy, shadowy look, and voyeuristic aura of low-rent porno, they
have no erotic appeal whatever, at least not for me, but operate
purely as obsessive meditations on the body and representation. By
contrast, DePalma's film *Body Double* (1984), to which I alluded
earlier, deconstructs the ways in which women's bodies are objecti-
fied for the male gaze through pornographic representation, but
also participates in the very economy of pornographic representa-
tion it supposedly exposes.

At its most incisive (though critical standards for "body art" are
hard to articulate), Acconci's work avoids becoming what it decon-
structs because Acconci is so much aware of the impact of
mediation on the shaping of the image he presents, and draws
attention to that impact through his "sloppiness" – his "failure" to
keep the woman out of the frame so that his "transformed" body
can appear to be real and autonomous. DePalma's slickness, on the
other hand, undermines his own deconstruction by turning it
(perhaps intentionally) into spectacle, thus playing back into the
hands of hegemonic representations (see Polan 1986).

In his comments on his own performance work, Acconci refers
many times to the distance that inevitably intervened between
himself and the spectator. In the notes on *Rubbing Piece*, he says, "the
viewer might want to draw back, leave me alone" (1972: 9). In
commenting on *Trappings*, he notes that the spectator "shouldn't
want to have anything to do with me – I'm something to throw off,
withdraw from" (1972: 57). Discussing *Seedbed* (1971), a performance
in which Acconci masturbated under a ramp in a gallery, he observes
that "at the end of the day when I left the ramp . . . the people who
were still there would look at me very strangely, draw back, obvi-
ously . . . what can you possibly say to a masturbator?" (1972: 73). We
are drawn voyeuristically to Acconci's obsessiveness, but back away
from the person who performs such acts publicly, as art. We are

inclined to treat Acconci as a prostitute, as someone who performs with his body for our shameful pleasure. But the image of the prostitute illuminates Acconci's work in a more important sense as well.

In an essay entitled "The Feminine as Allegory of the Modern", Christine Buci-Glucksmann observes:

> Prostituted, dispersed, and fragmented bodies themselves express the destructive impulse of allegory – with its loss of aura, veils, immortality. But this destructive utopia is also critical; though regressive, it admits of a positive aspect – [what Walter Benjamin calls] "the dissipation . . . of appearances," the demystification of all reality that presents itself as an "order," "a whole," a "system."
>
> (Buci-Glucksmann 1987: 226)

Craig Owens (1984 [1980]) has claimed that allegory is the basic mode of postmodern art. The validity of that proposition is too large a question to address here, except to say that Acconci's prostituted, dispersed, and fragmented body does take its place in the kind of allegory described by Buci-Glucksman: a regressive image that, because of its insistence on the materiality of the body, cannot help but critically engage those ideological discourses that would suppress or co-opt that materiality, an image that therefore takes a step toward demystifying the economy of representations that enforces such suppression.

9 Boal, Blau, Brecht
The body

Augusto Boal's theatre is intensely physical in nature: everything begins with the image, and the image is made up of human bodies. Boal's theatre takes the body of the spect-actor as its chief means of expression. The body also becomes the primary locus of the ideological inscriptions and oppressions Boal wishes to address through theatre. The initial apprehension is of the body; discussion of the ideological implications of the images follows upon that apprehension.

Although his theatre privileges the body, Boal has not theorized the performing body in any continuous or systematic way. My project here is to examine what he has said on the subject and situate his thought in relation to that of other performance theorist-practitioners. In so doing, I shall treat Boal's scattered and fragmentary comments on the body as theoretical texts even though they are, in the main, occasional notes and sets of instructions whose intentions are more pragmatic and explanatory than theoretical. My intention here is not to hold Boal to a standard of theoretical rigor inappropriate to the nature of his writings, but rather to treat these writings as accesses to important issues concerning the body in performance implied and engaged in his work. Boal's fragmentary theorization of the body permits us insights into Boal's basic conception of theatre and the means by which he sees the theatre as serving an ideological function. I have taken two central moments in Boal's account of the history of the body in theatre as starting points for two separate, but related, discussions.

BOAL AND BLAU: THEATRE AND THE BODY OF DESIRE

For Boal, the body is the primary element of life inside and outside the theatre: "We have, before all else, a body – before we have a

name we inhabit a body!" (1992: 114); "The first word of the theatrical vocabulary is the human body" (1985: 125). Boal's remarkable choice of a creation myth for the theatre, "the fable of Xua Xua, the prehuman woman who discovered theatre" (1992: xxv–xxx), situates the origin of theatre in the pregnant body of Xua Xua, who, after giving birth to a son and losing control over this now separate entity that had been part of herself, discovers theatre. This discovery takes place at

> the moment when Xua Xua gave up trying to recover her baby and keep him all for herself, accepted that he was somebody else, and looked at herself, emptied of part of herself. At that moment she was at one and the same time Actor and Spectator. She was Spect-Actor.
>
> (Boal 1992: xxx)

It is not so much in the functions of acting and spectating that Boal sees the essence of theatre as in the (self-)consciousness they imply: "This is theatre – the art of looking at ourselves" (1992: xxx).

Boal's concept of the spect-actor who combines both functions is reminiscent of Michael Kirby's description of a performance art form he calls the Activity in which "the actions of the person himself become the object of his own attention" (1969: 155). The differences between Kirby's formulation and Boal's are instructive, however. For one thing, Kirby feels that an art form derived primarily from the experience of self-consciousness has to be called something other than "theatre" (1969: 158). Kirby was thinking primarily of such task-based, conceptual autoperformance modes as Fluxus performance, works of art which "can only be seen by one person and can only be viewed from within" (1969: 155). Even though Boal locates the essence of theatre in self-consciousness, the actions of the spect-actor are played out in a communal setting, to be perceived and addressed by a group of spect-actors all engaged in similar self-conscious activity. And whereas Kirby sees the purpose of this self-conscious activity as lying in its exploration of consciousness and its assertion that "all art exists essentially as personal experience" (1969: 169), Boal sees the self-consciousness he describes as a means to examine interpersonal, which is to say ideological, experience.

For Boal, theatre is a form of self-consciousness modeled on the postpartum division or the split posited by the mind/body problem before it is a transaction between actors and audience. Nevertheless, Boal's radical conflation of actor and spectator in a

single entity does not remove his theatre from the economy of desire that is, according to Herbert Blau, always played out in the deep structure of the theatrical event, not least in the spectators' desire to see theatre as the thing that can bring them together as a community.

Boal's suggestion that the theatre begins with what Blau calls an "original splitting" reverberates sympathetically with Blau, who notes, in *The Audience*, that "what is being played out [in theatre] is not the image of an original unity but the mysterious rupture of social identity in the moment of its emergence" (1990: 10). It is in such a rupture, splitting, or surrendering of unity that Xua Xua discovers the self-consciousness that produces her as both a social and a theatrical subject. Blau also points out the central paradox of theatre: "The very nature of theatre reminds us somehow of the original unity even as it implicates us in the common experience of fracture" (1990: 10). The desire that theatre evokes, addresses, but ultimately refuses to satisfy, is "for the audience [to become] as community, similarly enlightened, unified in belief, all the disparities in some way healed by the experience of theatre" (1990: 10). Whereas Blau's concern is with the actor/spectator relationship as an enactment of rupture that is still haunted by the ghost of this imagined primal unity, Boal dispenses with the traditional actor/spectator relationship in favor of the spect-actor, who, like Xua Xua, embodies both functions in a single, self-conscious entity.

That Boal's thought, like Blau's, is haunted by the specter of an imagined primal unity becomes apparent in a significant inconsistency in his discussion of the body. Boal proposes that theatre begins in Xua Xua's self-consciousness. In speaking of acting, he emphasizes the need for "rationalized emotion": the emotions the actor accesses through Stanislavskian emotional memory should not be employed in a raw state, but should be subjected to Brechtian rational analysis. In a passage as remarkable as the legend of Xua Xua, he cites as an example Dostoevsky's ability "to retain, during his fits [of epilepsy], sufficient lucidity and objectivity to remember his emotions and sensations, and to be capable of describing them" in *The Idiot* (1992: 48). A few pages later in the same book, however, at the head of a section on physical exercises, Boal asserts "that one's physical and psychic apparatuses are completely inseparable" (1992: 61). If this were true, there could be no rationalization of emotion, no theatre of self-consciousness as modeled by Xua Xua, for, as Blau reminds us, "what can look at itself is not one" (1990: 55), and the converse is also true: what is

one cannot look at itself. For the rest of Boal's conception of theatre to work, one has to assume some degree of separation between mind and body, and some degree to which consciousness is able to apprehend the workings of both mind (emotions) and body from a distance, an interior original splitting.

My purpose here is not to take Boal to task for being inconsistent, but rather to suggest that this provocative inconsistency exemplifies Blau's claim that theatre paradoxically gives rise to a desire for an imagined original unity even as the existence and experience of theatre are themselves testimony to the impossibility of that unity. This is as true of Blau's exploration of the actor/spectator relationship enacted between two separate bodies as it is of Boal's discussion of the spect-actor, the single entity that subsumes both functions within a single body. In focusing on the spect-actor, Boal posits an original splitting that produces a divided subject rather than an originary division between separate subjects. To put it another way, the hyphen in "spect-actor" is important as the indicator of a unity born of rupture. Boal's own rhetoric finally suggests that Xua Xua did not really reconcile herself to her baby's departure, did not really understand that he never was part of herself, but remains caught up, like Blau, like Boal, in the paradoxical economy of desire – the yearning for an impossible unity – that is theatre.

BOAL AND BRECHT: THE IDEOLOGICAL BODY

Having ventured forth in one direction, I would like to take another originary rupture in Boal's account of the history of theatre as the starting point for a different discussion.

> In the beginning the theatre was the dithyrambic song: free people singing in the open air. The carnival. The feast. Later, the ruling classes took possession of the theatre and built their dividing walls. First they divided the people, separating actors from spectators; people who act and people who watch – the party is over! Secondly, among the actors, they separated the protagonists from the mass. The coercive indoctrination began!
>
> (Boal 1985: 119)

If, for Blau, the moment at which the audience is divided from the actors is the moment at which theatre becomes possible, for Boal it is the moment at which theatre becomes ideological; and the moment at which the actor is separated from the dithyrambic

chorus is the moment at which theatre becomes a means of ideological oppression. (In saying this, I am not suggesting that Blau positions performance outside of ideology at any point in its hypothetical evolution; quite the opposite is true. My main purpose here is to clarify Boal's thought.) This oppression, signaled by a division of one body from the mass, is also inscribed upon the mass of bodies.

That the body is (quite literally) inscribed by ideological discourse is a major tenet of Boal's conception of a theatre committed to ideological analysis. Boal adopts Marx's base/superstructure model, according to which consciousness is determined by material relations; the first step of his method, therefore, is to free the body, our most basic connection with material life, from the "social distortions" imposed upon it by the oppressors' ideological discourses (1985: 126). His analysis of this social deformation of the body is based directly upon Marx's account of alienated labor. Boal refers to the ways in which the body is shaped by the regimens imposed upon it by the demands of particular kinds of work as "muscular alienation," which must be overcome before the body can become expressive in performance (1985: 127). In identifying the specific ideological discourses that shape the body as social body, Boal focuses on work and professional status (e.g., the cardinal versus the general [1985: 127–8]). Another interesting observation he makes is that the body's physical regimen is also shaped by place (1992: 73), by what Andrew Feenberg (1980) has called "the political economy of social space." He does not explicitly identify other ideological discourses (such as those of race or gender) as shaping the body, though such considerations are implicit in his work and emerge explicitly in the course of certain image theatre exercises, as we shall see.[1] Just as Marx sees the abolition of the division of labor as one of the essential steps in the transformation of capitalism into communism, so Boal proposes the "de-specialization" of the body as a necessary step toward the exploration of oppression through theatre (1992: 62).

Because the mechanisms of oppression shape the body, it is through the body and its habits that those mechanisms can be exposed. Boal provides numerous examples of this technique; I shall cite only one. He recounts one response to his request that the spect-actors participating in an image theatre session create static images of what they understand to be oppression:

In Sweden, a young girl of 18 showed as a representation of oppression a woman lying on her back, legs apart, with a man on top of her, in the most conventional love-making position. I asked the spect-actors to make the *Ideal Image*. A man approached and reversed the positions: the woman on top, the man underneath. But the young woman protested and made her own image: man and woman sitting facing each other, their legs intertwined; this was her representation of two human beings, of two "subjects," two free people, making love.

(Boal 1992: 3)

The exercise reveals how ideology (in this case the ideology of male dominance) is expressed at the most basic material level through everyday, habitual routines and regimens of the body, and, therefore, how nonhegemonic ideologies might be expressed through bodily counterroutines exploring physical alternatives to the oppressive regimen.

This conception of the relationship between ideology and the base of material, bodily existence, is strongly reminiscent of Brecht's concept of *Gestus*, "the attitudes which people adopt towards one another, wherever they are socio-historically significant (typical)" (Brecht 1964: 86). In *The Caucasian Chalk Circle*, Azdak expounds the idea of *Gestus* as he instructs his disguised visitor, who is hiding from the police, in how to appear poor:

Finish your cheese, but eat it like a poor man, or else they'll catch you Lay your elbows on the table. Now, encircle the cheese on your plate like it might be snatched from you at any moment.

(Brecht 1983: 191)

The act of eating thus becomes *gestic*, expressive of social relations of oppression, just as the gestic implications of a sexual position are brought out in the Boal exercise. Boal's notion of "the 'mask' of behavior" imposed on a person by multiple, habitual social roles (1985: 127) corresponds to the Brechtian *Gestus* in its largest sense, as the sum of all specific social gests. For both Brecht and Boal, the material life of the body is expressive of oppression because the body itself, its actions and gestures, are determined by ideological relations.

Despite their common analysis of the ideological body, Brecht and Boal contrast in the nature of their respective ideological commitments. Although most of Brecht's plays, especially his work of the 1940s, are not Marxist in any doctrinaire sense, the ideological

commitment he demands of his actors is quite explicit. In the "Short Organum", Brecht states that

> the actor ... must master our period's knowledge of human social life by himself joining in the war of the classes [T]he choice of viewpoint is ... a major element of the actor's art, and it has to be decided outside the theatre.

(Brecht 1964: 196)

It is this knowledge which undergirds the actor's representation of the Brechtian "master of meaning" discussed in Chapter 3. In the physicalization of the *Gestus*, then, the Brechtian actor exposes the social implications of particular actions and behaviors revealed when those actions are examined from a specific ideological point of view.

Although Boal couches his cultural analysis in Marxian terms, he is, as Adrian Jackson points out, careful to avoid categorization in terms of any particular political philosophy or ideology (Boal 1992: xxiii). He is also careful to insist that "it is not the place of the theatre to show the correct path" (Boal 1985: 141); the theatre is at most a laboratory for social experimentation, not a means of arriving at genuinely political solutions. Nevertheless, while Boal may not want his theatre to be associated with any particular point on the ideological spectrum, he clearly is committed to the idea of theatre as engaged in ideological work, and to a generally leftist conception of that work. What Boal seems to be after in his work with the spect-actor, however, is not so much a Brechtian gestic body educated and shaped by its experience of class struggle, as a body that can step aside momentarily from its particular ideological regimens to try on others for size. This is not necessarily with the intention of adopting them, but as a means of exploring other configurations. For the duration of an exercise, the oppressed may try on the body of the oppressor (or vice versa, as in the cheese scene from *The Caucasian Chalk Circle*), of other members of the oppressed group, of others they may be oppressing themselves, and so on. Or, as the Swedish woman's exercise indicates, potentially nonoppressive conditions may be embodied. Because Boal's spect-actors explore these options for themselves and each other, rather than as exemplars to an audience, they make no pretense to being masters of meaning. The social relations they embody are not reified as solutions, or even as steps toward solutions, but only explored as possibilities. To a certain extent, Boal reverses the relationship between social experience and theatre posited by Brecht.

Whereas, for Brecht, social experience should inform, and can be conveyed by, theatre, for Boal, performance is a way of exploring options which must then be tested in life. The real ideal condition (as opposed to the ideal *image*) must be determined, and the means to achieve it must be discovered, outside of the theatre. This perception of theatre's limited efficacy as social action distinguishes Boal from Brecht, and, most especially, from his more immediate predecessors, the Living Theatre and other Viet Nam era proponents of an ecstatic political theatre.[2]

Boal's proposition that the spect-actors can assay alternate embodiments is a problematic moment in his theorization of the body, for he seems to suggest that it is possible for the ideologically encoded body to adopt a neutral (i.e., nonideological) position, however momentarily, in its transit from one *Gestus* or mask to another. He writes of actors destroying "rigid, hardened 'structures' of ideas, muscles, movements, etc." without "replac[ing] them with others" (1992: 139). Especially from the perspective of the postmodernist view of the body adumbrated in the previous chapter, this seems highly unlikely: the body, always already ideological, can never escape ideological encoding; it exists only insofar as it is "structured" through discourses.

Another element of Boal's discussion of the body that is disturbing from this point of view is his privileging of the physical text over the verbal text. He refers to the physical tableaux of image theatre as "making thought *visible*" more efficaciously than could spoken language (1985: 137, original emphasis). At first blush, this foregrounding of the physical appears to link Boal with the tradition of "holy" theatre, with its emphasis on accessing levels of archetypal meaning through physical langugages. The neutral (nonideological) body position that Boal implies is reminiscent of similar formulations in the theories of "holy" theatre discussed in Chapter 2, where the separation of the body from its habitual social masks is a necessary condition for accessing deeper levels of meaning.

Upon closer examination of both the spirit and letter of Boal's writings, however, it becomes clear that the function of the neutral body in his theory is essentially the opposite of the function of similar formulations by theorists of "holy" theatre. For Appia, Copeau, and Grotowski, the body must be divested of its social masks in order to access universal, archetypal, or subconscious images, which are seen as more authentic than the social. Boal clearly does not share in this desire to transcend the social in favor

of the archetypal. The bodily neutrality he posits is a rhetorical figure standing for the ability to move from one mask to another while retaining a critical distance from all masks. Unlike the "holy" actor, the spect-actor cannot exist outside ideology and does not even attempt to, but can only try on different ideological positionings as they are inscribed on the body. The Boalian body is finally the virtual antithesis of the Grotowskian body; it is a body that remains firmly defined by its experience as a material entity that exists in relation to ideological systems, not a rarefied, dematerialized, spiritualized body. The spect-actor is a postmodern subject, divided in itself, fully aware that it cannot escape ideology, that its only choice is amongst different ideological masks. Boal implies, however, that this subject's own interior division becomes a source of the critical distance that enables it to realize, as I once heard Blau say, that even if the only choice we have is a choice of masks, some masks are better than others. Although aspects of Boal's thought and practice clearly link his work with the tradition of "holy" theatre and the communitarian experimental theatre practices of the 1960s, his connection to Brecht, and his commitment to a theatre rooted in the examination of material manifestations of ideology, prevent his thought from slipping into the mysticism of Grotowski or the solipsism of Kirby's Activity.

In a published discussion, Michael Taussig and Richard Schechner debate Boal's status relative to postmodernism. Schechner argues for seeing Boal as a postmodernist because his theatre entertains ideological options without privileging any as "true" or ideologically correct (1994 [1990]: 28). Taussig argues that Boal's faith in the ability of human beings to transcend difference and communicate directly with one another marks him as a traditional humanist (1994 [1990]: 30).

I would agree with Taussig to the extent of saying that Boal is a humanist in the same sense that Marx was a humanist. For Marx, alienation is pernicious primarily because it is dehumanizing: human beings, who are supposed to be autonomous, free subjects, endow things outside of themselves, whether another class, a deity, or the products of their own labor (commodities), with power over themselves and become slaves to those things. As I have suggested, Boal's use of the basic categories of Marxism in his analysis of the body in performance suggests that, like Marx, Boal wants to overcome alienation and restore basic autonomy by eliminating actor and spectator in favor of the spect-actor, thus undoing the traditional division of theatrical labor and overcoming alienation (the

audience's surrendering of its autonomy to performers who act in its stead) and returning the "protagonistic function" (Boal 1985: 119) to the audience from which it was taken at the second of the historic ruptures I have used as nodal points here.

Schechner's analysis of Boal is pertinent, however, to the ongoing discourse on the possibility of a postmodernist political art. One of the primary issues in that debate, discussed here in Chapter 6, has been the apparent impossibility of achieving the critical distance necessary to political art within the information-saturated environment of the postmodern (Jameson 1984b: 87). In my reading of Boal, he implies at least a provisional "solution" to this problem by grounding critical distance within the fractured subjectivity of the postmodern subject itself, without reifying that subject, claiming it can exist outside of ideology, or exempting it from the economy of desire that Blau sees as defining performance. In Boal's thought, a fractured, postmodern subjectivity becomes the necessary condition for critical distance rather than the condition that renders critical distance impossible. The legend of Xua Xua, the narrative of the birth of the theatrical and ideological subject in an original splitting, enables a reconceptualization of critical distance precisely as a postmodernist trope.

10 "Brought to you by Fem-Rage"
Stand-up comedy and the politics of gender

> Culturally speaking, women have wept a great deal, but once the tears are shed, there will be endless laughter instead. Laughter that breaks out, overflows, a humor no one would expect to find in women which is nonetheless their greatest strength because it's a humor that sees man much farther away than he has ever been seen.
>
> Hélène Cixous, "Castration or Decapitation?"

> It is not polite to laugh and point at the penile member.
>
> Cynthia Heimel, *Sex Tips for Girls*

One of the cultural legacies of the 1980s is the resurgence of stand-up comedy as a popular genre, evidenced by the appearance of comedy clubs in virtually every American city, the prevalence of stand-up comedy programs on cable and broadcast television, and the number of stand-up comics who have made the transition to film acting or roles in television situation comedies. An important aspect of the phenomenon is the increased access women gained to the stand-up comedy stage.[1] Phyllis Diller recalls that when she entered the field in 1955 there were no other women comics (quoted in Collier and Beckett 1980: 3). Estimates from the late 1980s suggest that about 10 percent of professional American stand-up comics are female, as are 25 percent of aspiring comics (see M. A. Dolan 1989; Unterbrink 1987: 197). In the wake of the comedy boom of the 1980s, there are a large number of well-known women comics, including several superstars of the genre, some of whom have used stand-up comedy as launching points for careers as film actors or television writers and producers.

The issues I will discuss here relate to the particular circumstances confronted by female comics in a culture that traditionally has suppressed women's humor and denied to women even the right to be funny. Traditional literary theories of humor and

comedy, social prejudices against joke-making as an aggressive and "unfeminine" behavior, and the processes by which cultural expression is disseminated in a patriarchal culture all create obstacles for the comic woman and the woman comic. A growing strain of feminist literary theory, on the other hand, suggests that humor and comedy may be valuable as empowering "feminist tools" (Barreca 1988: 5), especially when motivated by the anger women need to express at the social and cultural limitations they confront. My objects here are to situate the woman comic culturally, and to offer an analysis of a specific cultural text, Roseanne Barr's 1987 cable television special.

The mass-cultural context of stand-up comedy, which is disseminated today chiefly by broadcast and cable television, raises important issues as well. Chief among these is the traditional theoretical opposition of vanguard culture and mass culture, which sees mass culture as necessarily co-opted, and only vanguard culture as possessing critical potential. As rock music critic Dave Marsh asserts, today "all culture is made in an industrial context," and all cultural production, therefore, is politically compromised, "if participating in the only world any of us has to live in represents a compromise" (1985: 15). In analyzing a mass-cultural phenomenon, one must be alive to the potential for co-optation and recuperation that resides in mass culture, an issue I discuss here. My working assumption, however, is that mass-cultural status in and of itself does not vitiate a genre's or text's potential to do positive political work.

WOMEN'S COMEDY IN THE PATRIARCHAL PUBLIC SPHERE

As the well-worn clichés about women (especially feminists) having no sense of humor attest, women have been excluded from the comic tradition, except as the objects of male humor.[2] Perhaps literary critic Reginald Blyth's 1959 definition of women as "the unlaughing at which men laugh" can stand as the epitome of this tradition (quoted in Barreca 1988: 4). Humor in women's writing, for example, has often gone unrecognized as such by male critics or has been dismissed as trivial in comparison with the comic efforts of male writers. Comedy writer Anne Beatts suggests that part of the reason for men's failure to acknowledge women's humor is that "there is a women's culture that men just don't know about. So when they say, 'Hey, that joke's not funny,' it's sometimes because

they don't understand the vocabulary" (quoted in Collier and Beckett 1980: 24–5).

The issue goes beyond the specificity of cultural vocabularies, however, for humor is inextricably linked to social power and dominance. Unsurprisingly, social scientists have uncovered evidence that people generally laugh along with those they perceive as more powerful than themselves and tend not to make jokes at their expense, at least not in their presence (Pollio and Edgerly 1976: 221). Even women in positions of power are disinclined to make jokes with men present but will laugh at jokes made by men (Pollio and Edgerly 1976: 225). Pollio and Edgerly summarize the social situation succinctly: "men talk and joke; women smile and laugh." They go on to note that

> women just do not attempt to be humorous in a mixed group setting and the reason seems to be that women are neither expected, nor trained, to joke in this culture. It seems reasonable to propose that attempting a witty remark is often an intrusive, disturbing and aggressive act, and within this culture, probably unacceptable for a female.

"Responsive behaviors" such as laughing and smiling, however, are perfectly socially acceptable for a woman in our culture (Pollio and Edgerly 1976: 225).

Beatts's interpretation of these phenomena is that men are afraid of allowing women the access to power represented by humor (or of acknowledging that women in fact have such access) because a humorous woman threatens the central icon of the mythology that supports male dominance: "they unconsciously are afraid that the ultimate joke will be the size of their sexual apparatus" (quoted in Collier and Beckett 1980: 28).[3] Once women start making jokes, men fear, nothing will be exempt from female comic derision, no matter how sacred to patriarchy. Further evidence for the idea that a humorous woman is perceived as a threat to male sexual dominance is Mahadev Apte's observation that "in many cultures norms of modesty cause women who laugh freely and openly in public to be viewed as loose, sexually promiscuous, and lacking in self-discipline" (1985: 75). (At some point in their careers, most female comics have experienced similar responses from the men in their audiences, who either treat them with hostility or assume that a female comic is presenting herself as sexually available.)

Beatts's analysis suggests that humor by women may be an effective weapon against male social dominance and phallocen-

trism. When assessing the political positioning of a performance genre, however, it is not enough simply to evaluate its content; one must also look at the ideology of performance itself (see Blau 1983). The relationship between women and stand-up comedy as a performance genre is by no means unproblematic. For one thing, there is a plausible argument to be made that stand-up comedy is an intrinsically male-centered form. Lesbian comic Marjorie Gross has observed, in the context of a discussion of the comic's authority over the audience, that "holding a microphone is like holding a penis" (quoted in Collier and Beckett 1980: 99), an analogy endorsed by male comedians (see Borns 1987: 21). When discussing the dynamic of their work, both male and female comedians stress the importance of control over the audience, of mastery of the performance context, in which the phallic microphone plays a significant role. Jerry Seinfeld summarizes the essential relationship between audience and comic succinctly: "To laugh is to be dominated" (quoted in Borns 1987: 20). In his book on the evolution of the situation comedy, David Marc goes so far as to propose that the dynamics of stand-up comedy may suggest "totalitarian imagery" or "may even conjure hallucinations of Mussolini working the crowd from a terrace," though he goes on to dismiss such a perception of stand-up comedy as "a bum rap" (1989: 17).

A performance genre that apparently depends on the dominance of the audience by the performer through phallic assertion does not seem a promising candidate as a medium for women's expression. Indeed, Lisa Merrill, in an essay on feminist humor, implies that conventional stand-up comedy is less appropriate as a vehicle for feminist concerns than the decentered, multicharacter performances of Lily Tomlin and Whoopi Goldberg (1988: 275–8). Just as traditional stand-up comedy seems phallocentric from a formal perspective, historically, it has also assumed a heterosexual male audience and a performance presented for the enjoyment of the male gaze. As Merrill points out, "traditionally, women have been expected to identify with comedy which insults us" (1988: 274); such comedy radically disempowers the female spectator by obliging her to participate in her own objectification and victimization as the butt of the joke, if she is to participate at all.

One powerful recuperation of stand-up comedy as a feminist practice is represented by the work of Kate Clinton, the radical lesbian-feminist-humorist (who has contracted that designation to "fumorist"), who performs primarily for audiences of women and who began her performing career at women's coffeehouses and

feminist writing conferences. As Cheryl Kader has suggested, "Clinton's humor implies a spectator who is neither male nor heterosexual"; by constructing her audience as lesbian she creates "a community of spectators . . . which liberates its occupants from uniformity to general norms, however temporarily" (1990: 46, 48). Presumably, this construction of the audience as lesbian may also place the heterosexual male (and perhaps the heterosexual female) spectator in something like the uncomfortable position that the woman spectator has occupied relative to traditional stand-up comedy, though Kader interprets this kind of reversal more as a by-product of Clinton's performance practice than as its main point (1990: 52).

This kind of practice is extremely valuable politically in that it "open[s] up a space for a restructured history and a reconceptual-ized subject" (Kader 1990: 42). That it also, however, "succeeds in producing a *separation* from the dominant culture" (Kader 1990: 54) may be its weakness as much as its strength. Lauren Berlant describes such separating cultural practices as efforts to create a feminist public sphere, "a theatrical space in which women might see, experience, live, and rebel against their oppression *en masse*, freed from the oppressors' forbidding or disapproving gaze" (1988: 238). In Berlant's terms, these efforts are limited by their inability to engage mainstream culture, and perhaps exemplify what she describes as the "imaginary sphere of public–feminist intimacy, which relies on a patriarchal fantasy of woman's sameness to herself to produce an adversarial politics" (1988: 240). Berlant sees greater value for feminism in a strategy of "engagement of the female culture industry with the patriarchal public sphere, the place where significant or momentous exchanges of power are perceived to take place" (1988: 240).

Significantly, Clinton herself has expressed interest in reaching a broader audience, and has emerged from the coffeehouse circuit to play at comedy and music clubs and theatres, and on television comedy shows. She acknowledges that this has meant "internal-izing" her feminism (DeVault 1988). In 1996, Clinton ventured even further into the mainstream by bcoming a writer for the *Rosie O'Donnell Show*, a daytime televsion variety program presided over by another woman comic. Women comics who choose to remain within the conventional form and performance contexts of stand-up comedy are essentially appropriating a cultural form traditionally associated with, and still largely dominated by, male practitioners. Undoubtedly, they are offering themselves to "the

oppressors' forbidding or disapproving gaze" and run all the risks attendant on doing so. But those risks may be worth running if they give women greater access to the cultural arena and permit the female culture industry to engage the male public sphere, as Berlant argues they may.

The analysis of stand-up comedy upon which the previous comments are based is in any case incomplete, for it considers only the image of the comic without taking the audience into account. Specifically, it does not fully address the comic's relation to the audience, the dependence and vulnerability that the comic's often aggressive stance and phallic microphone only partly mask (consider, for example, the comic's extreme vulnerability to hecklers). Comics' own perceptions of their audiences may offer evidence that a kind of empowering of female performers and spectators can take place within the context of conventional stand-up comedy. Beatts observes that, whereas a woman in an audience who is with a man tends to wait to see if he will laugh before she will, women in a social setting unaccompanied by men feel much freer to express themselves humorously, and to respond to the humorous expression of other women (quoted in Collier and Beckett 1980: 26). As we have seen, her observation accords with social-scientific conclusions.

The experience of stand-up comedians suggests, however, that, while this situation may be normal (in the strict, statistical sense), it is not inevitable. Although Joan Rivers would probably not qualify as a feminist comedian in the minds of many, her observation on this subject is of interest. Rivers vigorously denies that there is any such thing as "women's humor," yet she does see a gender-inflected distinction among audiences. She refuses to perform for all-male audiences, not because she does not want to be objectified for the male gaze, but because she feels that men alone do not understand her humor. "You need women to relate to because the men relate to you through the women they are with, and then they go forward" (quoted in Collier and Beckett 1980: 8). This description reverses the social norm, in which the woman looks to her male companion for cues. It is also the case that most women comedians specifically address the women in their audiences during some portions of their acts. For those moments, the comedian creates a community with other women based on common experience (frequently of men) but not separate from the patriarchal public sphere. In the hands of the most skilled practitioners, this community becomes a strategic community, a moment at which a

shared subjectivity that excludes men is created under our very noses, again placing the men in the audience in the position women have traditionally occupied as comedy spectators. These examples suggest that the articulation of the comedian's performance as a cultural text, which occurs through negotiations between comic and audience conditioned by the gender identities of both, can produce circumstances within the context of the performance that run counter to the social norm, circumstances in which women may find a sense of empowerment through a sense of shared subjectivity – or by identifying with a performer who depends on their presence for the text she produces to have meaning, or by being the authority on what is funny to men. Similarly, the female comic can engage the women in her audience in a way that empowers both them and herself, even directly under "the oppressors' forbidding or disapproving gaze."

One clear indication that women's comedy is perceived as genuinely dangerous within "the patriarchal public sphere" is that it is so often subject to strategies of patriarchal recuperation. Women comics face the greatest risk that the challenge they represent will be neutralized by the contexts in which they are presented when their work is disseminated beyond the realm of the club performance, a relatively privileged realm over which the comedian, male or female, has the greatest control. I would like to offer two examples here of recuperative strategies to which female comics are subjected in two different cultural realms deriving from the institution of television: the videocassette market and the network talk show.

The packaging and production of a videotape entitled *Women Tell the Dirtiest Jokes* (High Ridge Productions 1985) offer instructive examples of how (male) producers attempt to recuperate provocative work by women and make it safe for the male gaze. The label on the front of the videocassette box is an illustration depicting several young, male sailors in the front row at a comedy club performance, blushing conspicuously at the utterances of a female comic onstage. Because the point of view of the illustration is at stage level and from behind the performer, the comic herself is represented only as a pair of shapely legs in stockings. At one level, this packaging seems designed to titillate the male viewer with a promise of raunchy women offered up to his gaze and, thus, to objectify the female performer. At another level, the title of the tape and the idea that what the woman is saying could make a sailor blush seem intended to suggest, in effect, that women have

beaten men at their own game by telling jokes even dirtier than typical locker-room repartee. This transforms the woman from a threatening Other into just one of the guys; her humor, which could be seen as a challenge to male power, becomes the same as the humor men exchange among themselves. The image undermines women's autonomy in two ways – through straightforward objectification and by denaturing the woman into a foul-mouthed "man without a penis" (Anne Beatts, quoted in Collier and Beckett 1980: 27).

This kind of contextualizing is not confined to the tape's packaging. The eight female comedians on the tape, all recorded before a live audience in a club-like setting, are introduced by a disembodied male voice informing us, barker-like, that we are about to see "eight lovely ladies." Another male voice takes over to introduce each of the acts, becoming an invisible and pervasive authority, defining each woman and categorizing her work. In some cases, the implications of the categorizing are disturbing, as when the voice refers to LaWanda Page as "the black queen of comedy."

The last thing on the tape is a song written by the program's producer, which is played over the end credits. Entitled "Pain," it seems designed to assuage the male ego after the assaults it has sustained at the hands of female comedians:

When you shake your hips, girl
How it drives the boys insane;
When you wet your pretty lips, girl
The feeling spreads – I can't explain
The pain

The song refers to pain inflicted on a man by a woman, but it translates the pain of stinging satire into the pleasurable pain of seduction, reducing the woman from a subject attempting to carve out a piece of discursive space into a male-constructed object whose every move, even if unconsciously motivated, is to be seen as an attempt to attract the male's attention. The final implication, then, is that even the female comics on the tape, some of whom are quite vigorous in their assault on male privilege, are really only engaging in seduction by unconventional means and need not be taken seriously. The curious end result of this packaging and production is that, whereas many of the comics themselves specifically address the women in their audience in an attempt to stress the commonality of women's experiences with men, the producers

seem to assume a male spectator, and seem to want to protect him from that unfamiliar entity, the aggressively funny woman, by objectifying her.

Another means by which women comics are frequently threatened with recuperation is mediation by a male talk show host as "kindly father" on network television.[4] Although the comics have relative autonomy during their five minutes on *The Tonight Show* or *The Late Show with David Letterman* (though they are always subject to network censorship), the host is in a position to contextualize the comic's performance. Not only does the host mediate between the performer and the home viewer through his introduction and the interview that often follows the comic's performance, but the program's apparatus further mediates the home viewers' response by positing the studio audience, manipulated by applause signs and other cued responses, as the "ideal audience" whose response the home viewer is implicitly asked to emulate (Allen 1987: 94).[5] The particular character of current hosts also works to neutralize the performances they present:

> The talk show host ... is a figure of the ideal viewer. As we watch TV's images, so does he sit and look on at his parade of guests, evincing a boyish wryness ... especially when he glances our way with a look that says, "Can you believe this?" He is a festive version of the anchorman, with an air of detached superiority that is enabled by his permanent youthfulness, and by his middle-American calm and plainness. Johnny Carson of Iowa, like his heir apparent, that supreme ironist, David Letterman of Indiana, always seems above the excesses of either coast, even as he brings them to us.
>
> (M. C. Miller 1986: 218–19)

Anything is grist for the mill in this parade of performances, none more challenging or meaningful than another. An example of how this effect can neutralize potentially challenging performances is that of Victoria Jackson's appearances on *The Tonight Show*. Jackson's peculiar postfeminist performances, which have combined high school gymnastics with songs on subjects one does not expect to hear of on Carson (female anger, suicide) sung poorly in a little-girl voice, are *sui generis* and difficult to fathom. Carson, however, successfully undermined any challenge Jackson may have posed, first by introducing her paternalistically as an oddity he discovered, then by eliciting mundane personal information from her during subsequent interviews. This trivialization has only been

furthered by the "dizzy blonde" characters Jackson usually played as part of the *Saturday Night Live* company and in films. The result is that Jackson, initially a fascinating, enigmatic performance artist who had achieved a degree of mainstream exposure, has become an eminently safe commodity.

Obviously, the same kind of contextualizing can rob a male performer's work of its impact as well, but the fact that the figures of authority on all the major late-night talk shows that serve as launching points for national recognition are men (Letterman, Leno, O'Brien)[6] confronts women performers with a set of issues their male counterparts do not have to negotiate in the same form. Betsy Borns discusses the fact that talk show hosts like Carson and Letterman prefer to give exposure to new comedians or those they can claim to have discovered. She uses the phrase "TV virginity" to describe the condition of comics before their initial talk show appearance (1987: 199). The implications of this phrase are particularly disturbing in the context of a discussion of female comics in that it implies that the talk show host as "kindly father" also figures as a seducer (or rapist?) whose paternalistic interest extends only to those he has deflowered.

Of necessity, this discussion of the positioning of women's comedy within the patriarchal public sphere must remain open-ended, for comedy's potential for empowering women is always accompanied by the potential for patriarchal recuperation; both can take place simultaneously, in fact. To assume, however, that because recuperative mechanisms are in place recuperation inevitably occurs would be to deny that audiences retain any capacity for independent action. The fact that a representation may appear to be highly compromised – in league with repressive cultural forces – does not determine how an audience will use that representation and, possibly, be empowered by it. Lawrence Grossberg argues for the value of the Gramscian concept of "articulation" as a way of under-standing the relation between a cultural text and its audience, a concept that suggests that audiences are always actively constructing texts rather than simply "decoding" the meanings that are present in them. "[The theory of articulation's] disdain for any assumed historical necessity and its emphasis on the reality of struggle direct the critic toward the complex and contradictory relations of power that intersect and organize an audience's relation to particular cultural texts" and challenge any assumption that the audience and the performer are simply putty in the hands of the hegemonic. "People are never merely passively subordinated, never

totally manipulated, never entirely incorporated"; rather, they can often discover sites of empowerment within seemingly co-opted discourses by finding their own ways of using them (Grossberg 1988: 169–70). Therefore, although the recuperative mechanisms I have discussed here may have the effect of domesticating women comics for male spectators, they may not succeed in inhibiting female spectators from being empowered by the comics' representations.

"BROUGHT TO YOU BY FEM-RAGE": THE ANGRY COMEDY OF ROSEANNE BARR

Regina Barreca argues that "recent feminist criticism has acknowledged the power of rage in writings by women, but has as yet left unexamined the crucial roles of comedy paired with anger as shaping forces and feminist tools" (1988: 5). In the final portion of this essay, I shall analyze the interplay of humor and anger in the work of Roseanne Barr, and show how that work self-consciously responds to the cultural positioning of the woman comic, especially in relation to the images of women disseminated by television.

Patricia Mellencamp has argued that women television comedians like Gracie Allen and Lucille Ball challenged male dominance by "unmak[ing] 'meaning' and overturn[ing] patriarchal assumptions" but that, finally, "neither escaped confinement and the tolerance of kindly fathers" (1986: 90). In Mellencamp's view, the comic and narratological codes of the situation comedy inevitably confined and tamed the woman comedian, despite her challenge to the domestic containment of American women so characteristic of the 1950s and 1960s and her appropriation of typically "male" comic modes (e.g., Ball's skill in physical comedy). In examining *The Roseanne Barr Show* (Barr 1987), one of Barr's HBO television specials (not to be confused with her network series *Roseanne*), I shall argue that Barr's distinctive hybridization of the situation comedy and stand-up comedy genres, and her explicit designation of anger as the source of her humor, enable her to thematize, and thus to resist, recuperation in a way that Allen and Ball could not.

Barr's hybridization of genres is an important strategy of resistance, for stand-up comedy, Barr's original medium, does not place the woman comic at the same risk of recuperation and containment as the situation comedy (though I have already pointed out the risk of recuperation the woman comic runs in the cultural realm). For one thing stand-up comedy is not a narrative form; there is no "situation" to surround and contain the actions of the comic woman.

Like so much postmodern performance,[7] stand-up comedy is monologic – the comedian stands alone, unmediated by other characters; there is no George for every Gracie, no Ricky for every Lucy. Marc argues vigorously that, as "an art of the middle" designed to appeal to the widest possible segment of the television audience, situation comedy "rarely reaches the psychological or political extremes that have been commonplace" in stand-up comedy, which remains a realm of idiosyncratic expression (1989: 26).

Despite the performative freedoms offered by stand-up comedy, the few female stand-up comedians of the 1950s and 1960s tended to work within self-imposed restrictions that reflected the social stigma attached to aggressively funny women. The traditional female comic's chief strategy was to render herself apparently unthreatening to male dominance by making herself the object of her own comic derision in what is usually referred to as "self-deprecatory" comedy. The self-deprecatory mode is the mode of both Phyllis Diller, who entered comedy in the mid-1950s, and Joan Rivers, who entered the field in the early 1960s. Both women have created personae who make their own supposed unattractiveness (to men) and their failure as housewives the subjects of their humor. (Rivers's notoriety derived in large part from material in which she ridicules other women celebrities for not meeting the patriarchal standards of beauty and decorum her own persona also does not meet.) Clearly, whatever anger may be implicit in the self-deprecatory comedy of Diller and Rivers has been turned inward onto the female subject herself, rather than outward onto the social conditions that made it necessary for Diller and Rivers to personify themselves in this way in order to have successful careers as comics. It seems to me that in *The Roseanne Barr Show*, Barr offers an example of a woman's humor that is explicitly based in the kind of active anger Barreca sees as an empowering response.

Roseanne Barr belongs to the family tree that produced both Diller and Rivers; because she has her own television series, comparison with Allen, Ball, and other domestic situation comedy performers becomes relevant as well. Like Diller's comic persona in particular, the Barr persona is once again that of a disgruntled housewife (or "domestic goddess," as Barr insists she wants to be called). But, whereas the personae of earlier comedians such as Diller and Rivers turn the anger and frustration of a life confined to domesticity in on themselves in self-deprecation, Barr's housewife persona speaks out petulantly against husbands, children, and the social expectations and limitations imposed on women. Whereas

the Diller and Rivers personae make their own supposed physical unattractiveness a source of humor, Barr insists on her right to be overweight, making those who are not the objects of her humor. She protests that Californians are "rude to the fat," implies that slender people are necessarily bulimic, and compares "skinny moms" with "fat moms":

> What do you want when you're really depressed, you know, some skinny mom: "Well, why don't you jog around a while and that'll release adrenalin in your blood and you'll better cope with stress" or some fat mom: "Well, let's have pudding, Oreos, and marshmallows."

Her response to the idea that people overeat as a sexual sublimation is: "I think people just have sex because they can't afford good food." Her definitive word on the subject is: "If you're fat, just like *be* fat and shut up. And if you're thin – fuck you!"[8]

In a discussion of Louie Anderson, a young male comedian who also refers to his own overweight status in his act, Marc comments that "a modern American fat person demonstrates a powerful mastery over social convention by actively calling attention to his presumably deviant and deficient condition" (1989: 18). While it is true that Anderson highlights and underlines the fact that the accepted lore about weight is precisely a matter of convention, and is thus empowered, his humor is essentially self-deprecatory. Barr takes the next step: she rejects self-deprecation, not just by drawing attention to social convention but also by insisting that she is *not* "deviant and deficient." And, of course, the question of body image in general, and of weight in particular, has special relevance to women in our culture. Whereas a fat man like Louie Anderson can still be accepted as jolly – a large elf, if not exactly Santa – a fat woman is not generally granted that latitude. As Carol Munter has pointed out, the body is a political arena for women:

> As long as we [women] remain unempowered, we will need our conflicts to disappear through the loss of a pound of flesh because we have no access to other modes of action We're taught to shape our bodies and not the world.

> (Munter 1984: 228–9)

Implicit in Barr's resounding "fuck you" to the thin world is a call to action, a refusal to turn her energies upon herself, her resentment literally broadcast as she chews gum or Cheetos directly into the microphone.

In addition to challenging the cultural standards of attractiveness reified in Diller's and Rivers's performances, Barr aggressively points up in no uncertain terms the absurdity of men's obsession with our sexual apparatus and the symbolic authority we believe it confers upon us. In a routine on the behavior of men and women while traveling together, she refers to men's chastising women for not being able to read maps. Apparently conceding that men are in fact the better map readers, she says, "They are good at that map-reading, aren't they? 'Cause only the male mind could conceive of one inch equalling a hundred miles." She goes on to describe the only other thing that men are better at than women: "peeing out a campfire." In a comic *reductio* of phallogocentrism, she enacts a man "writing [his] name in the snow," strutting and posturing proudly over his accomplishment.

It is worth observing that these subjects and strategies appear regularly in the work of other women comedians. In a routine included on the *Women Tell the Dirtiest Jokes* video, Barbara Scott follows a very similar pattern by first criticizing men's concern with the size of their apparatus then apparently praising them for their "writing" ability.

> Men – you give them an inch, and they'll add it to their own. Guys are neat, though, 'cause guys can do great things, like write their names in the snow. All I can do is dot "i"s and an occasional colon, you know.

She then demonstrates the writing of a colon by hopping. Here, of course, the woman seems to present herself as anatomically inferior to the man; her writing is only subsidiary to male writing, limited to dotting the "i"s made by men or providing their writings with punctuation. She contextualizes this part with the first line, however, poking fun at men's concern with the size of their apparatus. Her examination of the capacities of her own apparatus thus becomes a parodic version of male behavior. The physical gesture of hopping underlines the ludicrousness of the whole enterprise of writing in the snow, much as Barr's strut deflates male pride in this pointless accomplishment so intimately bound up with men's identification with the penis (enacted, from a completely different perspective, in several of Vito Acconci's performances, discussed in Chapter 8).

Comedian Carol Leifer applies a similar comic strategy to a different topic. A staple of her stand-up act is a bit that begins with her saying, "What can I tell you about myself? I'm divorced, no

children . . . well, none that I know about" (1989). As she says these last words, she gives the audience a knowing wink and makes other stereotypically "male" gestures. Again, the anatomical comparison underlies the power of the joke, here in an attack against men's assumption that our anatomical difference somehow makes us less responsible than women for the production of children, and the assumption that one's worth as a man is measured in potency, promiscuity, and the victimization of women.

Leifer and Barr end their respective acts on very similar notes. Leifer ends with a comment on birth control, noting that the pill has wrought havoc with her hormones: "I woke up with a beard – on my dick!" Barr ends with a rejoinder to people who accuse her of being unfeminine because of her aggressive comedy. Her response: "Suck my dick!" In both instances, these last lines are the most overtly vulgar moments in the comedians' respective performances. At one level these remarks are simply what comedians refer to as "dick jokes," cheap shots whose primary impact derives exclusively from their shock value (Borns 1987: 14–15). In each case, however, the woman comedian turns the dick joke into something more challenging than a jarring instance of locker-room humor. Even though (perhaps because) Leifer's joke apparently posits the woman as the victim of a contraceptive technology invented by a man, which has, in a surreal twist, turned her *into* a man, the fact that it occurs at the end of her act is highly significant. Because of this placement, her remark joins Barr's in constituting the comic woman's most overt challenge to phallocentrism. Anne Beatts posits the image of a man without a penis as the male recuperation of womanhood; Leifer and Barr insist that their status as comics makes them self-constructed women *with* penises. By claiming to possess a metaphoric penis, each woman claims her right to the comic stage and challenges the cultural values that assert that women are not supposed to be aggressive and funny, are not supposed to have access to the power that humor represents.

The patriarchalist nightmare Beatts describes has come true: given access to the comic stage, women have indeed made men's sexual apparatus one of their ultimate jokes. They have also gone well beyond such mockery: by claiming to have a penis they are thematizing the inequity of a politics that equates possession of a penis with the symbolic authority of the phallus. This is indeed "humor that sees man much farther away than he has ever been seen" (Cixous 1981), humor that altogether usurps traditional male prerogative.

The form of Barr's television special is as important as its content. By crossing generic boundaries Barr critiques the containment of the woman within the bounds of domesticity that Mellencamp sees in situation comedy, and thus resists patriarchal recuperation by thematizing it. Indeed, *The Roseanne Barr Show* can almost be seen as a direct response to Mellencamp's perceptions of situation comedy women. Although the centerpiece of *The Roseanne Barr Show* is her stand-up act, she presents that act within a domestic context; her stand-up routine even takes place on a set decorated as a living room rather than the traditional bare stage. It is in this sense that *The Roseanne Barr Show* is a generic hybrid, combining elements of both stand-up and situation comedy. The Barr persona is, in a sense, the fulfillment of Lucy Ricardo's dreams: she is both a housewife and a professional entertainer. Although her professional status may be a sign of some sort of "progress" (from the 1950s to the 1980s? from broadcast to cable?), she remains subject to the same containing forces Lucy battled.

Far from dismissing the domestic containment implied by the treatment of the comic woman in traditional situation comedies, Barr represents and thematizes containment in her work by encasing her stand-up act in a sort of triple Pirandellian frame. The outermost frame involves scenes of Barr, the housewife, at home with her "real" family before and after her stand-up performance (her husband in these scenes is played by Bill Pentland, Barr's husband at the time). The next frame presents Barr in a trailer home behind the theatre with her fictional family, ostensibly the one she comments on in her act. The children of this family come onstage during her act, and Barr has to leave the stage to return to the trailer and keep the domestic front running smoothly. Her real family sits in the audience and watches the scenes involving her "stage" family. The third frame is the fiction that her stand-up act is a show sponsored by a product called "Fem-Rage." A male announcer asserts this fact and describes the product at the beginning and the end of Barr's act; a mock commercial for the product appears in between.

The stage family is the housewife's nightmare Barr comments on in her stand-up act: a slovenly husband in an undershirt (played by Tom Arnold, who would be her second husband) who does nothing but drink, belch, and watch sports on television; children running amok through the trailer. The real family seems much more supportive, laughing while listening to Barr practice her jokes but also criticizing her relentlessly for her jokes, for the

way they, the real family, are represented by the stage family, and so on. Barr overcomes one level of containment: as the show's creative force, she can shape the stage family any ways she likes. At the end of her performance, she returns to the trailer to find her husband asleep and transforms him magically from a slob into a tuxedoed beau who literally sweeps her off her feet. Ironically, however, this happy ending only throws her into the arms of her real family, who are harping on her act and their place in it, as always. This family lives in a comfortable-looking house, not a trailer; the opening scene is scored with a doo-wop number by Frankie Lymon and the Teenagers, as if to evoke the era of *The Donna Reed Show* and *Father Knows Best,* and these family scenes appear to have been shot on the *Happy Days* set. Barr's neighborhood, however, is not the safe, middle-class haven that is the locale for most traditional domestic situation comedies but, rather, the postmodern suburb of slasher films: those monsters from the id, Freddy Krueger and Jason (of the *Nightmare on Elm Street* and *Friday the 13th* movie series, respectively) lurk immediately outside the door. The Barr persona, a woman with considerable power to shape her own reality, is nevertheless entrapped by domestic containment: her life is quite literally in danger except when she is confined in one or another version or representation of a domestic scene.

The third frame, however, proposes a provocative response to that very entrapment. The announcer's references to Fem-Rage, which frame Barr's stand-up act, and the commercial for it within the act, contextualize her performance in a very specific way. The tag line for Fem-Rage is: "For that one time of the month you're allowed to be yourself." Because the announcer clearly speaks for Barr, he does not become the pervasive voice of male authority that dominates and domesticates the female comics in *Women Tell the Dirtiest Jokes.* That we see him at one point also tends to emphasize that he is a professional announcer in Barr's employ, not an ineffable, transcendent male presence. The commercial reveals that Fem-Rage is a product that gives women the strength to stand up to a male-dominated world. In the commercial, Barr plays Doris, a timid nuclear power plant employee whose male boss refuses to listen to her when she tells him that he is causing a meltdown. Shoved aside, she takes solace with some female coworkers who encourage her to try Fem-Rage, telling her: "It's pure encapsulated estrogen which enhances the natural female hormone, and counteracts that learned feminine social response."

Thus fortified, Doris returns to the control room, shoves her boss aside, and saves the world.

Barr's stand-up performance can easily be seen as an example of the literary/performance genre Lauren Berlant defines as "the female complaint," a genre "situated precisely in the space between a sexual politics that threatens structures of patriarchal authority and a sentimentality that confirms the inevitability of the speaker's powerlessness" (1988: 243–4). Certainly, Barr seems to present herself as the type of woman Berlant identifies as the producer of the complaint, one "who wants to maintain her alignment with men to speak oppositionally but without fear for her position within the heterosexual economy" (1988: 243).

I would argue, however, that Barr's version of the complaint finally does not merely "confirm the inevitability of the speaker's powerlessness." Berlant notes that, "as a euphemism for menstruation, 'the female complaint' typifies the banality of female suffering" thus trivializing and dismissing it (1988: 243). Through her Fem-Rage commercial, Barr undermines this trivialization, turning the female complaint – in both of Berlant's senses – quite literally into a source and sign of power: of comedic power in her stand-up act, of physical power in the mock commercial. Rage, she suggests, is the natural state of women's being, at least in a world that attempts to contain women through the imposition of "that learned feminine social response." And she makes no mystery about the source of her comedy; as the announcer tells us, Barr's humor is quite literally "brought to you by Fem-Rage." Barr presents her persona as a situation comedy housewife who is self-consciously aware of the conventions that seek to contain her, and angry about them. Her role as stand-up comic gives her a platform from which to express that anger. Although she does not escape the domestic constraints that fettered Gracie and Lucy, she resists them: she is not just silently subject to those constraints, as Gracie and Lucy finally turned out to be. Roseanne Barr's voice is that of what Judith Wilt describes as the matriarchal comic who has "given herself to love, marriage, family, community, a hostage to the fortunes of that myth" (1980: 176), but with the difference that this time the matriarch is angry, and she wants us to know it.

11 The surgical self
Body alteration and identity

The problem of theorizing the body, which, as we have seen throughout this book, is always central within performance theory and criticism, has taken on a new urgency in light of ever-accelerating technological interventions. Computer bulletinboard users take full advantage of the opportunity to create and sustain disembodied identities and discourse in cyberspace. Virtual reality technologies promise an even more developed version of disembodied experience in which the participant's body will become a somatic synthesizer whose primary function will be to produce "real" physical responses triggered by artificially created sensory stimuli. To an ever greater extent, medicine, too, takes the virtual body as its object. An MRI (magnetic resonance image) is, after all, an image of a digitized, videated body (see Kember 1995); a surgeon may then operate on that body guided by its mediatized image on a video monitor. The object of both diagnosis and treatment is a virtual body thoroughly penetrated and constructed by imaging technologies. Even as developments such as the AIDS crisis and the appearance of a flesh-eating virus remind us of the body's fragile materiality, that body is increasingly dematerialized by the medical practices designed to help it withstand destruction.

This ongoing technological dematerialization of the body has generated counter-responses, both in performance and in the culture at large. The editor of a collection of New Age-ish essays on the body writes that "We no longer listen to our bodies directly, but only to what modern science tells us about our bodies [T]he somatically felt body . . . and the tactile–kinesthetic body . . . are all but repudiated" (Sheets-Johnstone 1992: 3). Andrew Murphie notes that performative responses to the advent of the technobody range from the anxiety expressed or implied in much of the Body Art of the late 1960s and 1970s – the last-ditch celebration of "Meat Joy"

even as the "meat" itself was slipping into obsolescence – to the cyborgian ecstasy expressed to different degrees in the work of Laurie Anderson and Stelarc (1991: 210). Neither response seems satisfactory: the ecstatic celebration of the technobody is insufficiently critical, while critiques that want to restore to the body a prelapsarian integrity are merely nostalgic. Too often, performance practices that have sought to reclaim the body without denying technology have succeeded only in "making the body docile for its tasks in the technological age" (Murphie 1991: 224).

A relatively small, but intriguing, trend within performance art in the 1990s has been the performance of the medical body. Examples include my two subjects here: French performance and multi-media artist Orlan, whose current project contextualizes cosmetic surgery as performance, and Kate Bornstein, who presents her postoperative, transsexual body as the object of her performances. Given the extent to which the body is subjected to, invaded, and, ultimately, produced by technologies while under medical treatment, it may be that the medical body is the ideal vehicle for performances concerned with the fate of the body, self, and identity in a technologized and mediatized postmodern culture. Both Orlan and Bornstein evade the problematic Murphie identifies, that of performance's merely preparing the body for its subjugation by technology, by balancing celebration of technology's potential for body alteration through plastic surgery with a critique of the ways that body technologies may be used to serve dominant ideological interests. The site on which both the celebration and the critique take place is the relation of what can only be called the "self" to the body.

The relation of self to body is the central theme of popular medical discourse on plastic surgery. The author of a book entitled *Cosmetic Surgery for Women* asserts that "most people have two images of themselves: the person they see when they look in the mirror, and the ideal of who they would like to be" (Moynahan 1988: 203). Similarly, the author of *Liposuction: New Hope for a New Figure through the Art of Body Contouring* summarizes the procedure by saying: "the 'miracle' of liposuction has given you a second chance to have the kind of body you've always wanted" (Tcheupdjian 1988: 232). These statements, and many others like them, presume that what might be called the self (understood here as the functions of intellect, personality, and psyche separate from the body) constitutes the definition of the individual to which the body should be made to conform. This self is imagined as

transparent to itself, stable, and essentially static: it knows what type of body it wants and it has *always* wanted that type. Once that body type is achieved through surgery, the self has found its perfect outward representation.

This concept of self underpins the discourse not just of cosmetic surgery, but of all forms of elective plastic surgery, including gender-reassignment surgery, popularly characterized as a way of correcting nature's mistakes, of liberating the woman-trapped-in-a-man's-body or the man-trapped-in-a-woman's-body. In these cases, the gender identification of the inner self is represented as "correct," and the body is represented as the errant exterior that must be brought in line with the desires of that self. Bernice Hausmann's description of the discourse of gender-reassignment surgery applies to plastic surgery generally. "To advocate hormonal and surgical sex change as a therapeutic tool," she writes, " . . . it is necessary to acknowledge a certain autonomy of the psychological realm; in other words, it is necessary to make psychology the realm of stability and certainty, while the body is understood as mutable" (1992: 288–9). I want to argue here that both Orlan and Bornstein use the technology of plastic surgery in ways that challenge the rhetoric of the stable self intrinsic to the surgical discourse. Rather than being the means by which an integral inner identity achieves its appropriate physical representation, plastic surgery, as used by both of these artists, contributes to the definition of a posthumanist self, a self for which identity is mutable, suspended, forever in process.

THEATRE OF OPERATIONS I: ORLAN

Orlan's conceptual performance project since 1990, entitled "The Reincarnation of Ste. Orlan," consists of her undergoing a series of cosmetic surgeries intended to reconstruct her facial features to resemble those of female figures in well-known works of art. She plans to give herself "the nose of a famous, unattributed School of Fontainebleau sculpture of Diana, the mouth of Boucher's Europa, the forehead of Leonardo's Mona Lisa, the chin of Botticelli's Venus and the eyes of Gerome's Psyche" (Rose 1993: 85). She has produced a computer-generated image with these features superimposed upon her own and sometimes claims that she will continue to have operations until her face resembles the composite. Orlan had her first six surgeries in France and Belgium; her seventh operation took place in New York City in November of 1993. It was

relayed by satellite to the Sandra Gering Gallery in New York's Soho and other points around the world where audiences gathered to observe the event in progress and to communicate with the artist by phone, fax, and videophone.

Orlan stages her operations as performances, with texts, props, music, dancers, and costumes (both for herself and for the medical personnel). She also documents them on video. In order to be able to supervise these performances as director/choreographer, she accepts only a local anaesthetic for operations normally performed under general anaesthesia. In her gallery shows, Orlan displays and sells videos of the operations, photographic installations that trace her recovery from surgery and her changing appearance, and art objects incorporating vials of the bodily materials removed during her surgeries.

Unlike such earlier body artists as Chris Burden and Gina Pane, who positioned themselves as outlaws or, at least, as marginal figures performing antisocial acts in obscure corners, Orlan mounts her critique of a widespread cultural body practice from within the terms of that practice itself.[1] In this respect, her work exemplifies resistant postmodernist political art as that concept has been elaborated in earlier chapters of this book, demonstrating what Craig Owens calls "the impossible complicity" of postmodernist political art, "the necessity of participating in the very activity that is being denounced *in order to denounce it*" (1984 [1980]: 235, original emphasis).

It is important to be clear about just what is being denounced in Orlan's work. A statement Orlan circulates declares that "Orlan brings into question the standards of the beauty [sic] imposed by our society. The standardization of images inscribe themselves principly [sic] in women's flesh through the immediacy of plastic surgery . . . " (Undated b). Orlan's performed critique of physical standardization as the premise of cosmetic surgery echoes a similar emphasis in feminist accounts of cosmetic surgery as "a form of cultural signification" (Balsamo 1992: 209). As Anne Balsamo makes very clear, the discourse and practice of cosmetic surgery serve to reinforce a culturally determined canon of beauty imposed by men on women, belying the claim that the purpose of cosmetic surgery is to "enhance a woman's 'natural' beauty." The "ideal face" depicted in one surgical textbook "is of a white woman whose face is perfectly symmetrical in line and profile" (Balsamo 1992: 211). "[A]s a cultural artifact, the 'aesthetic face' symbolizes a desire for standardized ideals of Caucasian beauty" (Balsamo 1992: 212).[2]

Even the author of a book called *Cosmetic Surgery: A Consumer's Guide* unwittingly suggests the status of plastic surgery as a tool of patriarchal domination through standardization when she suggests that it and Chinese foot-binding are equivalent forms of "personal enhancement" (Rosenthal 1977: 11).

Kathryn Pauly Morgan has raised the question of what might constitute a politically valid feminist response to the practice of cosmetic surgery and proposes what she calls the Response of Appropriation. Morgan suggests that "healthy women who have a feminist understanding of cosmetic surgery are in a situation to deploy cosmetic surgery in the name of its feminist potential for parody and protest" (1991: 45). She proposes that women might have themselves altered surgically to look older and "uglier" (i.e., to defy their culture's standards of female beauty). In Morgan's view, mutilating oneself to prove a point is no worse than the normal, socially accepted practice of allowing oneself to be surgically mutilated in order to conform to cultural standards of beauty (1991: 46).

Although Orlan does not follow Morgan's proposal to the letter, it seems to me that her project is in the spirit Morgan envisions. Orlan's mix-and-match approach to selecting her new features challenges cosmetic surgery's claim of naturalism. Her new features are drawn from different periods and styles of art and show, therefore, that the concept of "natural beauty" is a matter of history and fashion, a discursive construct, not a natural phenomenon. Although Orlan has not set out to make herself look older or uglier (she insists, in fact, that she does not want to do anything to herself that will result in social rejection), her current appearance is in defiance of cultural canons of beauty. During a visit to Atlanta in 1994, her face was described repeatedly (and rather rudely) as evoking that of a space alien on *Star Trek*. The features that contribute most to her alien appearance are forehead implants intended to replicate the appearance of the Mona Lisa's famous brow. These implants are distinctly unnatural in appearance and come close to achieving Morgan's program of intentional uglification, yet they also refer to a culturally accredited icon of female beauty. (If, as is sometimes supposed, the Mona Lisa is in fact a self-portrait of Leonardo in drag, this icon is not just a standard of female beauty created by a man, but an icon that actually uses a man as its standard of female beauty.) The fact that Orlan's unconventional physiognomy is the result not of defiance of her culture's standards but, rather, of an effort to conform to canonical

models of beauty is an irony not to be overlooked. As in the case of Acconci's attempt to feminize himself, the work's critical edge derives from the *failure* of the subject to become the desired image.

Orlan's critique is given historical depth by the connections she implies between cosmetic surgery and the visual arts as cultural discourses that shape ideas of female beauty. Lynda Nead observes that "Art and medicine ... [are] the two disciplines in which the female body is most subjected to scrutiny and assessed according to historically specific norms" (1992: 11). Orlan marks the intersection of the discourses of art and medicine in their historical relationship to women by proposing to have herself inscribed with the image of the "ideal" woman as imagined by historically accredited, white male European artists through the contemporary male-dominated medical practice of cosmetic sugery. Orlan thus literalizes the concept of "aesthetic surgery" (another name cosmetic surgery goes by) and implicitly points to the parallels between the principles employed by artists and surgeons in their (re)construction of the female body. From this point of view, it becomes clear that cosmetic surgery is simply a recent arrival in a long line of aesthetic and representational practices that mold the female image to a fictional, male-imposed standard and thus objectify and commodify the woman. Orlan is becoming a sort of living palimpsest demonstrating the complicity of aesthetics, fashion, and patriarchy with the representational practices that define and enforce cultural standards of female beauty (e.g., painting, sculpture, surgery).

In one of her documents, Orlan stresses: "I am not against plastic surgery, I'm against the standard way it is used ... " (Undated a). In this respect, too, her performance is in accord with some feminist accounts of cosmetic surgery. Both Balsamo and Morgan, for example, make the same distinction as Orlan between the *technique* of cosmetic surgery and the oppressive ideological uses to which that technique can be put. Morgan raises the question of whether cosmetic surgery constitutes "a potentially liberating field of choice" for women and goes on to observe that "the technology of cosmetic surgery *could* clearly be used to create and celebrate idiosyncracy, eccentricity and uniqueness ... " (1991: 34, 35, my emphasis). In light of the critique of cosmetic surgery adumbrated in Orlan's performances, it seems clear that she opposes the use of technical intervention on the body to further ideological domination of that body, but she is not opposed to intervention on the body *per se*. She neither sees technological intervention on the body as necessarily oppressive, nor considers the body as in any sense

foundational or inviolable. Quite the contrary; far from expressing concern over "distortions of nature" attendant upon advanced technological intervention, she dismisses the ideas that "the body is sacred and magical" and "that we must accept ourselves" as "primitive" (Undated a).[3]

Whereas many body artists implicitly or explicitly emphasize the amount of pain they sustain in their work, Orlan categorically denies that she experiences pain in the course of her performances. (Her denial is, of course, strategic: there is no question but that she experiences considerable pain as a consequence of the operations.) Inasmuch as pain has often been used by feminist performance artists to represent the cultural and political oppression of women (Forte 1992: 250–4), Orlan's denial is perhaps unsettling in the context of a defense of her work as feminist. It is, however, consistent with her refusal to treat the body as foundational. Body art that foregrounds the reality of the pain the artist experiences (or risks) in the production of the work often posits the body's material presence as irreducible.[4] Orlan's work, by contrast, valorizes the dematerialized, surgically altered, posthumanist body, a body that experiences no pain even as it undergoes transformation because it has no absolute material presence; its materiality is contingent, malleable, accessible to intervention.

For Mark Dery, Orlan's "professed feminism and her manifest posthumanism cancel each other out: Those who declare war on 'what is natural' are in no position to bemoan the unnatural 'standards of beauty imposed by our society' ... " (1996: 241). I would argue that the contradiction Dery has detected in Orlan's project exists only in his description of it. For one thing, Orlan critiques cultural standards of beauty because she perceives them as oppressive to women, not because they are "unnatural." Furthermore, the notion that feminism and posthumanism are mutually exclusive implies that feminism is necessarily based on an essentialist view of the female body. In fact, there is no intrinsic contradiction between Orlan's critique of the way women's bodies are inscribed by a patriarchal society and her (perhaps techno-utopian) vision of a body that is open to other inscriptions.

Orlan's strategy of resistance is apparent not only in her manipulation of the iconography of cosmetic surgery but also in the nature of her participation in the operations. All medical practices and discourses place the patient in a position of inferiority to the practitioner. In the case of cosmetic surgery, the inequality of this relationship is inflected by the typical genders of the participants.

Referring to the way in which pre-operative consultations are staged, Carole Spitzack writes: "the male physician, the 'other,' is both knowledgeable and 'centered.' He, unlike the fragmented female patient, is in a position to render an a priori judgment" (1988: 44). Orlan's refusal to play the role of the passive patient is very important in terms of the gender politics of medicine. Far from being the passive body on which the surgeons perform, she is an active participant: the surgeons are as much performers in her theatre of operations as she is the object performed upon in their operating theatre. While I cannot claim that Orlan completely turns the tables of the power relations that define the surgical scene in her performances (she is, after all, the patient undergoing surgery), I might venture to claim that she gives as good as she gets. Just as Orlan, as patient, is inscribed within the medical discourse of cosmetic surgery, so the surgeons are inscribed within the artistic discourse of Orlan's performance: they operate against sets, wear costumes, share the operating room with dancers, take direction from a conscious patient, and so on. Arguably, they are the artisans who execute Orlan's aesthetic project, much like the fabricators who cast statues in bronze or pull prints for other artists.

Spitzack characterizes the situation of cosmetic surgery as governed by the *surveillance* of the female patient (1988: 38). In this matter, too, Orlan's leveling of the medical playing field is evident. The features with which she is inscribed are chosen by her from works of art, not in consultation with a surgeon. In an exact reversal of the usual procedure, she provides the surgeons with computer-generated images of the features she wants; usually, it is the surgeon who uses sophisticated imaging technologies to offer options to the patient. Orlan is not exempt from surveillance by the Foucauldian "medical gaze," but neither are the surgeons and their work exempt from surveillance by the aesthetic gaze represented by Orlan's video and still cameras. Surgeons use impressive "before and after" photographs in consultations with patients. Orlan takes her own "before and after" photos; in a wry comment, one of her "after" images shows her with three new features, glamorously made up, and wearing a Bride of Frankenstein wig (Frankenstein Meets *Vogue!*). The photos and videos Orlan makes of the operations and their after-effects fill in the gaps between the conventional "before" and "after" images, showing the bloody reality that intervenes between what cosmetic surgeons represent as "pathology" and "health." Through these photographs and her videos, Orlan

exposes and demystifies the surgical discourse. As Tanya Augsburg puts it, Orlan presents a "very public parody of plastic surgery as covert event, as a secret yet highly valued cultural performance" (1994). Orlan's exhibition and publication of these images constitute a form of surveillance to which most medical practitioners probably would prefer not to be subjected.[5] Indeed, an ostensibly humorous comment by a psychiatrist who was asked to write on Orlan betrays the challenge her posture poses to the authority of medical practitioners: "The subject–object Orlan is manifestly afflicted with an insidious form of artistic monomania. [. . .] She could present a danger to society in the case of an epidemic of this sort of mono-mania" (i.e., if more patients took control of the medical interventions and representations to which they are subject!) (quoted in Waxman 1993: G11).

I have detailed the way in which Orlan's performance project constitutes a feminist critique of cosmetic surgery because I find that critique cogent and powerful, particularly as it is inscribed in the flesh of the critic. My interpretation of her work is problema-tized, however, by many of Orlan's own pronouncements on the relationship between self and body in her project, statements which seem, at first glance, to echo the official rhetoric of cosmetic surgery. She has frequently said that her desire is to bring her external appearance more in line with her inner sense of self by trans-forming a masculine appearance into a more feminine one. The following is a statement of that desire, extracted from an interview with Orlan that appeared in the *Washington Post*:

> This is a meticulous attempt, little by little, to find a more fragile, reflexive, less sensual person. It's a transsexual operation – from woman to woman. I was always very timid, very tender, fragile. I was like that as a young girl. But when I wanted to do things in society I had to create an aggressive, hard personality. An external sensuality. [T]he idea is to find what I think is most deep, most elusive in me. . . . A more vulnerable person, who allows herself to show that vulnerability, tenderness and timidity. . . . It's not a question of putting on a mask, but of taking one off. . . . I think we can bring appearance around to reality.
>
> (Quoted in Waxman 1993: G10)

Orlan's suggestion here that she hopes to use cosmetic surgery (literally) to cut through the rough, masculine social mask in order to reveal her true, vulnerable, tender, feminine essence seems

disturbingly to play right into the hands of cosmetic surgery as an oppressive, gender-political cultural practice.

As someone who wants to justify an argument that Orlan's work has positive political value, I was initially distressed by these statements. Upon further reflection, I have come to see them as Warholesque provocations in which Orlan mimics the conventional discourse of the cosmetic surgery patient. There is more than a touch of irony in her description of her project as "a transsexual operation – from woman to woman." The implication that the masculine woman Orlan considers herself to be and the feminine woman she hopes to become actually belong to different sexes suggests a politically inflected reading of gender roles that belies the conventionality of Orlan's claim that she is a feminine woman waiting to be released from the prison of a masculine appearance.

Orlan's choices of iconography are also inconsistent with her expressed desire to become more feminine. According to Barbara Rose, Orlan's reasons for selecting certain artistic images as the basis for her new appearance "go beyond the appearance of their 'ideal' features . . . : she chose Diana because the goddess was an aggressive adventuress and did not submit to men . . . and the Mona Lisa because of her androgyny . . . " (1993: 85). Aggressiveness and androgyny are hardly qualities conventionally associated with the tender, vulnerable, timid feminine that Orlan describes.

Although I have suggested that Orlan's description of her project as a transsexual operation be understood as cultural criticism, it can also be taken more literally in that Orlan does exhibit the "poly-surgical attitude" that Hausmann considers "constitutive of transsexual subjectivity." Hausmann's argument is that transsexual subjectivity "is organized around a demand for sex-conversion surgery. Once this surgery is achieved, this subjectivity of demand coalesces around a new surgical goal." Therefore, many postoperative transsexuals undergo subsequent cosmetic surgeries to enhance their new gendered appearance (1992: 298–9). Like a typical cosmetic surgery patient, Orlan has stipulated that the series of operations she is undergoing is intended to realize a certain image. Her statements about the exact number of operations her project entails are wildly inconsistent, however; she has sometimes said seven, sometimes twenty, sometimes as many is it takes to make her appearance match the computer composite. Orlan, it seems, is never a finished product, never definitively post-surgical.

Hausmann's controversial reading of transsexual subjectivity[6] can help us to understand Orlan's polysurgical attitude as

something other than the scalpel-slavery it is sometimes said to be. Like transsexual subjectivity, the subjectivity Orlan adumbrates through her art is constituted by its relation to surgery. But whereas, in Hausmann's view, the transsexual exhibits a polysurgical attitude because identity *qua* transsexual is realized through surgery, Orlan's open-ended surgical program leaves her identity indeterminate. Whereas the transsexual uses repeated cosmetic surgeries to confirm a new identity established by the initial gender-reassignment surgery, Orlan's new identity is never established but always deferred until the next operation or that unspecified moment when the surgeries will end. Orlan has said that when the surgical project is complete, she will hire a public relations firm to choose a new name for her and work within the French legal system to have her new name and face legally accepted as her identity. (The fact that Orlan is not, of course, her given name is already a displacement and deferral of identity.) This plan suggests a lack of desire on Orlan's part to close off the mutability of body and identity her surgical explorations have made possible. Once the medical phase of her project ends, the legal phase begins; once the face is in its final form, the name will be put into play.

THEATRE OF OPERATIONS II: KATE BORNSTEIN

If Orlan can be described as a sort of figurative transsexual, that designation applies literally to actor/performer and author Kate Bornstein, a postoperative man–woman transsexual. In her book *Gender Outlaw*, Bornstein identifies gender as the single most oppressive socio-cultural discourse and advocates a program of active resistance to gender categories and their normative force. Like Judith Butler, Bornstein points to the moment of "gendering" at birth by a doctor as the subject's initiation into the system of oppression (1994: 22; Butler 1993: 7–8). Like many feminist writers, Bornstein rejects essentialism, particularly the essentialism of what she calls "biological gender," the belief that gender is a "corporal or chemical essence" (1994: 30). (Bornstein's attack on essentialism is, in part, a response to feminists who have rejected her for not being a "real" woman.) Whereas sociologist Claudette Guillaumin claims that society takes males and females and makes them into "men" and "women" by forcing adherence to physical and behavioral norms (1993: 41), Bornstein argues that society constructs "males" and "females" by forcing adherence to biological norms. For Bornstein, the self is gender-amorphous, holding within itself the

potential for many different and changing gender and sexual identities. To settle for a singular gender is an act of self-denial: "it's something we do to avoid or deny our full self-expression" (1994: 45).

Hausmann points out that the discourse of gender-altering surgery displays a "reproductive bias" in its approach to intersex subjects (i.e., hermaphrodites) which translates into a heterosexual bias in its approach to transsexual subjects:

> It is well known within the transsexual community that to admit the possibility of a homosexual postoperative life is to risk losing the possibility of admission to a surgical program. An expression of disgust toward homosexuality and a representation of one's own desire as authentically heterosexual (only trapped in the wrong genital structure) are established points in the official etiology of male transsexualism.
>
> (Hausmann 1992: 293–4)

Bornstein's relationship to gender-reassignment surgery parallels Orlan's relationship to cosmetic surgery: she simultaneously echoes the conventional surgical discourse and resists that discourse from within its own terms.[7] Bornstein reproduces the conventional discourse by stressing how much happier she is with the "surgically-constructed, hormonally-enhanced woman's body" she now has than she was with a man's body (1994: 11). She resists the surgical discourse's reproductive bias in her assertion of a lesbian identity. In her play *Hidden: A Gender*, Bornstein addresses this issue through a dialogue between the autobiographical character Herman and Doc Grinder, a burlesque representative of the medical establishment. To Doc Grinder's insistence that Herman cannot become a woman and continue to love women, Herman replies that "My gender identity has nothing to do with my sexual preference. . . . My being a woman does not mean I must love men. These are two separate issues" (1994: 191). This is a pointed rejoinder to the surgical discourse described by Hausmann, a discourse that refuses to treat gender identity and sexual orientation as *separate* issues but demands that the desire for transsexual surgery be linked with a reconfigured heterosexual identity.

Bornstein enacts perhaps her most radical critique of the surgical discourse by asserting that her new female body is not the final expression of her inner self. In a poetic monologue entitled "The Seven Year Itch," she explains that she underwent gender-reassignment surgery with the conventional expectations all plastic

surgery patients are supposed to have – that she will finally have the body she's always wanted:

> when I went through with my gender change,
> when I had the surgery,
> when they raised and lowered the knife,
> when they cut through the blood and bone and nerve,
> I thought to myself now I'm gonna know some peace of mind . . .
> I said to myself the war is over,
> let's build a memorial to the dead.
> But it didn't work out that way.
> There were still wars going on in my brain.
>
> (Bornstein 1994: 230)

Bornstein's resistance to the surgical discourse is manifest in her inability to consider her male self as simply "dead" and her refusal to "become" a naturalized woman by suppressing the fact that she was once a man and constructing a new biography for herself as a woman, as her doctors have encouraged her (and all other gender-reassignment patients) to do.

Contradicting the popular perception of the male–female transsexual as originally a woman-trapped-in-a-man's body and challenging the discourse of plastic surgery as the technology that enables the self to construct its own best external representation, she asserts: "I know I'm not a man . . . and . . . I'm probably not a woman either . . . " (1994: 8). Observing in "The Seven Year Itch" that the human epidermis ostensibly replaces itself fully every seven years, Bornstein asserts that her current body is a "home-grown" female body, but challenges essentialism by warning us not to assume that her identity is therefore now fixed: "by the time the next seven years have come and gone/I'm gonna be new all over again" (1994: 228, 238). She imagines transsexualism not as a crossing over from one side of the gender binary to the other but as "the in-between place . . . a place that lies outside the borders of what's culturally acceptable" (1994: 94) whose occupants possess fluid gender identities: "Gender fluidity is the ability to freely and knowingly become one or many of a limitless number of genders, for any length of time, at any rate of change" (1994: 52). Indeed, the only time when Herman and Herculine, the two transsexual characters in *Hidden: A Gender*, are shown to be truly happy is when they achieve a state of gender-amorphousness as a transitional moment in their respective transsexual transformations, and are given the non-gender-specific character designations of "One" and "Another"

(1994: 210–13). Once their gender transformations are completed, they can no longer even remember this euphoric state (1994: 220).

Clearly, Bornstein valorizes "the explosive possibility of . . . multiply signifying sex and sexuality" that the protocols of gender-reassignment surgery seek to contain and suppress (Hausmann 1992: 293). Bornstein imagines surgery as a means for achieving a partial and temporary physical identity rather than a definitive external expression of a stable inner self. Rather than seeing the psychological as the realm of certainty to which the body must be made to conform, Bornstein sees the psychological as inherently unstable and indeterminate, at least where gender identity and sexual preference are concerned. The body can be made to conform to the self's changing sense of gender and sexuality but that process never yields a final product.

SURGICAL SELVES

Plastic surgery plays a central role in both Orlan's and Kate Bornstein's performance work, and both resist the surgical discourse's deterministic characterization of the relationship between self and body even as they present themselves as products of that very discourse. Orlan claims to want to bring her external appearance in line with a clearly articulated and stable sense of self but her project actually consists of an endless deferral of the moment at which that new identity will be fixed on her body. Although Bornstein is, at least for the moment, a finished surgical product, she sees surgery as an inadequate tool for the expression of an inherently indeterminate self which, like the body, must always be seen as subject to radical transformation.

In proposing a body that is continually available to surgical intervention, Orlan and Bornstein court the problematic identified by Murphie: there certainly is a danger that the net effect of their performance work could be to model a body that is so comfortable with surgical alteration that the performance ends up merely "making the body docile for its tasks in the technological age." By interrogating plastic surgery as an ideological practice, Orlan and Bornstein suggest that their performances should not be taken as uncritical celebrations of technological intervention on the body. They nevertheless embrace the surgically constructed body and refuse to ground their respective critiques of plastic surgery in a foundationalist concept of the "natural" body, a body prior to technological inscription that can somehow be reclaimed. In this

respect, their work represents a further elaboration of the post-modern body concept discussed in Chapter 7. A body that is understood to be discursively produced and ideologically encoded can also be seen as a site of resistance where hegemonic discourses and codings can be exposed, deconstructed, and, perhaps, rewritten. Though the balance between critique and complicity thus achieved is fragile and precarious, I think Orlan's and Bornstein's performances present realistic and progressive insights into the negotiations over the technological construction of the body in which we will all undoubtedly have to engage to an increasing extent as we enter the twenty-first century.

Notes

1 INTRODUCTION

1 One indication of this continuity is that the particular version of Performance Studies I practice emphasizes "theatrical" performance over cultural performance. Marvin Carlson draws this distinction between performance of whatever kind that *consciously* engages its audience in "cultural and social metacommentary" and cultural performances (such as rituals, ceremonies, etc.) that can be interpreted as providing such commentary but whose overt purposes lie elsewhere (1996: 196).

2 See Worthen (1995) for a carefully reasoned response to Schechner, and the many responses to Worthen printed in the same issue of *TDR*. For a less temperate response to Schechner, see Hornby (1995).

3 This passage is clearly intended as a rejoinder to Schechner's advocacy of the elimination of theatre departments in favor of performance departments. It is also intended, however, as a rejoinder to the rhetorical excesses of some of those who defend the purity of Theatre Studies against the sullying influence of Performance Studies.

4 It was with great pleasure, therefore, that I discovered that fully a third of the essays in an important recent anthology entitled *Performativity and Performance* (Parker and Sedgwick 1995) are devoted to the concept of catharsis.

5 The initial panels at the 1984 meeting were followed up in 1985, first at a spring symposium I directed at the College of William and Mary in Virginia entitled "Toward a New Poetics of Theatre: Critical Theory and Its Application to Performance," then with a panel I chaired at the summer ATA meeting in Toronto, entitled "Toward a New Poetics II."

6 For an overview of recent theories of the body and its cultural significations, including the issue of essentialist and non-essentialist views, see Auslander (1995a).

2 "HOLY THEATRE" AND CATHARSIS

1 The examples of "holy" theatre mentioned by Brook are the work of Artaud, Grotowski, the Living Theatre, Samuel Beckett, and Merce Cunningham.

2 My discussion of Aristotle follows House (1958: 100–11) and Brunius (1966: 55–9). Both use J. Burnett's translation of Aristotle.

3 For an analysis of Aristotle which does not accept the idea that catharsis is an educative function, see Ford (1995). Ford argues that Aristotle's minimal discussion of catharsis in the *Poetics* indicates that Aristotle considered the psychological and affective results of tragedy to lie outside the proper concerns of poetics. While Aristotle could acknowledge those effects in the *Poetics*, he had to define theatre as an art form in more objective terms.

4 All translations from French texts by Copeau and Artaud are my own.

5 Brook states: "We used Artaud's striking title to cover our own experiments . . . although many of the exercises were very far from what he had proposed" (1969: 45).

6 There is an infrequently acknowledged historical link between Artaud and Copeau in the person of Charles Dullin. Dullin, who had acted under Copeau at the Vieux-Colombier, employed Artaud in his own company during 1921. The possibility of an indirect Copeauvian influence on Artaud, transmitted through Dullin, has never been fully investigated to my knowledge.

7 Cf. Copeau: "Le tout du Comédien, c'est de se donner" (1955: 31).

8 Grotowski's performance work can be divided into three phases: his theatre work with the Teatr Laboratorium and others, his subsequent paratheatrical exercises, and the later Theatre of Sources. I allude here to the first two phases. The transcultural experiments Grotowski has carried out under the Theatre of Sources rubric somewhat resemble Brook's cross-cultural performance experiments. For Grotowski's overview of his own career, see "From the Theatre Company to Art as Vehicle" (in Richards 1995: 115–35).

3 "JUST BE YOUR SELF": *LOGOCENTRISM* AND *DIFFÉRANCE* IN PERFORMANCE THEORY

1 In an article exploring the question of deconstruction in the theatre, Gerald Rabkin (1983) indicates that the director is the primary "deconstructor" of the theatrical text. In so saying, Rabkin implicitly grants the director a logocentric privilege that is incompatible with a deconstructive perspective. If we take Derrida's notion of *différance* seriously, we must conclude that what we commonly refer to as the director's "concept" does not guide the production but is, in fact, generated by the production. The apparent presence of a concept behind the production is an effect of the play of difference that constitutes the production itself, its relation to the play text, to other productions of the same text, etc.

2 Wiles's suggestion that Stanislavski's use of a fictional character, Tortsov, to present his ideas makes his system seem more unified and "organic" than it actually is suggests an interesting avenue for Stanislavski criticism.

3 Josette Féral (1982) addresses similar issues in her discussion of the

relationship between theatre and performance, describing performance as made up of a flow of theatrical signifiers divorced from their conventional signifying functions. Rather than describing this flow as the pure play of *différance*, however, she suggests that performance's use of theatrical signifiers makes performance deconstructive of theatre. See Chapter 5 for further discussion of Féral.

4 My continued use of the word "poetics" reflects this essay's origin as a contribution to the "New Poetics" panel discussed in the Introduction. This passage, and the immediately preceding one, is a revised version of a statement that occasion seemed to demand on the viability of deconstruction as the basis for a new poetics of theatre.

5 Given that Brecht surely must be said to have achieved at least partly deconstructive objectives in his approach to theatrical production, Derrida's dismissal of him is surprisingly and unjustifiably abrupt: "Alienation only consecrates . . . the nonparticipation of spectators (and even of directors and actors) in the creative act" (1978: 244).

4 TASK AND VISION: WILLEM DAFOE IN *LSD*

1 All quotations from Willem Dafoe are from a personal interview with the author.

2 The discussion here is of the late Ron Vawter, who died of AIDS a decade after this essay was originally published. The fact that Vawter was gay, and had a military background, may have contributed to his fiercely funny, satirical portraits of heterosexual machismo in Wooster Group performances.

3 Since this essay was written, Dafoe has appeared in a much greater range of film roles than he had at that point, including "sensitive" men and, even, victims.

4 For a discussion of postmodern catharsis with a very different emphasis, see Diamond (1995).

5 For further discussion of the relationship between film acting and avant-gardistic performance, see Auslander (1996: 201–2). For an analysis of the cultural situation in which performers pass between experimental and commercial work, see Auslander (1992a: 57–81).

5 *PRESENCE* AND *THEATRICALITY* IN THE DISCOURSE OF PERFORMANCE AND THE VISUAL ARTS

1 There is an unexpected kinship between Fried and Jean-François Lyotard, who also sees postmodernism as emerging within modernism:

The postmodern would be that which, in the modern, puts forward the unpresentable in presentation itself; that which denies itself the solace of good forms, the consensus of a taste which would make it possible to share collectively the nostalgia for the unattainable; that

which searches for new presentations, not in order to enjoy them but in order to impart a stronger sense of the unpresentable.

(Lyotard 1984 [1982]: 81)

To avoid a lengthy discussion, I will only suggest here that Fried sees the impurity of the theatrical (*"what lies* between *the arts"*) precisely as a violation of the integrity of "good forms" and taste, and, therefore, as "unpresentable" in the context of modernism. I am not suggesting, of course, that Lyotard shares Fried's negative view of postmodernism.

2 For a fuller discussion of Féral's and Pontbriand's respective essays in the context of postmodernist performance criticism, see Auslander (1992a: 35–55).

3 It is worth noting that Willem Dafoe's description of his work with the Wooster Group corresponds in many particulars to Féral's account of performance: as discussed in the previous chapter, he, too, stresses the lack of illusionism, the refusal of theatrical representation, and the sense of a continuous present moment in Wooster Group performances.

6 TOWARD A CONCEPT OF THE POLITICAL IN POSTMODERN THEATRE

1 Richard Schechner was greatly concerned with the frontal orientation of post Viet Nam-era experimental theatre

because to experiment with the space of the whole theatre, and to bring the theatrical event into the world outside the theatre building, is to investigate most directly the relationships between performers and spectators, and between theatrical events and social life. I read the retreat to frontal staging as an avoidance of dealing with these relationships.

(Schechner 1982: 29)

In response to Schechner, Timothy Murray argues that

the theatricality of the van-guard demystifies the hegemonic ideology of progressive avant-gardism [T]he van-guard directly confronts not merely a relevant political position, but any attempts to deny the social function of aesthetic praxis as the work of criticism in action

(Murray 1984: 99)

2 Sue-Ellen Case and Jeanie Forte argue that "The problem is that in the closed system of deconstruction the only possible reference is to the dominant ideology it deconstructs. In effect, it reproduces things as they are" (1985: 64). I take up this issue later in the present essay.

3 Patrice Pavis sees the current experimental theatre's "fascination with textual manipulation and the deconstruction of every work" as symptomatic of a general postmodern depoliticization (1992 [1986]: 70).

Johannes Birringer describes the textual theory of Derrida and Barthes as deconstruction "at its politically weakest," locating apoliticality within deconstruction itself (1991 [1985]: 171).

4 Not all commentators agree, of course. Mike Davis, rejecting Fredric Jameson's (1984b) characterization of the postmodern as "late capitalist," takes the view that we are witnessing "not a new, higher stage of capitalism . . . but a morbid symptom of the financial overaccumulation prolonged by the weakness of the US labour movement and productive capital's fear of a general collapse" (1985: 109). Barbara Foley (1985), in a general attack on deconstruction, suggests that a classical Marxist/Leninist analysis remains appropriate to contemporary society. Jameson (1984a) makes the point that any argument concerning postmodernism, whether favorable or antagonistic toward its cultural products, whether affirming or denying the very notion of a postmodern era, reflects the arguer's ideology.

5 My placement of the historical point of transition from modernism to postmodernism in theatre is later than others' formulations for other cultural and artistic areas (e.g., architecture, the visual arts). Perhaps the conventional wisdom that theatre is a relatively conservative art form which tends to follow rather than to initiate trends is apposite here.

6 Although I cite Chaikin's book as a reference point, his own theorizing is more sophisticated, complex, and contradictory than the general trend discussed in this passage.

7 For a classic formulation of dramatic characters as autonomous beings which may possess the actor, see Dullin (1970).

8 R. G. Davis pointed out in 1971 that the Yippies and other radicals who sought to produce change through the media failed to recognize that the power of the media belongs to those who own them, not necessarily to those who manage to have their messages conveyed by them (1975: 167–8).

9 Mary Daly argues that the witch hunts in medieval and Renaissance Europe were intended "to break down and destroy strong women," "to purify society of the existence and the potential existence of such women," especially those not "defined by assimilation into the patriarchal family" (1978: 183–4). Although Daly does not discuss the Salem trials, her analysis could surely be applied both to a feminist/revisionist history of those events and to *The Crucible*. Abigail's strong assertion of her sexuality in Miller's play certainly marks her as unassimilable into the patriarchal family as it is represented there.

10 LeCompte's own account of the Wooster Group's political stance is that they are looking for "another way of making theatre, another way of viewing politics that is not literal, issue-oriented – it's not attached, so to speak" (quoted in Aronson 1985: 74).

11 See also Rabkin (1985), who attempts to use Barthes's distinction between "work" and "text" in constructing a defense of authorial rights on the grounds that protection of an author's control over her product will encourage good writing.

12 A quotation from Leary which appeared on a poster for *LSD* (reproduced in Aronson 1985: 69) describes his conflict with social authority in terms of the Harvard–Yale football rivalry: as a perennial, necessary, essentially symbolic conflict in which each side plays by known rules and expects the other side to respond in kind. The conflict between Miller and the Wooster Group can be seen profitably in the same terms. The role of the Wooster Group in the game is to resist the legal requirements governing their use of Miller's text. That they played resistantly rather than transgressively is indicated by the fact that they stopped performing the piece rather than provoke a court battle.

7 EMBODIMENT: THE POLITICS OF POSTMODERN DANCE

1 Foster's reading of dance through theory has implications for theory as well as for dance. In the following passage, Vincent B. Leitch quotes, then explicates, a section of J. Hillis Miller's "Fiction and Repetition: *Tess of the d'Urbervilles*" (1975: 58–9):

"[T]he reader must execute a *lateral dance of interpretation* to explicate any given passage, without ever reaching, in this sideways movement, any passage that is chief, original, or originating, a sovereign principle of explanation" [original emphasis].

The metaphor of the dance reveals for us the moves in the act of interpretation. Insofar as a text is a spatialized tapestry of myriad interlocking threads (for example, words, images, characters, themes), it is constituted as level, meaning that no spot or passage can rise above any other. Nothing may be privileged: there can be no origin, no end, no priority element, no sovereign principle. To the extent that a text is a temporal chain of interwoven elements, the reader can only transfer elements from one sequence to another, stopping now and then – at will – to confer meaning through an arbitrary act of interpretation. There can be no "true" explanation or meaning of the text – only more or less vital patterns of textual connections. Thus, the dance of deconstruction is ultimately liberated and hollowed out by difference. The parallel here with contemporary dancing is remarkably strong: after the waltz we have the swinger's solo; and at the disco the music never stops, the dancers merely walk off when they've had enough.

(Leitch 1983: 192–3)

What model of necessarily repetitive dance does Leitch have in mind here? Foster's model of dance as discourse hardly supports Leitch's implicit contention that dance is a level signifying field in which "nothing may be privileged." Indeed, Foster is concerned with developing a structural vocabulary to show precisely that different forms of dance can and do privilege different approaches to the subject/body relation, amongst other things. And just what are the

implications of Leitch's use of social dances (waltz, "swinger's solo"[?], disco) as his metaphors for deconstruction? Does this mean that literary interpretation is somehow enmeshed in private social ritual rather than presented before an audience as aesthetic performance, like concert dance? Foster's use of theory to "de-nature" traditional assumptions about dance throws into relief theorists' use of dance and other performance modes as metaphors when explicating their theory.

2 Although the descriptive material related to the work of the Grand Union, Meredith Monk, and Twyla Tharp is largely identical in Foster's two texts (1985, 1986), the frameworks in which it appears are very different. In the earlier text, Foster refers to the work as postmodernist, and her analysis is explicitly political in motive; in the later text, she does not use the term "postmodernist" and presents the same material primarily to elaborate a paradigm of danced representation. When citing material that appears in both sources in identical form, I have endeavored to cite both texts. An attentive reader will thus be able to see the ways in which the two texts differ in emphasis.

3 For a critique of Foster's historical and critical categories and the accuracy of her descriptions of dance practices, see Siegel (1988).

4 Although Foster borrows her notion of the spectator's participation in choreography from Barthes's idea of the writerly Text (as opposed to the readerly Work), her version of the concept is quite different from Barthes's. Foster's description of "dance that is open-ended and delivers no single message" (1986: 226) more or less corresponds to Barthes's description of Text as "plural" (1977: 159). However, Foster suggests that each spectator engages this plurality by "choosing what to watch" (1986: 226) and thus constructing an interptetation. Each spectator realizes that her interpretation is but one among many, all equally valid. In Foster's democratic vision, the dance shows the spectators "how, ultimately, all interpretations, including their own, would be woven together in one collective fabric" (1986: 223). Foster's conception of the open-ended dance as interpretable, even if polyvalent, is not in agreement with Barthes, for whom Text "answers not to an interpretation, even a liberal one, but to an explosion, a dissemination." Rather than offering the reader options, Text overwhelms the reader, reducing her to a "passably empty subject," "someone at a loose end" (Barthes 1977: 159). (Typically, Barthes likens the experience of Text to *jouissance* (1977: 164).) The Barthesian Text does not permit many equally valid interpretations, but permits no "interpretations" at all, because it is not "readable" in that way. In her aesthetic/social vision of a dance Text that is interpreted by its spectators into a group of discrete Works, all of which coexist in democratic harmony, Foster reinscribes the potentially explosive Text within a monistic, rationalistic concept of a social whole. Barthes's social vision of the Text is more ambiguous and riskier: "the Text achieves, if not the transparence of social relations, at least that of language relations; the Text is that space where no language has a hold over any other, where languages circulate (keeping the circular sense of the term)"

(1977: 164). Barthes's formulation accords no privilege to the "language" of egalitarianism – his emphasis on the notion of circularity asserts the permanent instability of Text, which never resolves itself into the interpretive democracy posited by Foster.

5 Hal Foster employs the adjective "resistant" in this context; Susan Foster uses "resistive." I use the former.

6 Theatrical semiotics typically depart from the assumption that anything (or body) that appears in a performance context becomes a sign. Keir Elam, for instance, argues that "whatever cannot be related to the representation as such is converted into a sign of the actor's very reality – it is not, in any case, excluded from semiosis" (1980: 9). I find that Foster's formulation that the running dancer in the Hay piece represents herself and Elam's notion that the actor can be a sign for her own reality without occupying that reality tend toward infinite regress. For a different approach to this issue, see Passow, who argues that semiosis is not simply a given of the performance context, that in some cases the spectator does respond to the performer's body as a "real" body, not an iconic sign for a body (1981, particularly: 244–7).

7 It is, of course, possible to theorize the body in performance without insisting that all performance manifestations are representations and also without slipping into essentialism. For example, one can see the performing body as doubly coded, defined by the codes of a particular performance, but always already inscribed, *qua* social body, by social discourses (e.g., science, medicine, hygiene, law, etc.). The study of the body in performance would thus become the study of the interplay of these encodings. I discuss this possibility further in Chapter 8.

8 Foster sees Cunningham's work as a necessary condition for the evolution of postmodern dance but argues that, for all its irony, Cunningham's choreography is not postmodernist because it is not concerned with the ideological encoding of the body: it "never unmask[s] human movement as a signifying practice" (1985: 46). Foster's definition of postmodernism would seem to include the idea that postmodernist art deconstructs representations conceived as ideological for ideological ends, either progressive (resistant) or reactionary. Although Foster does not describe Hay's work as postmodernist, she clearly feels that it exhibits features similar to those of work she does so label.

Sally Banes also places Cunningham "on the border between modern and post-modern dance" (1987: xvi), arguing that postmodern choreographers have carried Cunningham's theories further than he has (1987: 7). She includes Hay as a full-fledged postmodernist. Banes identifies three different categories of postmodern dance that have appeared since the 1960s and argues that all three can be grouped meaningfully under the rubric of postmodernism. Because Banes sees postmodernism as a continuation of the oppositional tradition of modernist avant-gardism, she excludes Tharp, who works with ballet companies and for the movies, from the ranks of postmodern choreographers, referring to her as a former postmodernist who moved over to the mainstream (1987: 19).

Roger Copeland, who would like to include Cunningham among the postmodernists, sees "compelling justifications for backdating the origins of postmodern dance to the mid-1950s, when Cunningham began to consolidate an approach to choreography that persists to this day" (1983: 34). Copeland also sees Hay as postmodernist, and so suggests that there may be two types of postmodern dance, "the analytic" and "the therapeutic" (1983: 33). Drawing his definition of postmodernism largely from architectural criticism, Copeland suggests that Tharp may be the quintessential postmodernist choreographer

if . . . we understand the essential characteristics of postmodern architecture to be a retreat from the doctrines of purity and unity, a learned and eclectic historicism, and perhaps a new determination to heal the century-old rift between the modernist avant-garde and the middle class mainstream.

(Copeland 1983: 39)

9 Foster describes her approach to dance history as a Foucauldian "archaeology of dance" rather than a history *per se* (1986: 248, n. 2). For Foucault, however, the present is unknowable: we cannot grasp the contents of the "positive unconscious of knowledge" that determines the "rules of formation" of the discourses of our own age (Foucault 1973: xi; see also Leitch 1983: 147). If an archaeology of the present is impossible, how can our knowledge of the present, governed by rules we cannot perceive, be used to guide an archaeological exploration of the past? I have already implied here (and shall imply again) that Foster's history is teleological, which Foucault's discontinuous and localizing archaeology most definitely is not.

8 VITO ACCONCI AND THE POLITICS OF THE BODY IN POSTMODERN PERFORMANCE

1 Elam grants that iconism is "wholly conventional" and that convention is, in part, ideological (1980: 21–3, 52). He insists, however, that anything that occurs on a stage is a sign (see Chapter 7, n. 6). Wladimir Krysinski (1981) argues that the body's instinctual charge undermines its subjugation to the *logos* of the dramatic text; he wants to develop a theory of theatrical semiotics that can account for this process.

2 Joseph Roach (1985) has done an admirable job of tracing the relationships among scientific and medical discourses and ideas on acting in the seventeenth and eighteenth centuries. However, he does not investigate the ideological ramifications of those discourses.

3 See Kirby (1969) for a definition of Activities. Acconci describes some of his own work as activities, though he uses the term differently than Kirby.

4 See, e.g., Heimel (1983): "One must, first and foremost, understand

the psychology of the penis" (121); "The penis knows its Ten Commandments" (186).

5 I discuss the work of Orlan and Kate Bornstein, two other performance artists whose work focuses on issues of gender and body transformation, in Chapter 11.

9 BOAL, BLAU, BRECHT: THE BODY

1 For discussions of the issue of gender in Boal's work, see Jan Cohen-Cruz and Mady Schutzman (1990) and Berenice Fisher (1994).

2 For a discussion of the ecstatic turn in American political theatre, see Auslander (1992a: 35–42).

10 "BROUGHT TO YOU BY FEM-RAGE": STAND-UP COMEDY AND THE POLITICS OF GENDER

1 One provocative piece of show business lore is that many young female stand-up comics, including Judy Tenuta and Carrie Snow, got their start in a way that is a mirror image of the traditional avenue followed by male comedians of previous generations – by emceeing at male strip clubs.

2 An essentialist view of male humor, however, is no more acceptable than an essentialist view of female humor. It is important to note that men do not necessarily enjoy humor that reaffirms cultural and social dominance, such as racist or sexist humor. During a visit to a comedy club, I saw a black male comic berate his substantially (though not exclusively) white male audience because it would not laugh at his crudely sexist jokes. His repeated rejoinder was: "What is it – fag night at the club?" A more important case in point is that of the comic Arsenio Hall, who apologized for the poor judgment of a comic who had been on his late-night television talk show. The comic had done a tasteless "date rape" joke; Hall interrupted his own monologue the next night to apologize.

3 Beatts's hypothesis may have some empirical grounding. Melvin Helitzer reports:

Research on sexual humor indicated that student joke tellers were more likely to select jokes with sexist content discriminating against males regardless of the gender of the performer or the audience. And the most common subjects were those which denigrated bodily parts and sexual performance. It is, therefore, hostility against male sexual inadequacy, more than sexism against women, that appears to be the dominant theme of most sexual humor.

(Helitzer 1984: 25)

Helitzer's finding is suspect because he does not specify the nature of the "research" that produced it. It also seems to be challenged, at least in part, by a study in which different versions of the same jokes were

used: "Both males and females appreciated the joke versions in which a male dominated a female significantly more than those in which a female dominated a male" (Zillman and Cantor 1976: 97). Nevertheless, Helitzer's finding certainly suggests that if women's humor implicitly (or explicitly) attacks phallic authority, it aims for a vulnerable target.

4 I have borrowed the expression "kindly father" from Patricia Mellencamp (1986), who uses it to designate male characters in television situation comedies who keep their "zany" female counterparts in check (e.g., Ricky Ricardo and George Burns). I return to Mellencamp's argument later in the present essay.

5 In moving from a discussion of the possibilities for female empowerment inherent in the comic/audience dynamic to a discussion of the dangers of recuperation inherent in cultural media, I have also moved from the context of "live" performance to that of mediated performance. It would not be valid to conclude, however, that live performance necessarily offers more of a foothold for critical practice and empowerment than mediated performance. It is true that the comic/audience dynamic that informs club performances does not occur when the same performance appears on television, with the studio audience serving as a surrogate for the home audience and cueing the latter's responses. Nevertheless, as John Fiske (1987) points out, television audiences exercise considerable discretion in how they use and interpret the texts offered to them; the fact of mediation does not in itself determine the "meaning" of the mediated text.

6 For a while, Joan Rivers was the only woman host of a late-night television talk show, but that did not last. At present, Rosie O'Donnell, is enjoying success with a daytime talk show formatted like a late-night show. There is speculation that her success will pave the way for other, similar shows with female hosts.

7 For a discussion of stand-up comedy in the context of postmodernism, see Auslander (1992b).

8 Much has changed since I first formulated these ideas in 1988. After divorcing her first husband and marrying comic Tom Arnold, Roseanne Barr, then known as Roseanne Arnold, experienced several years of highly negative publicity concerning her divorce, her rowdy relationship with Arnold, her controversial rendition of the national anthem at a baseball game, and her alleged intractability as the star of the highest-rated television show in the country. She then seemed to undertake a specific effort to rehabilitate her public image, in part by becoming an advocate of weight-loss and cosmetic surgery. In so doing, she sacrificed much of the edge that originally gave her stand-up comedy its pith and power. After divorcing Arnold, she returned to something like her earlier, ornerier persona, while at the same time presenting herself as the victim of an abusive upbringing. Although she is now (1996) known only as "Roseanne," I refer to her here by the name she used when she produced the performance I am analyzing.

11 THE SURGICAL SELF: BODY ALTERATION AND IDENTITY

1 Laura Cottingham makes the same observation in a more negative context. Referring to Burden's having had himself shot for one piece and crucified on a Volkswagen for another, she writes:

> Neither of these actions collude in any way with actions considered normative in society; the same cannot be said for a woman undergoing facial surgery in an attempt to look like an idea of beauty. Similarly, Burden's acts were anarchic in the sense that he did not submit to any institutional authority.... Orlan's performance, however, delivers her body to one of the most authoritative institutions in modern society – the medical establishment.
>
> (Cottingham 1994: 60)

I hope to make clear here that both the idea of beauty underpinning Orlan's project and the ways she delivers herself to the medical establishment are points of resistance to dominant discourses.

2 Kathryn Pauly Morgan notes that this standardized ideal is embraced by many of the women who seek plastic surgery: Jewish women want smaller noses, Asian women want their eyes "Westernized," African-American women want lighter skin. "What is being created in all of these instances is not simply beautiful bodies and faces but white, Western, Anglo-Saxon bodies in a racist, anti-Semitic context" (1991: 36). While it is true that individual women freely choose to have this "elective" surgery, "the reality is often the transformation of oneself as a woman for the eye, the hand, and the approval of the Other – the lover . . . , the customers, the employers, the social peers" (1991: 38).

3 These quotations cast doubt on the validity of Rose's claim that Orlan's "program also provides a devastating critique of the psychological and physical consequences of the distortions of nature implied in the advanced technologies discovered by scientific research, from microsurgery to organ transplants to potential genetic engineering" (1993: 87).

4 "I searched for those circumstances in which the body is undeniable, when the body's material presence is a condition of the circumstance. Interestingly, one is that of pain, and another is that of live performance: two cases where the body must be acknowledged" (Forte 1992: 251).

5 It has been pointed out to me that inasmuch as the processes and results of plastic surgery are readily available for viewing on cable television and the Internet, it can hardly be seen any longer as a covert event in need of demystification. There is some truth to this. But I would point out, first of all, that the way plastic surgery is represented on television and the Internet is controlled by the surgeons, not their patients. Orlan presents the procedures and results of cosmetic surgery from a radically different perspective. Secondly, even though the technical procedures and effects of plastic surgery are much more publicly visible than in the past, the fact that an individual has had

plastic surgery is still kept secret more often than not. For both these reasons, Augsburg's description remains valid and Orlan's intervention remains significant.

6 I realize that many members of the transsexual community do not consider Hausmann's account of their subjectivity to be valid. My use of her theorization is not intended as an endorsement of the accuracy of her claims. I employ her essay because I find that her concept of the polysurgical attitude sheds some light on the performance practice of Orlan, for whom transsexuality is a metaphor. When I return to Hausmann in my discussion of Kate Bornstein below, I use her work to establish the normative, institutional view of transsexuality against which Bornstein is reacting.

7 It should be clear that, although I am suggesting a parallel between Bornstein's and Orlan's respective performance works at a political level, I am not suggesting that the tone of Bornstein's writing and performance partakes of the same postmodernist, posthumanist irony that informs Orlan's performance project. Bornstein is notable, in fact, for the open sincerity of her performance persona and the absence of irony in her work.

Bibliography

Acconci, Vito (1972) Special Acconci issue of *Avalanche*, 6.
Allen, Robert C. (1987) "Reader-oriented Criticism and Television," in *Channels of Discourse: Television and Contemporary Criticism*, R. C. Allen (ed.), Chapel Hill, NC: University of North Carolina Press, pp. 74–112.
Anders, France (1959) *Jacques Copeau et le Cartel des Quatre*, Paris: Nizet.
Appia, Adolphe (1960) *The Work of Living Art*, Coral Gables, FL: University of Miami Press.
—— (1962) *Music and the Art of the Theatre*, Coral Gables, FL: University of Miami Press.
Apte, Mahadev L. (1985) *Humor and Laughter: An Anthropological Approach*, Ithaca, NY: Cornell University Press.
Arac, Jonathan (1986) "Introduction," in *Postmodernism and Politics*, Jonathan Arac (ed.), Minneapolis, MN: University of Minnesota Press, pp. ix–xliii.
Aronson, Arnold (1985) "The Wooster Group's *LSD (. . . Just the High Points . . .)*," *TDR*, 29, 2: 65–77.
Artaud, Antonin (1964) "Le Théâtre et son double," in *Oeuvres Complètes* IV, Paris: Gallimard.
Ashbery, John (1976) "Years of Indiscretion," in *The Double Dream of Spring*, New York: Ecco Press, p. 46.
Augsburg, Tanya (1994) "The Persistence of Subjectivity: On Medical Technology, Meta-Performance, and Feminism in Orlan's Surgical Performances." Unpublished paper presented at Nexus Center for Contemporary Art, Atlanta, GA, 15 April.
Auslander, Philip (1989) "Going with the Flow: Performance Art and Mass Culture," *TDR*, 33, 2: 119–36.
—— (1992a) *Presence and Resistance: Postmodernism and Cultural Politics in Contemporary American Performance*, Ann Arbor, MI: University of Michigan Press.
—— (1992b) "Comedy About the Failure of Comedy: Stand-up Comedy and Postmodernism," in *Critical Theory and Performance*, Janelle G. Reinelt and Joseph R. Roach (eds.), Ann Arbor, MI: University of Michigan Press, 196–207.
—— (1995a) Review of books on the body, *TDR*, 39, 3: 169–80.
—— (1995b) "Evangelical Fervor," *TDR*, 39, 4: 178–83.

—— (1996) "Liveness: Performance and the Anxiety of Simulation," in *Performance and Cultural Politics*, Elin Diamond (ed.), London and New York: Routledge, pp. 198–213.

Balsamo, Anne (1992) "On the Cutting Edge: Cosmetic Surgery and the Technological Production of the Gendered Body," *camera obscura*, 28: 207–37.

Banes, Sally (1987) *Terpsichore in Sneakers: Post-Modern Dance*, Middletown, CT: Wesleyan University Press.

Barr, Roseanne (1987) *The Roseanne Barr Show* (videotape), Rocco Urbisci (prod. and dir.), HBO Video (Comedy Club series).

Barreca, Regina (1988) "Introduction," in *Last Laughs: Perspectives on Women and Comedy*, Regina Barreca (ed.), New York: Gordon and Breach, pp. 3–22.

Barthes, Roland (1977) *Image/Music/Text*, trans. Stephen Heath, New York: Hill and Wang.

Baudrillard, Jean (1981) *For a Critique of the Political Economy of the Sign*, trans. Charles Levin, St Louis, MO: Telos Press.

—— (1983) *In the Shadow of the Silent Majorities*, trans. Paul Foss, Paul Patton, and John Johnston, New York: Semiotext(e).

Baxandall, Lee (1969) "Spectacles and Scenarios: A Dramaturgy of Radical Activity," *TDR*, 13, 4: 52–71.

Berlant, Lauren (1988) "The Female Complaint," *Social Text*, 19/20: 237–59.

Birringer, Johannes (1991 [1985]) "Postmodern Performance and Technology," in *Theatre, Theory, Postmodernism*, Bloomington, IN: University of Indiana Press, pp. 169–81.

Blau, Herbert (1982a) *Blooded Thought: Occasions of Theatre*, New York: Performing Arts Journal Publications.

—— (1982b) *Take Up the Bodies: Theater at the Vanishing Point*, Urbana, IL: University of Illinois Press.

—— (1983) "Ideology and Performance," *Theatre Journal*, 35, 4: 441–60.

—— (1987) *The Eye of Prey: Subversions of the Postmodern*, Bloomington, IN: Indiana University Press.

—— (1990) *The Audience*, Baltimore, MD: Johns Hopkins University Press.

Boal, Augusto (1985) *Theatre of the Oppressed*, trans. C. A. and M. L. McBride, New York: Theatre Communications Group.

—— (1992) *Games for Actors and Non-actors*, trans. Andrew Jackson, London and New York: Routledge.

Borns, Betsy (1987) *Comic Lives: Inside the World of American Stand-up Comedy*, New York: Simon and Schuster.

Bornstein, Kate (1994) *Gender Outlaw*, New York, London: Routledge.

Bové, Paul A. (1986) "The Ineluctability of Difference: Scientific Pluralism and the Critical Intelligence," in *Postmodernism and Politics*, Jonathan Arac (ed.), Minneapolis, MN: University of Minnesota Press, pp. 3–25.

Brecht, Bertolt (1964) *Brecht on Theatre*, John Willett (ed.), New York: Hill and Wang.

—— (1983) "The Caucasian Chalk Circle," in *Two Plays by Bertolt Brecht*, trans. Eric Bentley, New York: Meridian.

Brook, Peter (1969) *The Empty Space*, New York: Avon.

Brunius, Teddy (1966) *Inspiration and Katharsis*, Swedish Studies in Aesthetics 3, Uppsala: Uppsala University.

Buci-Glucksmann, Christine (1987) "Catastrophic Utopia: The Feminine as Allegory of the Modern," in *The Making of the Modern Body: Sexuality and Society in the Nineteenth Century*, Catherine Gallagher and Thomas Laqueur (eds), Berkeley, CA: University of California Press, pp. 220–9.

Butler, Judith (1993) *Bodies that Matter: On the Discursive Limits of Sex*, London and New York: Routledge.

Carlson, Marvin (1996) *Performance: A Critical Introduction*, London and New York: Routledge.

Case, Sue-Ellen (1988) *Feminism and Theatre*, New York: Methuen.

Case, Sue-Ellen and Forte, Jeanie K. (1985) "From Formalism to Feminism," *Theater*, 16: 62–5.

Celant, Germano (1980) "Dirty Acconci," *Artforum*, 19: 76–83.

Chaikin, Joseph (1972) *The Presence of the Actor*, New York: Atheneum.

Cixous, Hélène (1981) "Castration or Decapitation?" trans. Annette Kuhn, *Signs: Journal of Women in Culture and Society*, 7, 1: 41–55.

Cohen-Cruz, Jan and Schutzman, Mady (1990) "Theatre of the Oppressed Workshops with Women: An Interview with Augusto Boal," *TDR*, 34, 3: 66–76.

Collier, Denise and Beckett, Kathleen (1980) *Spare Ribs: Women in the Humor Biz*, New York: St Martin's Press.

Copeau, Jacques (1955) *Notes sur le métier de comédien*, Paris: Michel Brient.

Copeland, Roger (1983) "Postmodern Dance/Postmodern Architecture/ Postmodernism," *Performing Arts Journal*, 19: 27–43.

—— (1989) "Art Against Art," *American Theatre*, July/August: 1–18, 57.

Cottingham, Laura (1994) "Orlan," *Frieze International Art Magazine*, 14: 60.

Crimp, Douglas (1984 [1979]) "Pictures," in *Art After Modernism: Rethinking Representation*, Brian Wallis (ed.), New York: New Museum of Contemporary Art; Boston, MA: David R. Godine, pp. 179–87.

Culler, Jonathan (1982) *After Structuralism*, Ithaca, NY: Cornell University Press.

Daly, Mary (1978) *Gyn/Ecology: The Metaethics of Radical Feminism*, Boston, MA: Beacon Press.

Davis, Mike (1985) "Urban Renaissance and the Spirit of Postmodernism," *New Left Review*, 151: 106–13.

Davis, R. G. (1975) *The San Francisco Mime Troupe: The First Ten Years*, Palo Alto, CA: Ramparts Press.

Derrida, Jacques (1976) *Of Grammatology*, trans. Gayatri Spivak, Baltimore, MD: Johns Hopkins University Press.

—— (1978) *Writing and Difference*, trans. Alan Bass, Chicago, IL: University of Chicago Press.

—— (1981a) *Positions*, trans. Alan Bass, Chicago, IL: University of Chicago Press.

—— (1981b) *Dissemination*, trans. Barbara Johnson, Chicago, IL: University of Chicago Press.

—— (1982) *Margins of Philosophy*, trans. Alan Bass, Chicago, IL: University of Chicago Press.

Dery, Mark (1996) *Escape Velocity: Cyberculture at the End of the Century*, New York: Grove Press.

DeVault, Russ (1988) "A Working 'Fumorist': Comic Kate Clinton Brings Feminism to Her Humor," *Atlanta Journal–Constitution Weekend*, 24 September 1988: 25.

Diamond, Elin (1995) "The Shudder of Catharsis in Twentieth-Century Performance," in *Performativity and Performance*, Andrew Parker and Eve Kosofsky Sedgwick (eds), New York and London: Routledge, pp. 152–72.

—— (1996) "Introduction," in *Performance and Cultural Politics*, Elin Diamond (ed.), London and New York: Routledge, pp. 1–12.

Diderot, Denis (1970) "The Paradox of Acting," in Toby Cole and Helen Kirch Chinoy (eds), *Actors on Acting*, New York: Crown Publishers, pp. 162–70.

Dolan, Jill (1995) "Response to W. B. Worthen's 'Disciplines of the Text/Sites of Performance,' " *TDR*, 39, 1: 28–35.

Dolan, Mary Anne (1989) "Today's Women Comics – Knock-Down Funny, Knock-Down Serious," *Los Angeles Times*, 2 January 1989: Sec. 2, 5.

Dullin, Charles (1970) "The Birth and Life of Characters," in *Actors on Acting*, Toby Cole and Helen Kirch Chinoy (eds), New York: Crown Publishers, pp. 226–34.

Dworkin, Ronald (1983) "Law as Interpretation," in *The Politics of Interpretation*, W. J. T. Mitchell (ed.), Chicago, IL: University of Chicago Press, pp. 249–70.

Elam, Keir (1980) *The Semiotics of Theatre and Drama*, London: Methuen.

Eldredge, Sears A. (1979–80) "Jacques Copeau and the Mask in Actor Training," *Mime, Mask, and Marionette*, 2, 3/4.

Eldredge, Sears A. and Huston, Hollis W. (1995 [1978]) "Actor Training in the Neutral Mask," in *Acting (Re)Considered*, Phillip B. Zarrilli (ed.), London and New York: Routledge, pp. 121–8.

Erickson, Jon (1995) *The Fate of the Object: From Modern Object to Postmodern Sign in Performance, Art, and Poetry*, Ann Arbor, MI: University of Michigan Press.

Feenberg, Andrew (1980) "The Political Economy of Social Space," in *The Myths of Information: Technology and Postindustrial Culture*, Kathleen Woodward (ed.), Madison, WI: Coda Press, pp. 111–24.

Féral, Josette (1982) "Performance and Theatricality: The Subject Demystified," *Modern Drama*, 25: 170–81.

Fisher, Berenice (1994) "Feminist Acts: Women, Pedagogy, and Theatre of the Oppressed," in *Playing Boal: Theatre, Therapy, Activism*, Mady Schutzman and Jan Cohen-Cruz (eds), London and New York: Routledge, pp. 185–97.

Fiske, John (1987) *Television Culture*, London and New York: Routledge.

Foley, Barbara (1985) "The Politics of Deconstruction," in *Rhetoric and Form: Deconstruction at Yale*, Robert Con Davis and Ronald Schleifer (eds), Norman, OK: University of Oklahoma Press, pp. 113–34.

Ford, Andrew (1995) "*Katharsis*: The Ancient Problem," in *Performativity and Performance*, Andrew Parker and Eve Kosofsky Sedgwick (eds), New York and London: Routledge, pp. 109–32.

Forte, Jeanie (1992) "Focus on the Body: Pain, Praxis, and Pleasure in Feminist Performance," in *Critical Theory and Performance*, Janelle G. Reinelt and Joseph R. Roach (eds), Ann Arbor, MI: University of Michigan Press, pp. 248–62.

Foster, Hal (1983) "Postmodernism: A Preface," in *The Anti-Aesthetic: Essays on Postmodern Culture*, Hal Foster (ed.), Port Townsend, WA: Bay Press, pp. ix–xvi.

—— (1984 [1982]) "Re: Post," in *Art After Modernism: Rethinking Representation*, Brian Wallis (ed.), New York: New Museum of Contemporary Art; Boston, MA: David R. Godine, pp. 189–201.

—— (1985) *Recodings: Art, Spectacle, Cultural Politics*, Port Townsend, WA: Bay Press.

Foster, Susan Leigh (1985) "The Signifying Body: Reaction and Resistance in Postmodern Dance," *Theatre Journal*, 37, 1: 45–64.

—— (1986) *Reading Dancing: Bodies and Subjects in Contemporary American Dance*, Berkeley, CA: University of California Press.

Foucault, Michel (1973) *The Order of Things: An Archaeology of the Human Sciences*, New York: Vintage Books.

Frank, Waldo (1925) "Copeau Begins Again," *Theatre Arts Magazine*, 9: 584–90.

Frenkel, Vera (1981) "Discontinuous Notes on and after a Meeting of Critics, by one of the Artists Present," *artscanada*, 240/241: 28–41.

Fried, Michael (1968 [1967]) "Art and Objecthood," in *Minimal Art: A Critical Anthology*, Gregory Battcock (ed.), New York: Dutton, pp. 116–47.

—— (1983) "How Modernism Works: A Response to T. J. Clark," in *The Politics of Interpretation*, W. J. T. Mitchell (ed.), Chicago, IL: University of Chicago Press, pp. 221–38.

—— (1987) Statement, in *Discussions in Contemporary Culture* Number One, Hal Foster (ed.), Seattle, WA: Bay Press, pp. 55–8.

Fuchs, Elinor (1983) "The Death of Character," *TheatreCommunications*, 5, 3: 1–6.

—— (1984) Performance Note, *Performing Arts Journal*, 23: 51–5.

—— (1985) "Presence and the Revenge of Writing: Re-thinking Theatre After Derrida," *Performing Arts Journal*, 26/27: 163–73.

Gallagher, Catherine and Laqueur, Thomas (eds) (1987) "Introduction," in *The Making of the Modern Body: Sexuality and Society in the Nineteenth Century*, Berkeley, CA: University of California Press, pp. vii–xv.

Goldman, Eric F. (1960) *The Crucial Decade and After: America, 1945–1960*, New York: Random House.

Greenberg, Clement (1962) "Art After Abstract Expressionism," *Art International*, 6, 8 (October): 24–32.

Grossberg, Lawrence (1988) "Putting the Pop Back into Postmodernism," in *Universal Abandon? The Politics of Postmodernism*, Andrew Ross (ed.), Minneapolis, MN: University of Minnesota Press, pp. 167–90.

Grotowski, Jerzy (1968) *Towards a Poor Theatre*, New York: Simon and Schuster.

—— (1973) "Holiday: The Day that is Holy," trans. Boleslaw Taborski, *TDR*, 17, 2: 133–4.

Guillaumin, Claudette (1993) "The Constructed Body," trans. Diane Griffin Crowder, in *Reading the Social Body*, Catherine B. Burroughs and Jeffrey David Ehrenreich (eds), Iowa City, IA: University of Iowa Pess, pp. 40–60.

Hausmann, Bernice L. (1992) "Demanding Subjectivity: Transsexualism, Medicine, and the Technologies of Gender," *Journal of the History of Sexuality*, 3, 2: 270–302.

Heimel, Cynthia (1983) *Sex Tips for Girls*, New York: Simon and Schuster.

Helitzer, Melvin (1984) *Comedy Techniques for Writers and Performers*, Athens, OH: Lawhead Press.

High Ridge Productions (1985) *Women Tell the Dirtiest Jokes* (videotape), Stephen L. Singer (prod.), Greg Grosz (dir.).

Hornby, Richard (1995) "The Death of Literature and History," *Theatre Topics*, 5, 2: 143–50.

House, Humphry (1958) *Aristotle's Poetics*, London: Rupert Hart-Davis.

Innes, Christopher (1981) *Holy Theatre: Ritual and the Avant Garde*, New York: Cambridge University Press.

Jacobi, Jolande (1973) *The Psychology of C. G. Jung*, New Haven, CN: Yale University Press.

Jameson, Fredric (1981) "'In the Destructive Element Immerse': Hans-Jürgen Syberberg and Cultural Revolution," *October*, 17: 99–118.

—— (1984a) "The Politics of Theory: Ideological Positions in the Postmodern Debate," *New German Critique*, 32: 53–65.

—— (1984b) "Postmodernism or the Cultural Logic of Late Capitalism," *New Left Review*, 146: 53–92.

Kader, Cheryl (1990) "Kate Clinton: The Production and Reception of Feminist Humor," in *Sexual Politics and Popular Culture*, Diane Raymond (ed.), Bowling Green, OH: Popular Press, pp. 42–55.

Kakutani, Michiko (1984) "When Great Actors Put Their Stamp on a Role," *New York Times*, 20 May, Sec. 2, 1.

Kember, Sarah (1995) "Medicine's New Vision?" in *The Photographic Image in Digital Culture*, Martin Lister (ed.), London and New York: Routledge, pp. 95–114.

Kirby, Michael (1969) "The Activity: A New Art Form," in *The Art of Time: Essays on the Avant-Garde*, New York: Dutton, pp. 153–69.

—— (1995 [1972]) "On Acting and Not-Acting," in *Acting (Re)Considered*, Phillip B. Zarrilli (ed.), London and New York: Routledge, pp. 43–58.

Krauss, Rosalind (1987) Statement, in *Discussions in Contemporary Culture Number One*, Hal Foster (ed.), Seattle, WA: Bay Press, pp. 59–64.

Krysinski, Wladimir (1981) "Semiotic Modalities of the Body in Modern Theater," *Poetics Today*, 2/3: 141–61.

Kubiak, Anthony (1987) "Disappearance as History: The Stages of Terror," *Theatre Journal*, 39, 1: 78–88.

Kuhn, Thomas S. (1970) *The Structure of Scientific Revolutions*, Second Edition, Chicago, IL: University of Chicago Press.

Leifer, Carol (1989) Stand-up comedy performance at the Punch Line Comedy Club, Sandy Springs, GA.

Leigh, Barbara Kusler (1979) "Jacques Copeau's School for Actors," *Mime Journal*, 9/10: 7–75.

Leitch, Vincent B. (1983) *Deconstructive Criticism: An Advanced Introduction*, New York: Columbia University Press.

Liddy, G. Gordon (1981) *Will*, New York: Dell.

Lyotard, Jean-François (1984) *The Postmodern Condition: A Report on Knowledge*, trans. Geoff Bennington and Brian Massumi, Minneapolis, MN: University of Minnesota Press.

—— (1984 [1982]) "Answering the Question: What is Postmodernism?" trans. Régis Durand, in *The Postmodern Condition: A Report on Knowledge*, pp. 71–82.

Lyotard, Jean François and Thébaud, Jean-Loup (1985) *Just Gaming*, trans. Wlad Godzich, Minneapolis, MN: University of Minnesota Press.

Marc, David (1989) *Comic Visions: Television Comedy and American Culture*, Boston, MA: Unwin Hyman.

Marsh, Dave (1985) "It's Like That: Rock & Roll on the Home Front," in *The First Rock & Roll Confidential Report*, Dave Marsh (ed.), New York: Pantheon, pp. 12–34.

Mellencamp, Patricia (1986) "Situation Comedy, Feminism, and Freud: Discourses of Gracie and Lucy," in *Studies in Entertainment: Critical Approaches to Mass Culture*, Tania Modleski (ed.), Bloomington, IN: Indiana University Press, pp. 80–95.

Melville, Stephen (1981) "How Should Acconci Count for Us?" *October*, 18: 79–89.

Mennen, Richard (1975) "Jerzy Grotowski's Paratheatrical Projects," *TDR*, 19, 4: 58–69.

Merrill, Lisa (1988) "Feminist Humor: Rebellious and Self-Affirming," in *Last Laughs: Perspectives on Women and Comedy*, Regina Barreca (ed.), New York: Gordon and Breach, pp. 271–80.

Miller, Arthur (1959) *The Crucible*, New York: Bantam Books.

—— (1978) "It Could Happen Here – And Did," in *The Theater Essays of Arthur Miller*, Robert A. Martin (ed.), New York: Viking, pp. 294–300.

Miller, J. Hillis (1975) "Fiction and Repetition: *Tess of the d'Urbervilles*," in *Forms of Modern British Fiction*, Alan Warren Freeman (ed.), Austin TX: University of Texas Press, pp. 43–71.

Miller, Mark Crispin (1986) "Deride and Conquer," in *Watching Television*, Todd Gitlin (ed.), New York: Pantheon Books, pp. 183–228.

Morgan, Kathryn Pauly (1991) "Women and the Knife: Cosmetic Surgery and the Colonization of Women's Bodies," *Hypatia*, 6, 3: 25–53.

Moynahan, Paula A., MD (1988) *Cosmetic Surgery for Women*, New York: Crown.

Munter, Carol (1984) "Fat and the Fantasy of Perfection," in *Pleasure and Danger: Exploring Female Sexuality*, Carole S. Vance (ed.), Boston, MA: Routledge and Kegan Paul, pp. 225–31.

Murphie, Andrew (1991) "Negotiating Presence: Performance and New Technologies," in *Culture, Technology, and Creativity in the Late Twentieth Century*, Philip Hayward (ed.), London: John Libbey, pp. 209–26.

Murray, Timothy (1984) "The Theatricality of the Van-Guard: Ideology and Contemporary American Theatre," *Performing Arts Journal*, 24: 93–9.

Nead, Lynda (1992) *The Female Nude: Art, Obscenity and Sexuality*, London and New York: Routledge.

Orlan (Undated a) "History," published and distributed by the artist.
—— (Undated b) "Philosophy," published and distributed by the artist.
Osborne, Harold (1973) *Aesthetics and Art Theory*, Westport, CT: Greenwood Press.
Owens, Craig (1984 [1980]) "The Allegorical Impulse: Toward a Theory of Postmodernism," in *Art After Modernism: Rethinking Representation*, Brian Wallis (ed.), New York: New Museum of Contemporary Art; Boston, MA: David R. Godine, pp. 203–35.
Parker, Andrew and Sedgwick, Eve Kosofsky (eds) (1995) *Performativity and Performance*, New York, London: Routledge.
Passolli, Robert (1972) *A Book on the Open Theatre*, New York: Avon.
Passow, Wilfried (1981) "The Analysis of Theatrical Performance," trans. R. Strauss, *Poetics Today*, 2, 3: 237–54.
Pavis, Patrice (1992 [1986]) "The Classical Heritage of Modern Drama: The Case of Postmodern Theatre," in *Theatre at the Crossroads of Culture*, trans. Loren Kruger, London and New York: Routledge, pp. 48–74.
Polan, Dana B. (1986) "'Above All Else to Make You See': Cinema and the Ideology of Spectacle," in *Postmodernism and Politics*, Jonathan Arac (ed.), Minneapolis, MN: University of Minnesota Press, pp. 55–69.
Pollio, Howard R. and Edgerly, John W. (1976) "Comedians and Comic Style," in *Humour and Laughter: Theory, Research and Applications*, Anthony J. Chapman and Hugh C. Foot (eds), London: John Wiley and Sons, pp. 215–42.
Pontbriand, Chantal (1982) "'The Eye Finds No Fixed Point on Which to Rest . . . ,'" *Modern Drama* 25: 154–62.
Rabkin, Gerald (1983) "The Play of Misreading: Text/Theatre/Deconstruction," *Performing Arts Journal*, 19: 44–60.
—— (1985) "Is There a Text On This Stage? Theatre/Authorship/Interpretation," *Performing Arts Journal*, 26/27: 142–59.
Richards, Thomas (1995) *At Work with Grotowski on Physical Actions*, London and New York: Routledge.
Roach, Joseph (1985) *The Player's Passion: Studies in the Science of Acting*, Newark, DE: University of Delaware Press.
Robbins, Bruce (1986) "Feeling Global: John Berger and Experience," in *Postmodernism and Politics*, Jonathan Arac (ed.), Minneapolis, MN: University of Minnesota Press, pp. 145–61.
Rose, Barbara (1993) "Is it Art? Orlan and the Transgressive Act," *Art in America*, 81, 2: 82–7+.
Rosenthal, Sylvia (1977) *Cosmetic Surgery: A Consumer's Guide*, Philadelphia, PA: Lippincott.
Rouse, John (1995 [1984]) "Brecht and the Contradictory Actor," in *Acting (Re)Considered*, Phillip B. Zarrilli (ed.), London and New York: Routledge, pp. 228–41.
Russell, Charles (1980) "The Context of the Concept," *Bucknell Review*, 25, 2: 181–93.
Savran, David (1985) "The Wooster Group, Arthur Miller and *The Crucible*," *TDR*, 29, 2: 99–109.
Sayre, Henry M. (1989) *The Object of Performance*, Chicago, IL: University of Chicago Press.

Schechner, Richard (1982) "The Decline and Fall of the (American) Avant-Garde," in *The End of Humanism*, New York: PAJ Publications, pp. 11–76.
—— (1992) "A New Paradigm for Theatre in the Academy," *TDR*, 36, 4: 7–10.
Scheff, T. J. (1979) *Catharsis in Healing, Ritual, and Drama*, Berkeley, CA: University of California Press.
Sheets-Johnstone, Maxine (1992) "Charting the Interdisciplinary Course," in *Giving the Body Its Due*, Maxine Sheets-Johnstone (ed.), Albany, NY: SUNY Press, pp. 1–15.
Siegel, Marcia B. (1988) "The Truth About Apples and Oranges," *TDR*, 32, 4: 24–31.
Smith, A. C. H. (1972) *Orghast at Persepolis*, New York: Viking.
Spitzack, Carole (1988) "The Confession Mirror: Plastic Images for Surgery," *Canadian Journal of Political and Social Theory*, 12, 1–2: 38–50.
Stanislavski, Constantin (1936) *An Actor Prepares*, trans. Elizabeth Hapgood Reynolds, New York: Theatre Arts Books.
Taussig, Michael and Schechner, Richard (1994 [1990]) "Boal in Brazil, France, the USA: An Interview with Augusto Boal," in *Playing Boal: Theatre, Therapy, Activism*, Mady Schutzman and Jan Cohen-Cruz (eds), London and New York: Routledge, pp. 17–32.
Tcheupdjian, Leon, M.D. (1988) *Liposuction: New Hope for a New Figure through the Art of Body Contouring*, Chicago, IL: The Liposuction Institute.
Unterbrink, Mary (1987) *Funny Women: American Comediennes, 1860–1983*, Jefferson, NC: McFarland.
Waxman, Sharon (1993) "Art by the Slice: France's Orlan Performs in the Surgical Theater," *Washington Post*, 2 May 1993, *NewsBank* Performing Arts 1993: fiche 76, grids G10–12.
Wiles, Timothy J. (1980) *The Theater Event: Modern Theories of Performance*, Chicago, IL: University of Chicago Press.
Wilt, Judith (1980) "The Laughter of Maidens, the Cackle of Matriarchs: Notes on the Collision between Comedy and Feminism," in *Gender and Literary Voice*, Janet Todd (ed.), New York: Holmes and Meier, pp. 165–96.
Worthen, W. B. (1995) "Disciplines of the Text/Sites of Performance," *TDR*, 39, 1: 13–28.
Zillman, Dolf and Cantor, Joanne R. (1976) "A Disposition Theory of Humour and Mirth," in *Humour and Laughter: Theory, Research and Applications*, Antony J. Chapman and Hugh C. Foot (eds), London: John Wiley and Sons, pp. 93–115.

Name Index

Subject Index